12-07

DISCARD

CELEBRATING WASP STYLE

A PRIVILEGED LIFE

Susanna Salk

For my family (that includes Holly).

© Text and personal archives: 2007, Susanna Salk

© 2007 Assouline Publishing
601 West 26th Street, 18th Floor
New York, NY 10001, USA
www.assouline.com

ISBN: 978 2 7594 0126 0

Color Separation: Gravor (Switzerland)
Printed by SNP Leefung

CELEBRATING WASP STYLE
A PRIVILEGED LIFE

Susanna Salk

ASSOULINE

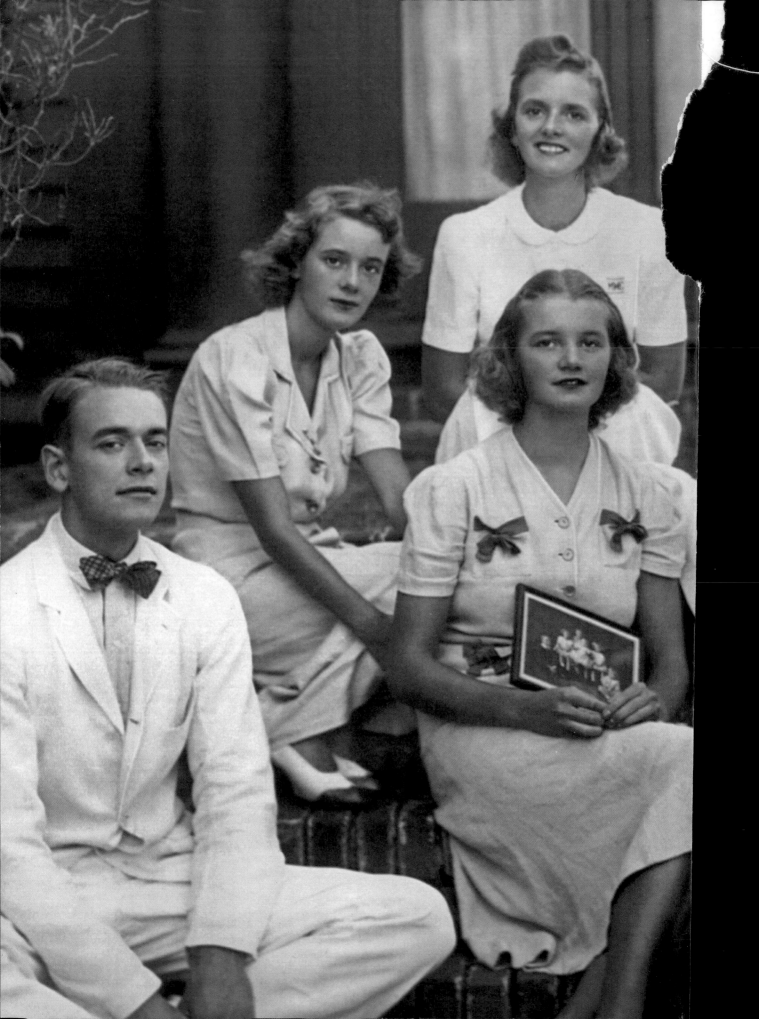

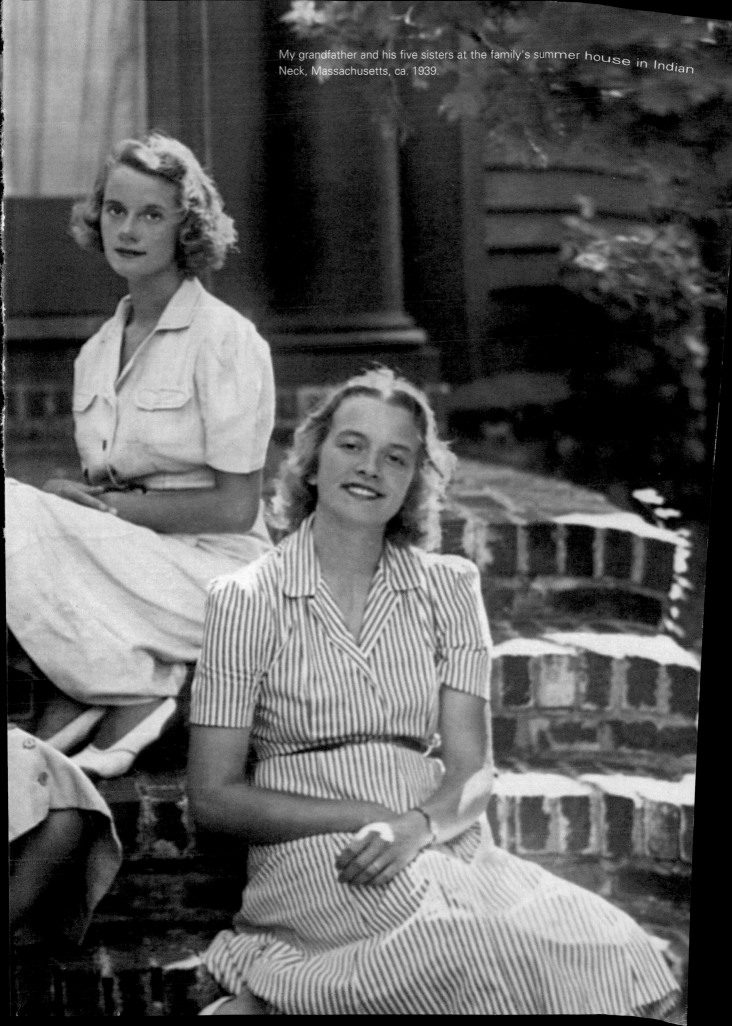

My grandfather and his five sisters at the family's summer house in Indian Neck, Massachusetts, ca. 1939.

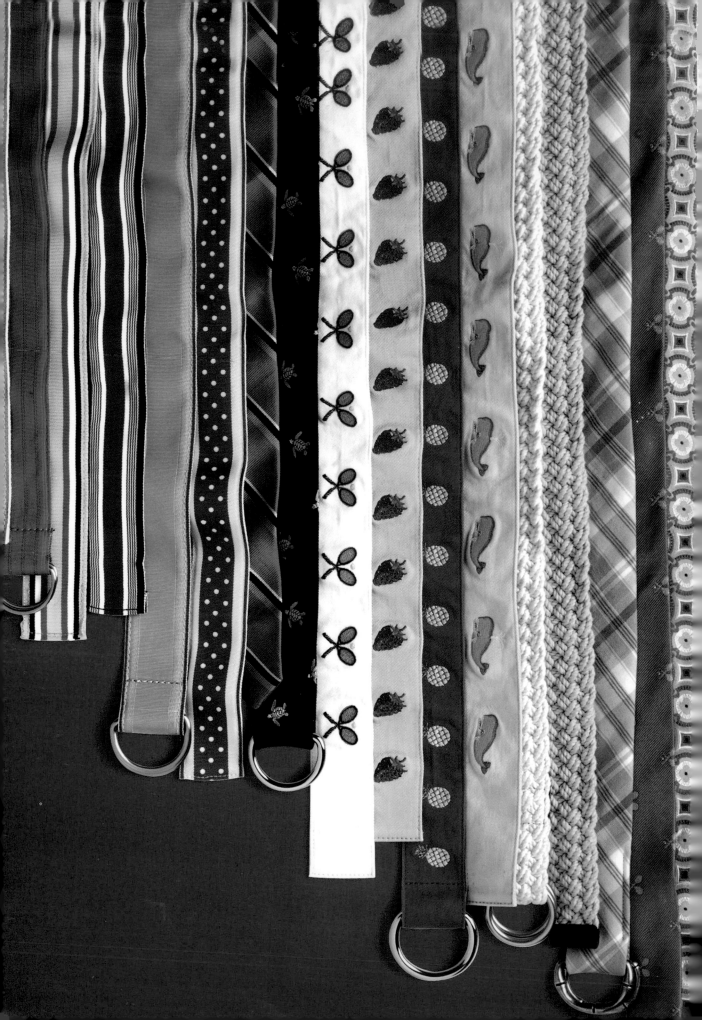

CONTENTS

J. Crew's ribbon belts embody this cheerful WASP wardrobe staple.

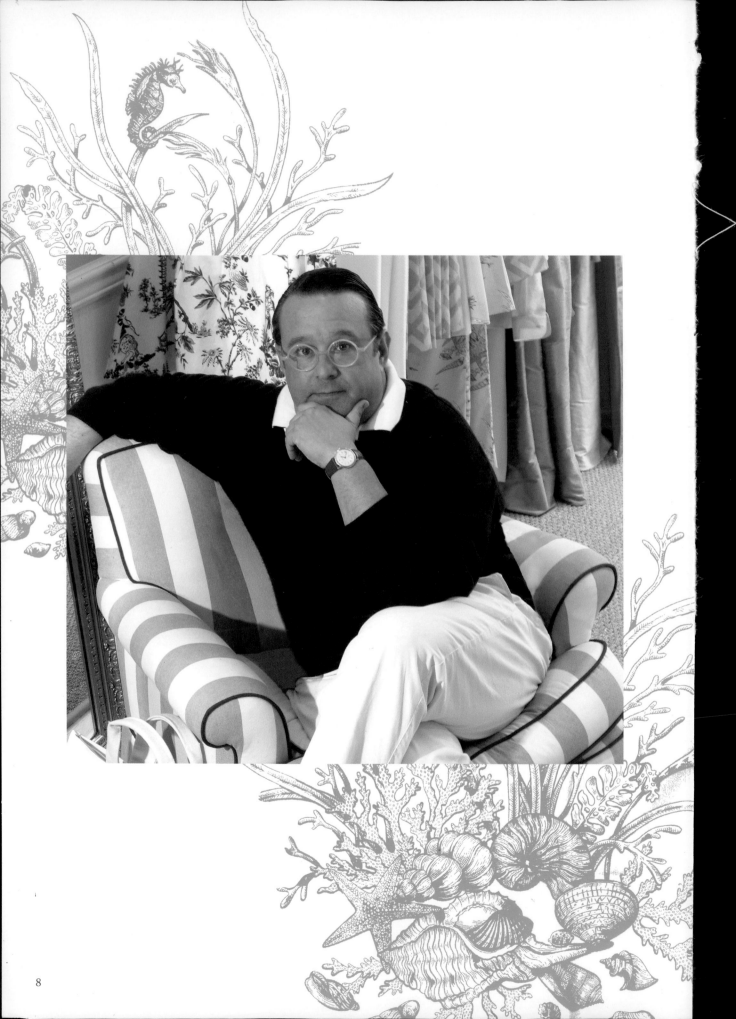

FOREWORD

BY STEVEN STOLMAN

When Susanna Salk asked me to write the introduction to this book, I couldn't help but find the irony of it rather amusing. After all, what does a nice Jewish boy from West Hartford, Connecticut know about WASP style? After mulling it over for a while, I realized that what people refer to as WASP style really has more to do with a certain sensibility than a religious persuasion. The well-worn, conservative ethic that we think of as WASP was simply the way pretty much everyone dressed and conducted themselves in a traditional New England suburb. I suppose the look was called "preppy" back then—although this was way before the publication of Lisa Birnbach's *The Official Preppy Handbook* (so were we unofficial preppies?). Our parents' generation took their sartorial cues from Grace Kelly, Cary Grant, and Jackie and Jack—clean-cut, intelligent, and optimistic. They styled their homes for comfort and encouraged good work and fine manners. Our role models, however, were a bit more bohemian—James Taylor, Carly Simon, Carole King, and, of course, Ryan O'Neal and Ali McGraw in Arthur Hiller's *Love Story*. But when Ali called Ryan "preppy" in one of the film's opening scenes, didn't she really mean "useless, spoiled elitist"? Remember, he was a WASP, while she was a good Catholic girl from Cranston.

During my childhood, West Hartford was very much a divided town. There was a Jewish side and a WASP side—complete with old guard restricted clubs—even an entire stonewalled neighborhood that was rumored to be for "Gentiles only." But

Steven Stolman, photographed in his Southampton store.

I never really took notice. We lived in a more blended area—a stately tree-lined street where in December some of the houses had menorahs in the windows while others had Christmas trees. I do remember a lot of Volvo wagons in the driveways, though. Was that WASPy or just sensible? We were all different yet the same—and it felt totally normal that our family's holiday meals featured gefilte fish while some of our neighbors had a nice ham. The ultimate common thread: driving down the street at dusk and seeing everyone's parents enjoying cocktails in their wood-paneled libraries. And if you think that our family was any different in that respect—well, you obviously don't know my parents. Perhaps we didn't have as many ancestral antiques as our fellow WASP neighbors, but it was kind of hard to bring paintings and furniture along while fleeing Minsk.

I attended a public high school that was so typical that it was actually used as a location for a movie that took place in a typical high school. It was so much more WASPy to go to one of the many private schools in the area—especially the one that boarded horses or the other one that Jackie went to. But still, at Hall High, WASP style ruled. Everyone wore frayed jeans and Topsiders, Shetland sweaters, and down vests. The girls all looked like Elizabeth McGovern in Robert Redford's *Ordinary People* and dressed in turtlenecks with little frogs all over them, wide wale corduroys, and Olaf Daughters clogs. Every so often, a little 1970s mod style would sneak in, but that was more for kids out in California, like the Bradys or the Partridges. No, our day-to-day lifestyles were spawned by the ethos of *Leave It to Beaver, Father Knows Best,*

and *The Donna Reed Show*. That is, until *Family* and *The Paper Chase* came on and everything changed.

My father bought his navy blazers and gray flannel trousers at The English Shop in town or at J. Press in New Haven. Similarly, I was sent to college in Pittsburgh with my own blazer and flannels (albeit from the husky department) along with a genuine Harris tweed jacket and a pair of Bass Weejuns that gave me blisters until the end of my sophomore year. When I moved to New York to attend Parsons School of Design, I continued to wear these clothes like a suit of armor—an affront to my fellow classmates decked out in the latest fashions. "You want to be a designer, for God's sake!" they would cry. "You dress like a dusty old English teacher." I still dress that way, although now I think that it makes me appear younger rather than older. Funny how never changing one's style tends to do that. Maybe when I'm ninety and still wearing khakis, Weejuns, and a sweater tied over my shoulders, I'll look only eighty. Am I a WASP wannabe? I dunno—I've never known any other way.

So what exactly is WASP style other than an oxymoron? It's a chiming clock on the mantle, cashmere, pearls, and the smell of Bay Rum. It's the first floor of Brooks Brothers, a ski rack on the car year round, and sneakers reddened from clay tennis courts. It's funny little cocktail snacks from S. S. Pierce—actually, anything to do with cocktails, a Bermuda suntan, and the automatic habit of saying, "Nice to see you" when shaking hands with someone. It's a certain joie de vivre mixed with polite restraint—served on the rocks in a double old-fashioned. It's as comfortable as an old club chair and as American as apple pie. Therefore, I wish you all a pleasant excursion through this lyrical celebration of all things WASP. You don't have to be one to appreciate it—I should know.

OPPOSITE: The Social Register is a compilation of names of the elite social tribe, from Boston to San Francisco. Since its inception in 1886, it is the only phone directory many WASPs would ever consult. In addition to members' winter and summer addresses, it also lists their club affiliations.

INTRODUCTION

WASP or Wasp \wäsp, wosp\ *n, often attrib.* [white Anglo-Saxon Protestant] (1957) *sometimes disparaging*: an American of Northern European and esp. British ancestry and of Protestant background; *esp.*: a member of the dominant and the most privileged class of people in the United States.

To me, being a WASP has nothing to do with religion or money. It's about childhood images: my father mowing our lawn in his faded Harvard crew T-shirt; a wooden spice rack in a Maine kitchen with hand-scrawled labels; carpooling in Mrs. Getchel's creaky Volvo scattered with dog and horsehair; bike riding in Edgartown, Martha's Vineyard dressed in drugstore flip-flops; the bobby pin holding back my fourth-grade teacher Mrs. Cobb's pageboy; Triscuits with Cracker Barrel Cheese and warm white wine in plastic tumblers for cocktail hour.

These quirky details are like landmarks to a world that seemed overly ordinary while I was immersed inside it. But now that I've traveled past its gates, I've come to realize its strangely magical atmosphere. Maybe because whenever I re-enter, nothing has changed: the places, homes, clothes, and the jaunty, sometimes peculiar way its people continually inhabit it. New generations simply and seamlessly replace the ones that came before, and the unexpected is a rare guest. But why such resistance to change and the fierce alignment to tradition? Is it snobbery, frugality, or stubbornness? Or maybe by sacrificing change for consistency, the world feels like it's a safer place. Control over one's conditions is, after all, the ultimate privilege.

While growing up, I watched *Gilligan's Island* but never made the humorous correlation that Lovey and Thurston Howell III were based on my world. We were as WASP as you could get, but my father never walked around sipping cocktails or had suitcases full of money. He worked hard, and we never took exotic vacations.

Posing for my sixth grade field hockey photo.

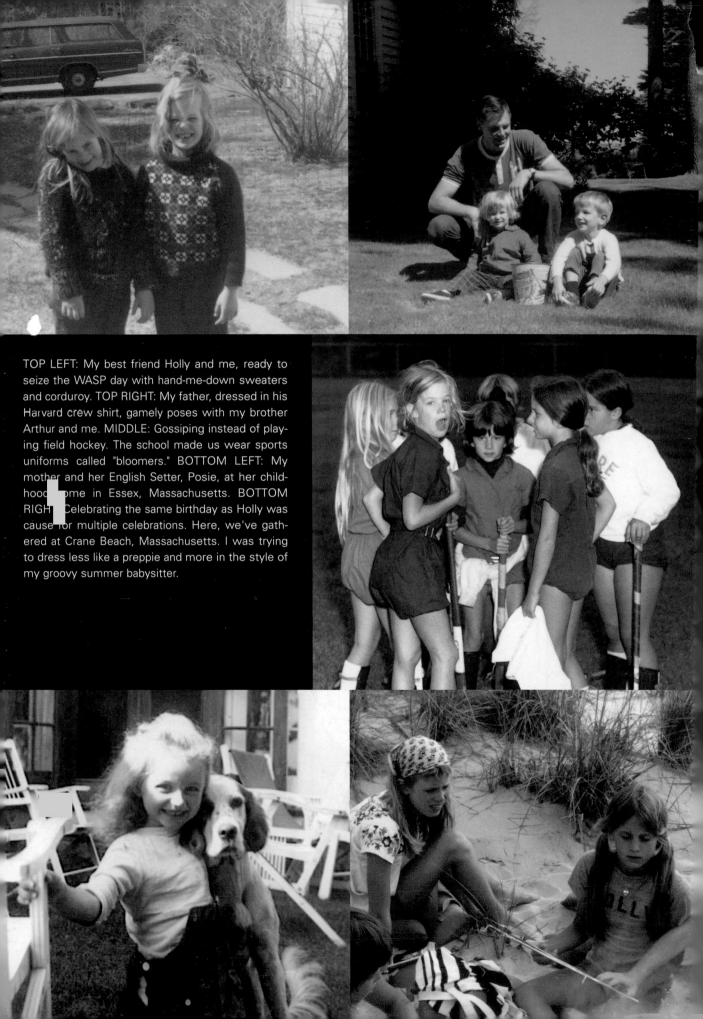

TOP LEFT: My best friend Holly and me, ready to seize the WASP day with hand-me-down sweaters and corduroy. TOP RIGHT: My father, dressed in his Harvard crew shirt, gamely poses with my brother Arthur and me. MIDDLE: Gossiping instead of playing field hockey. The school made us wear sports uniforms called "bloomers." BOTTOM LEFT: My mother and her English Setter, Posie, at her childhood home in Essex, Massachusetts. BOTTOM RIGHT: Celebrating the same birthday as Holly was cause for multiple celebrations. Here, we've gathered at Crane Beach, Massachusetts. I was trying to dress less like a preppie and more in the style of my groovy summer babysitter.

But Thurston did sound vaguely like my grandfather, with his plummy, gleeful declarations. And my mother had close friends named Muffy and Hatsie. It slowly started to dawn on me that I was part of a tribe that had as many tics and quirks as any found in the most remote regions of the planet.

As soon as I went to boarding school, where students from all walks of the world converged, the Yankee DNA of my tribe seemed especially unglamorous. In a Darwinian effort to adapt, I swapped my L. L. Bean boots for high heels, and accessorized with a boyfriend from Venezuela who wore a tiger's claw around his neck.

Then I went to college in New York, and *The Official Preppy Handbook* by Lisa Birnbach was on the best-seller list. My roommate read the book incredulously, refusing to believe that it was based on any fact. When I reluctantly showed her my photo album, instead of being horrified, she was fascinated. Suddenly, being a preppy was exotic, and I became equally intrigued with its many gradations and manifestations. There were Boston WASPs who were completely different than Upper East Side WASPs. (The former living more frugally than the latter.) There were people who dressed like preps but who weren't true WASPs, i.e., the enduring Ralph Lauren polo craze. There were WASPs who eschewed pink and green. (As for this author: never ever, not even on a belt.) There were even men who could remain positively macho wearing bright green blazers. (Trust me.) No matter the genre, there was a sense of the elusive and exclusive, a kind of womb-like layer that kept the outsider outside, and I was lucky enough to go in and out whenever I wanted.

Sometimes I felt like a museum guide. Taking a new boyfriend home one evening, he saw my parents reading the *New York Times* together on the love seat, awaiting our arrival. He noticed their simple country clothes of cotton and corduroy and equally identical postures. "Are they *really* doing that?!" he asked incredulously. For the first time, I felt lucky to be in a place where the dependability of certain simple pleasures still mattered.

Later, I married Eric, who grew up in Manhattan. When I first met my Jewish father-in-law in his imposing Park Avenue apartment, he hugged me, handed Eric a scotch, and proceeded to make us stir-fry in the kitchen. I felt like I had arrived home. And when Eric spent holidays with my family, he found an equally comfortable rapport with my parents (and the accompanying gin and tonics and casseroles). Maybe the walls between tribes weren't as stalwart as I had always assumed.

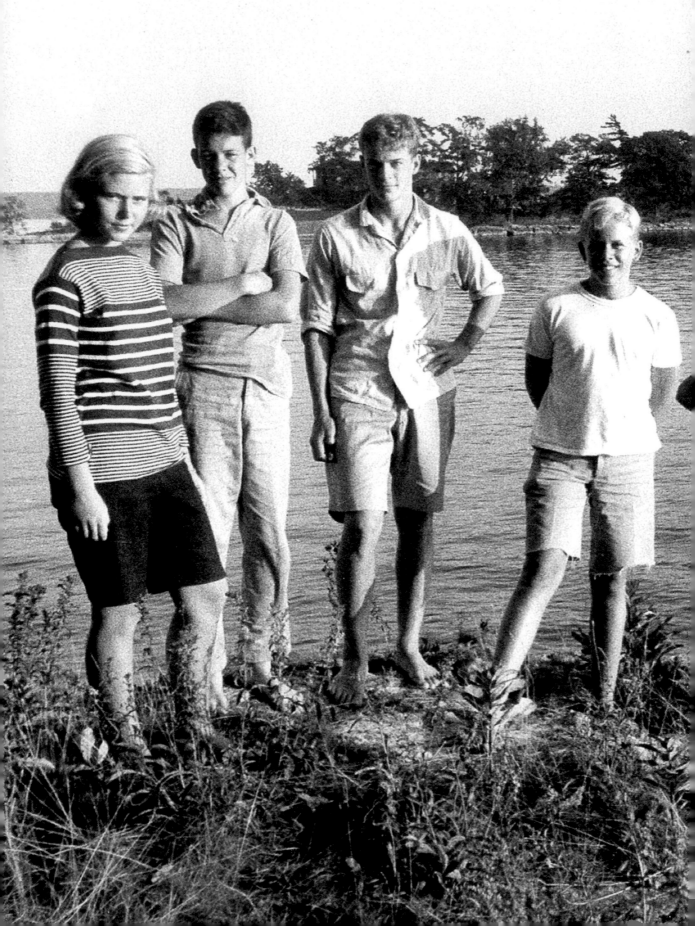

Eight years ago, we moved to Connecticut from Los Angeles, nostalgic for seasons and a place where our children had things to do on the weekend other than go to movie screenings. Here, I am as apt to see a member of my tribe in the supermarket aisle as not. I'm relieved I don't live solely in my old world, yet I'm glad it's nearby. And when life brings sudden and horrible change, the infinite consistency of where I grew up is profoundly comforting. After I watched the World Trade Center collapse on television, I picked up a L. L. Bean catalog and gazed at its pages completely shell-shocked: could there still be a world where people sat on sunny docks with initialized totes eating Pepperidge Farm Chessman Cookies? I suddenly wanted to wear safe, sexless clothes and be picked up by Mrs. Getchel again. She could drive me back to a time and place where things never seemed to go wrong.

Seeing how quickly time has fled in my own life, I wanted to gather all the timeless images from this world that I could find. From fashion to fiction, WASP style is far broader and more enduring than I ever imagined. So by throwing open the oft-closed doors on the WASP world, I hope to cast light on its unexpected grace, strength, quirkiness, and glamour. Not to intrude, but to capture. Just in case its timelessness should one day become short-lived.

Distant cousins at Watch Island, ca. 1953. The pine trees and rocky coastline are synonymous with WASP scenery.

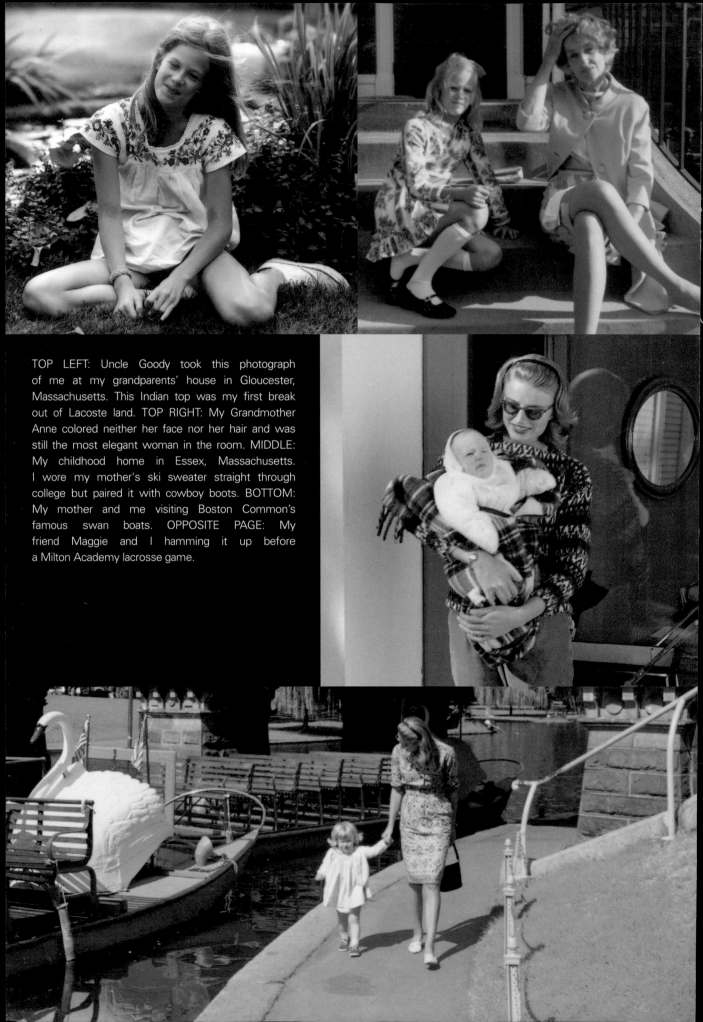

TOP LEFT: Uncle Goody took this photograph of me at my grandparents' house in Gloucester, Massachusetts. This Indian top was my first break out of Lacoste land. TOP RIGHT: My Grandmother Anne colored neither her face nor her hair and was still the most elegant woman in the room. MIDDLE: My childhood home in Essex, Massachusetts. I wore my mother's ski sweater straight through college but paired it with cowboy boots. BOTTOM: My mother and me visiting Boston Common's famous swan boats. OPPOSITE PAGE: My friend Maggie and I hamming it up before a Milton Academy lacrosse game.

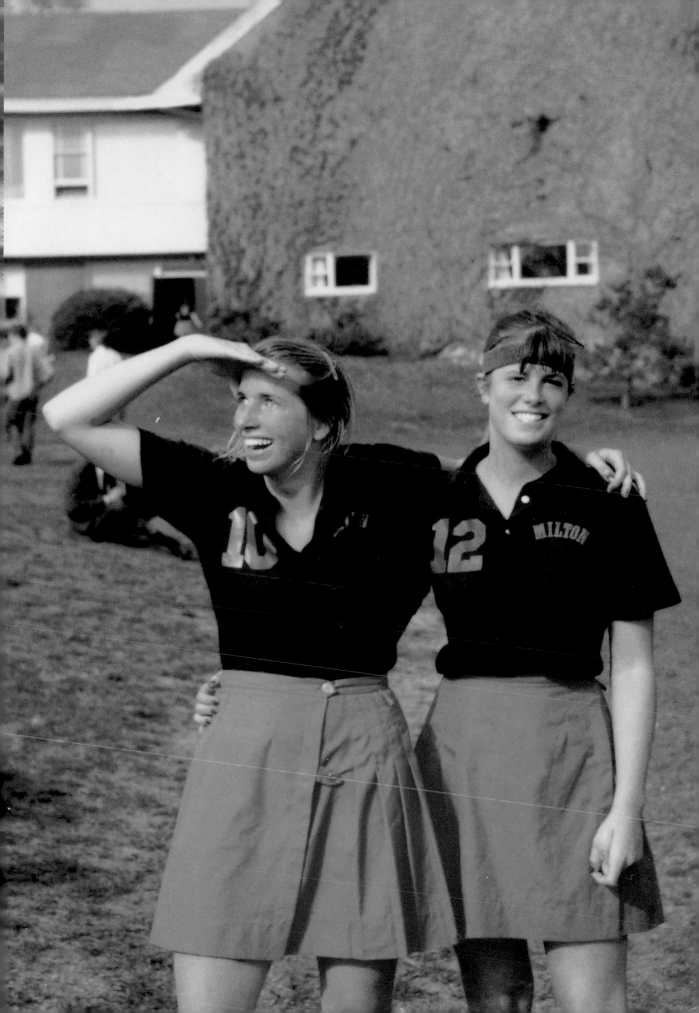

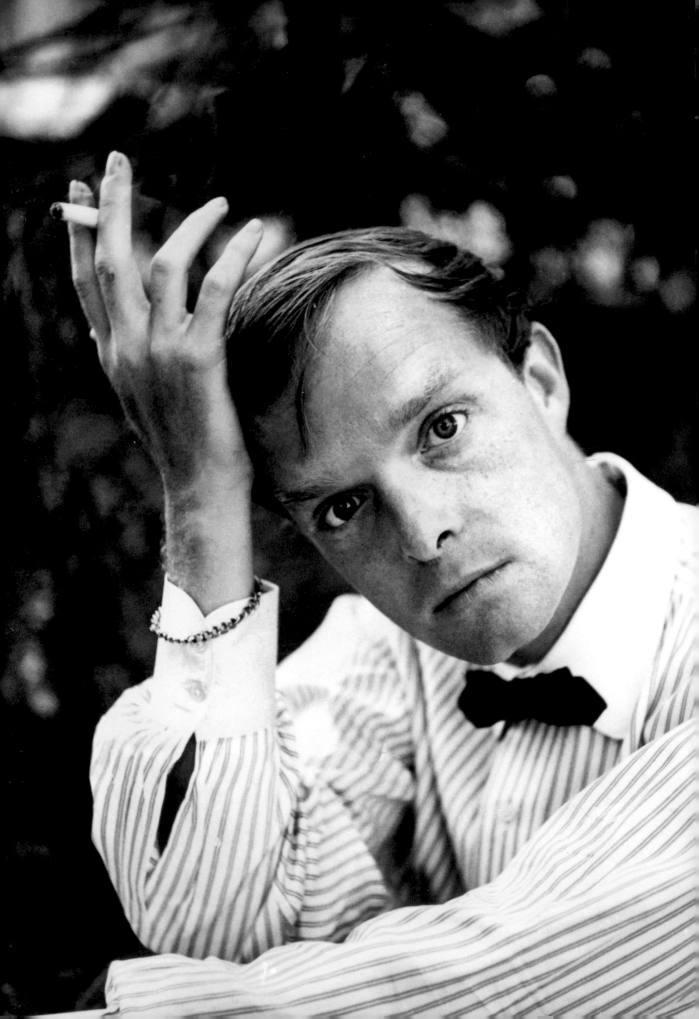

ICONS

At a wedding reception I attended some years ago, one of my parents' friends strolled over to ask how I was faring in Manhattan. I hadn't seen her since I was in fifth grade, but in her simple cotton dress, sandals, and pageboy haircut, she had not changed in twenty years. I inquired after her daughter who had recently moved to Manhattan from Boston. "Horribly!" she retorted. I expected the usual New York stories of impoverished living to follow. Instead, she leaned close, and emphatically whispered: "She's with YALIES!" It took me a while before I realized she meant those who graduated from Harvard's rival school, not some deviant motorcycle gang.

Stereotypes are born in truth. And the people who embody WASP's more pronounced characteristics are likely to be mimicked for their near-sightedness. But to do so would be equally myopic. For WASPs can break their own stereotypes as frequently as any other tribe can theirs. And there are WASP-y WASPs who are as complex and multifaceted as un-WASP-y ones. The following pages feature some of the people who have famously embraced WASP style in some form but have never let it define them entirely. They are emblematic of WASP style, not because of their ancestry (heritage often being irrelevant) but also because they exude an ideal combination of intellect, grace, and joie de vivre. Their spirit cuts an impressive swath across every aspect of our culture from past to present. From the clothes we wear to the books we read, their contributions are omnipresent but never overwhelming. And while their style reveals glimpses—both positive and negative—into a world many may never see, the iconic elements translate and manifest themselves into characteristics that have universal appeal and intrigue.

Truman Streckfus Persons was born in Louisiana but went on to adopt his wealthy stepfather's last name of Capote and moved to Greenwich, Connecticut before settling in New York.

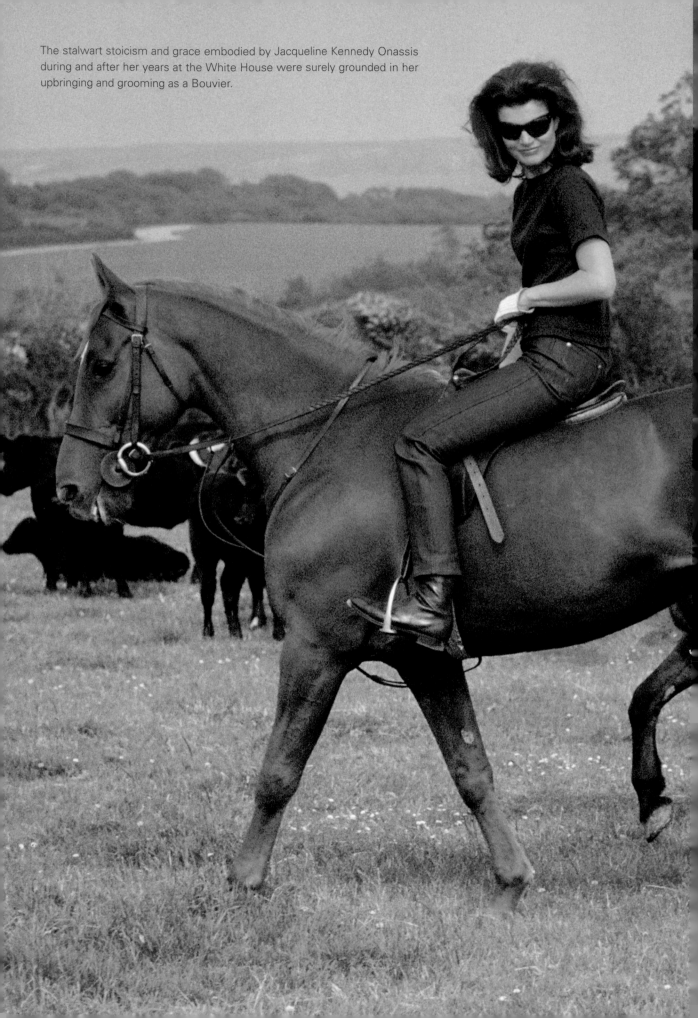

The stalwart stoicism and grace embodied by Jacqueline Kennedy Onassis during and after her years at the White House were surely grounded in her upbringing and grooming as a Bouvier.

"It's very difficult to keep the line between the past and the present. You know what I mean? It's awfully difficult."
—"Little Edie" Bouvier Beale

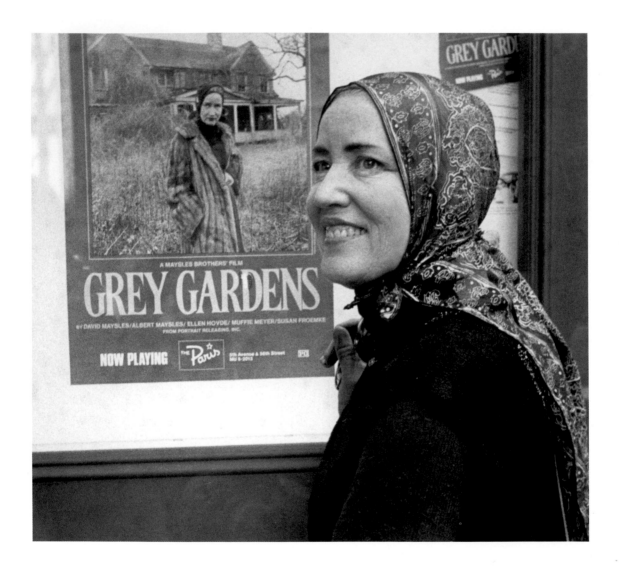

"Little Edie" Bouvier Beale, one of the subjects of the Maysles Brothers' documentary, *Grey Gardens* (1975). The mother-daughter relationship between "Big Edie" and "Little Edie" was as shockingly entertaining as their spacious but dilapidated East Hampton estate.

OPPOSITE: Whether in Montauk or London, barefoot or shod in leather sandals, Lee Radziwell's look was pure WASP refinement.

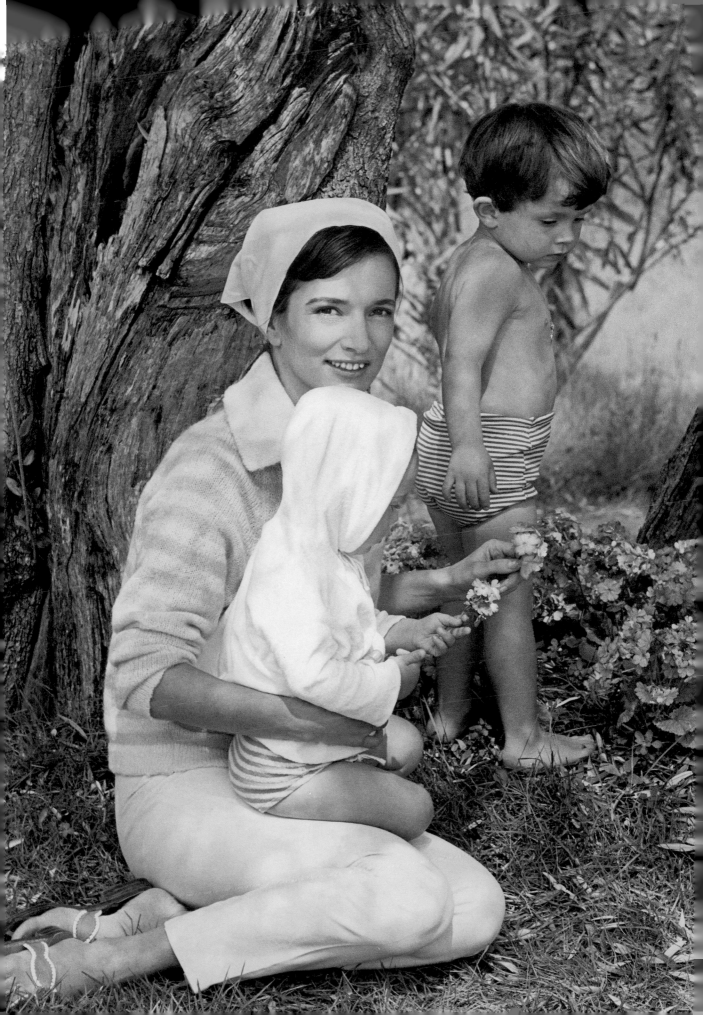

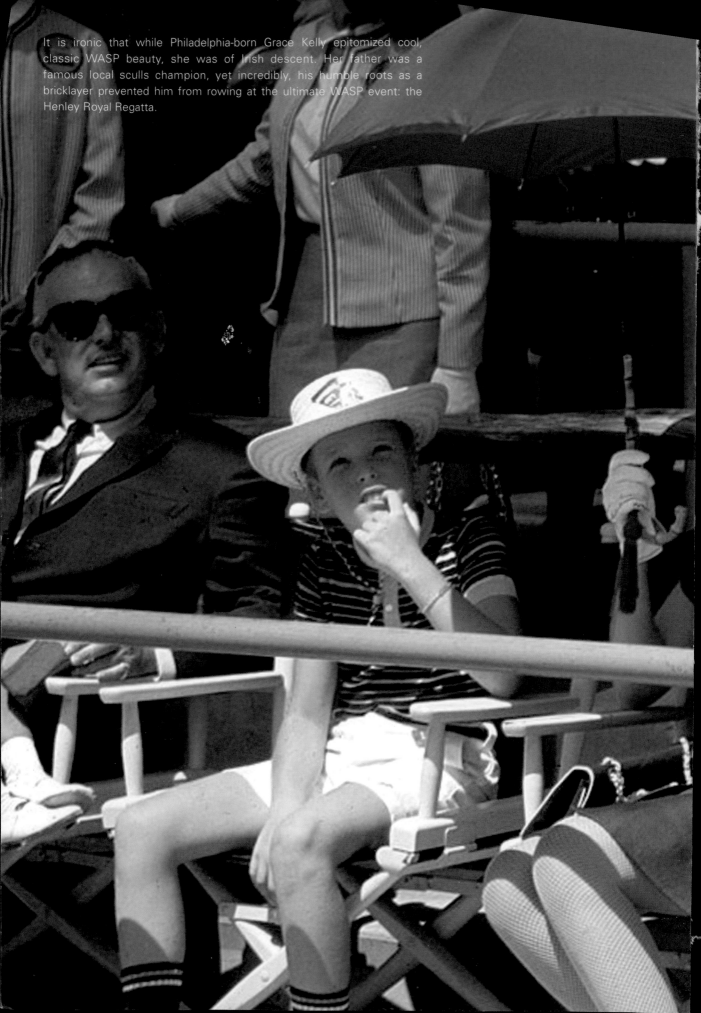

It is ironic that while Philadelphia-born Grace Kelly epitomized cool, classic WASP beauty, she was of Irish descent. Her father was a famous local sculls champion, yet incredibly, his humble roots as a bricklayer prevented him from rowing at the ultimate WASP event: the Henley Royal Regatta.

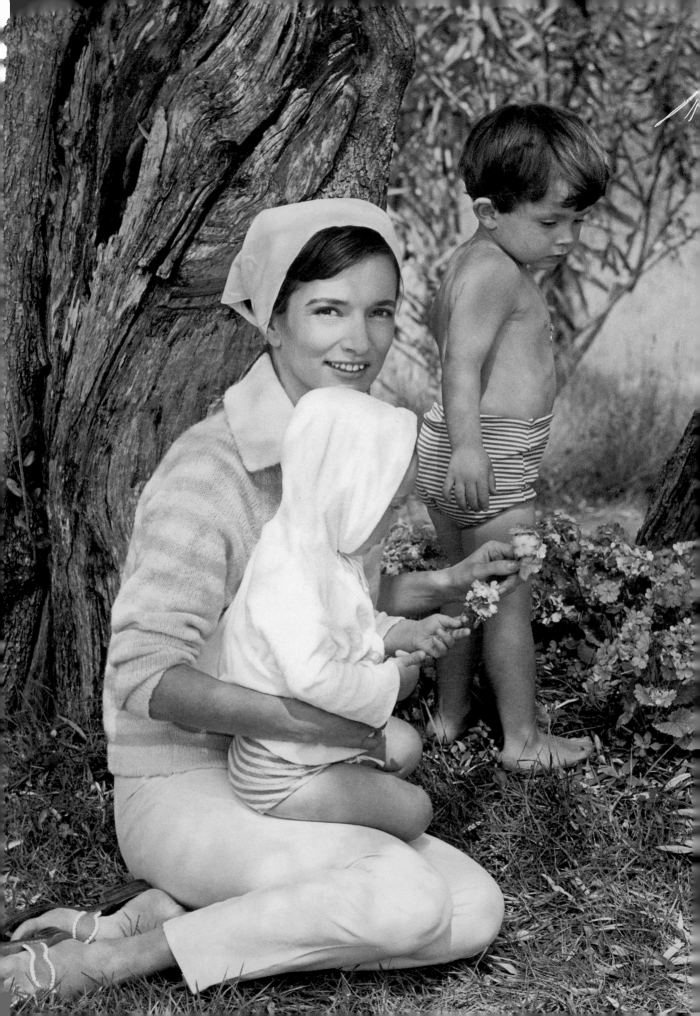

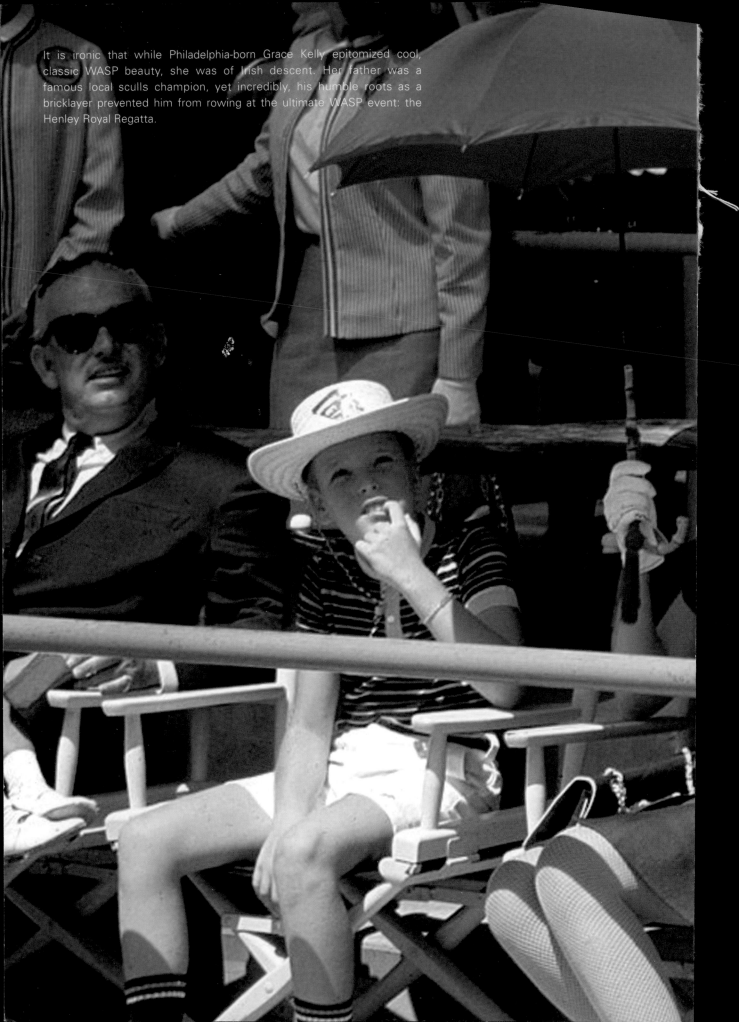

It is ironic that while Philadelphia-born Grace Kelly epitomized cool, classic WASP beauty, she was of Irish descent. Her father was a famous local sculls champion, yet incredibly, his humble roots as a bricklayer prevented him from rowing at the ultimate WASP event: the Henley Royal Regatta.

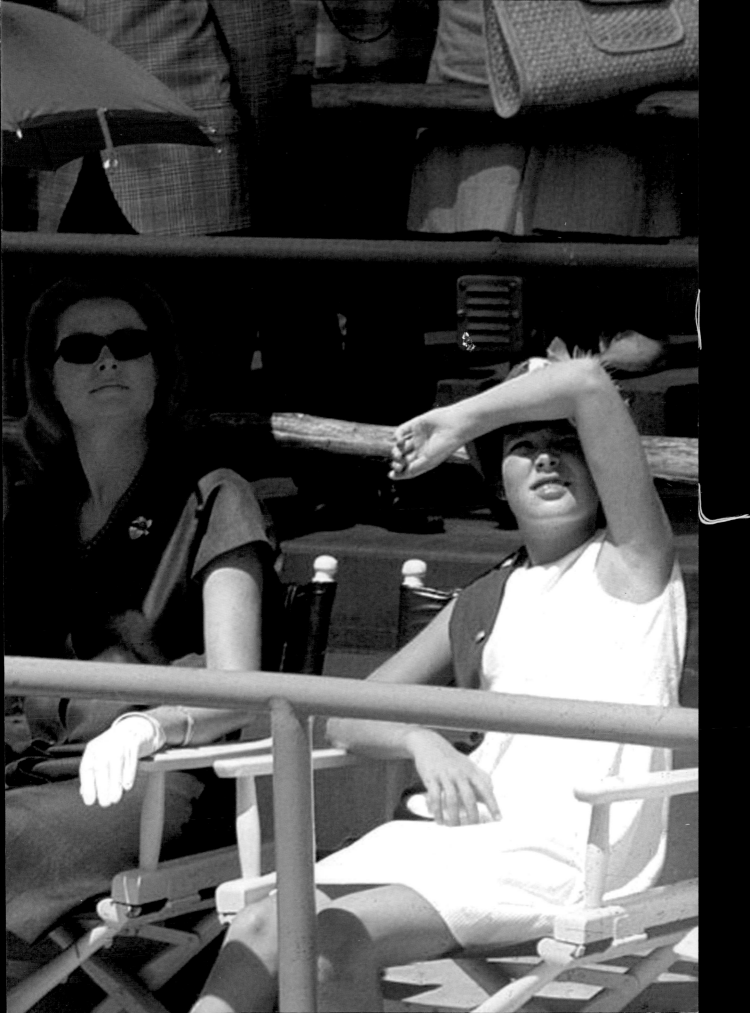

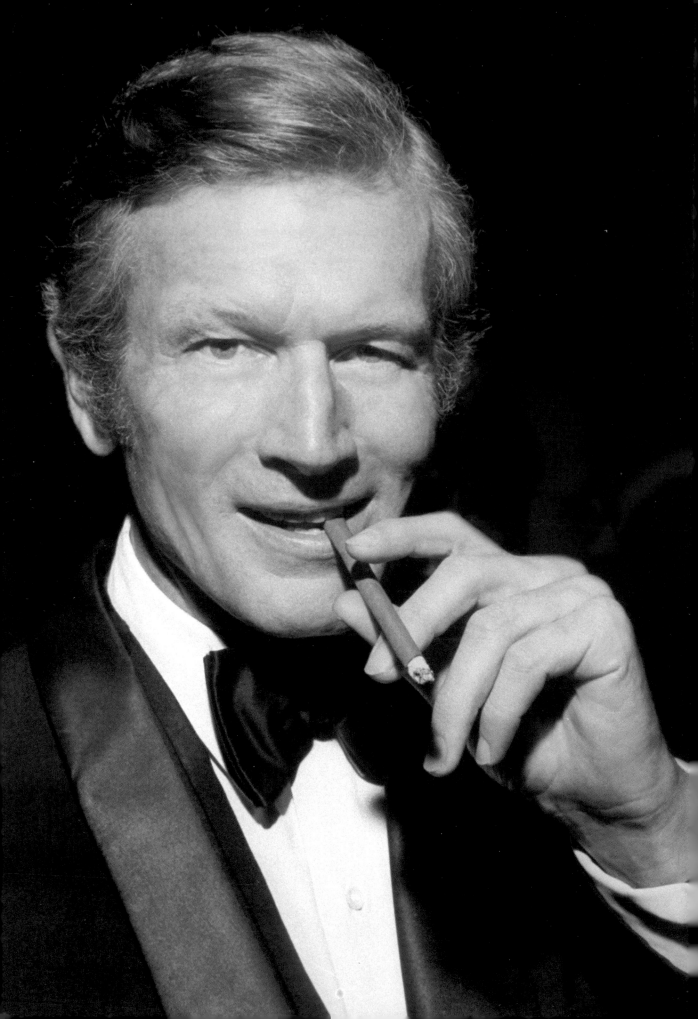

"HAVING THE RIGHT PET IS AS IMPORTANT AS HAVING THE RIGHT POLO SHIRT . . . IT IS ALLOWED TO CONTRADICT IN ITS BEHAVIOR EVERY ESTABLISHED RULE AND VALUE OF THE PREP HOUSEHOLD."
—LISA BIRNBACH, *THE OFFICIAL PREPPY HANDBOOK*

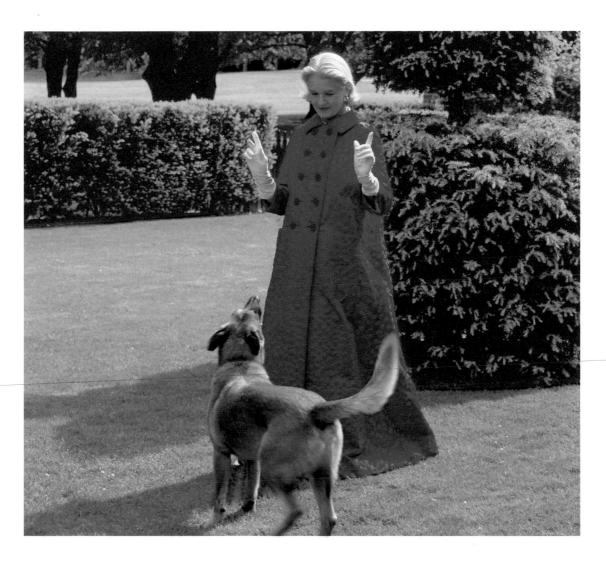

From the pink whimsy of her housecoat to the patrician arc of her white-gloved fingertips, C.Z. Guest sums up WASP style like no other.

OPPOSITE: Although not blue-blood born, John Lindsay cut a dashing WASP figure as New York's mayor from 1966 to 1973.

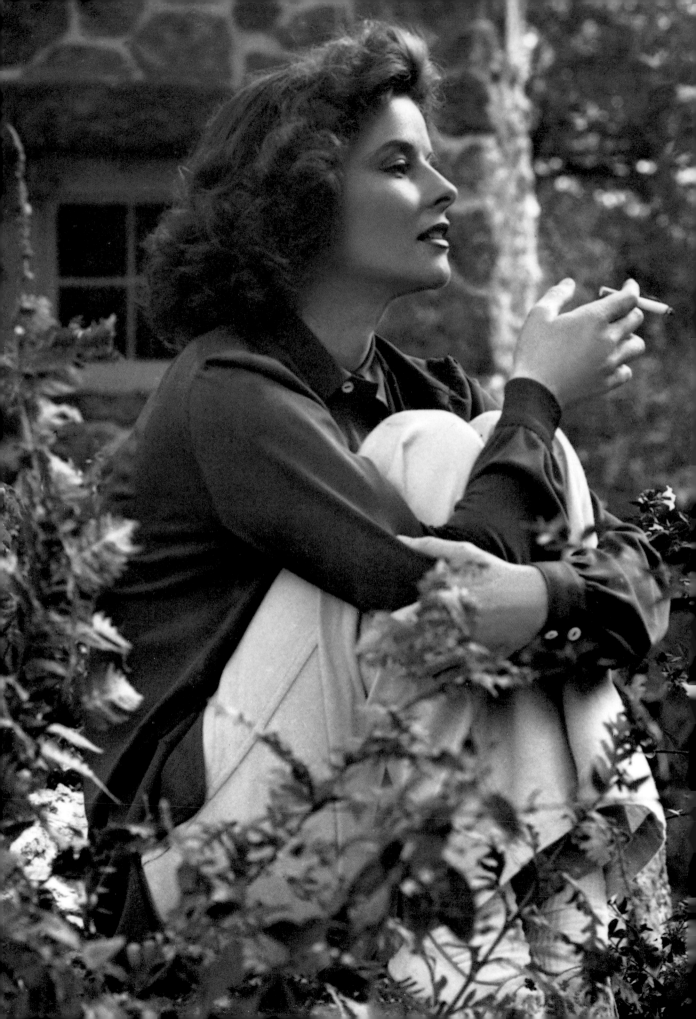

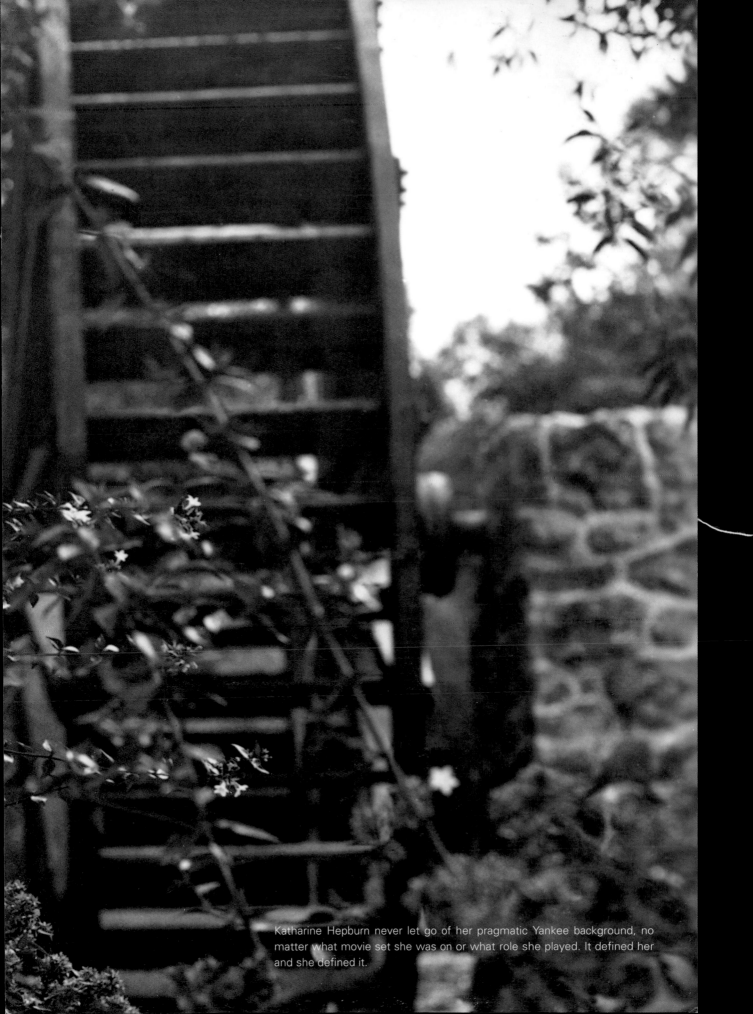

Katharine Hepburn never let go of her pragmatic Yankee background, no matter what movie set she was on or what role she played. It defined her and she defined it.

"POWER IS THE ABILITY TO DO GOOD THINGS FOR OTHERS."
—BROOKE ASTOR

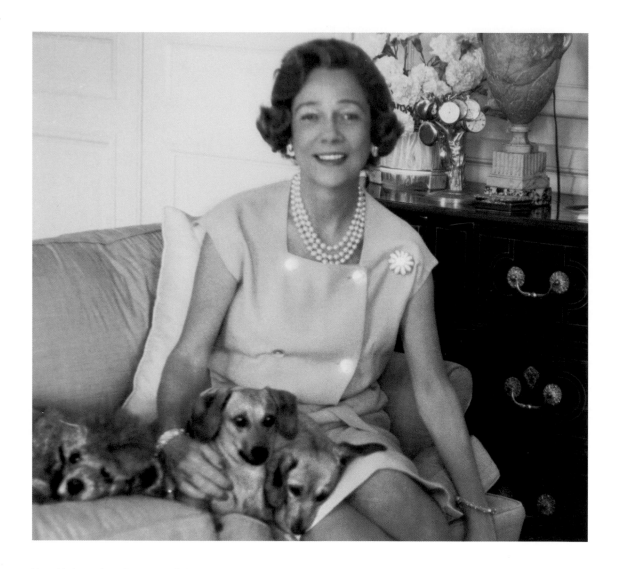

Her third marriage into one of America's wealthiest families enabled Brooke Astor to become a powerful force in her own right. And yet she'd make anyone feel at home beside her dogs on the sofa.

OPPOSITE: Audrey Hepburn defined classic, American style with her disarming personality and effortless fashion know-how.

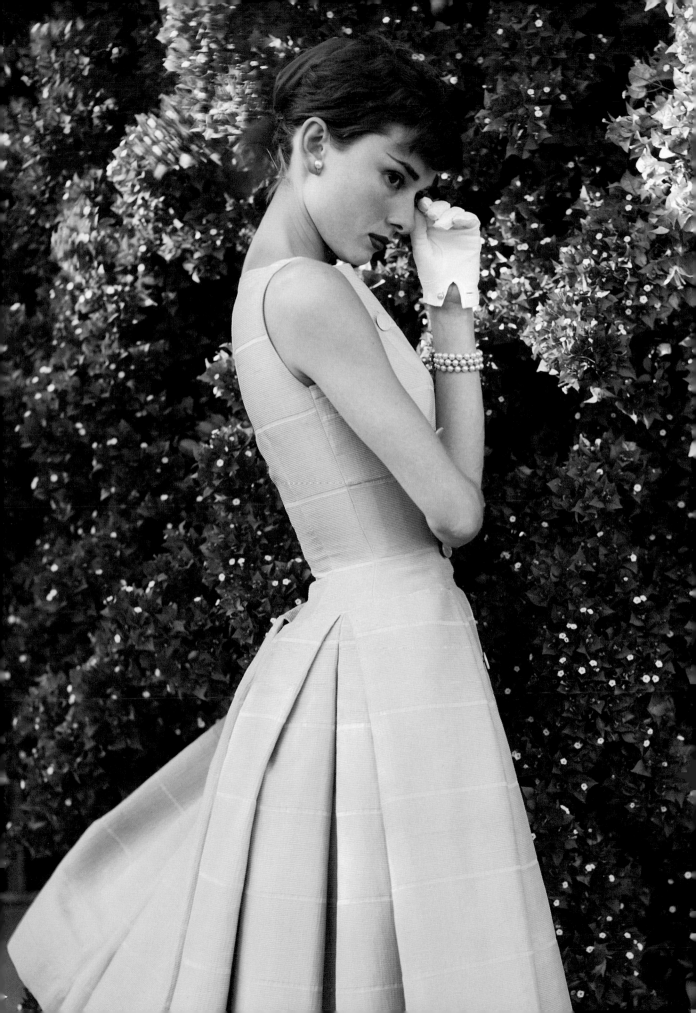

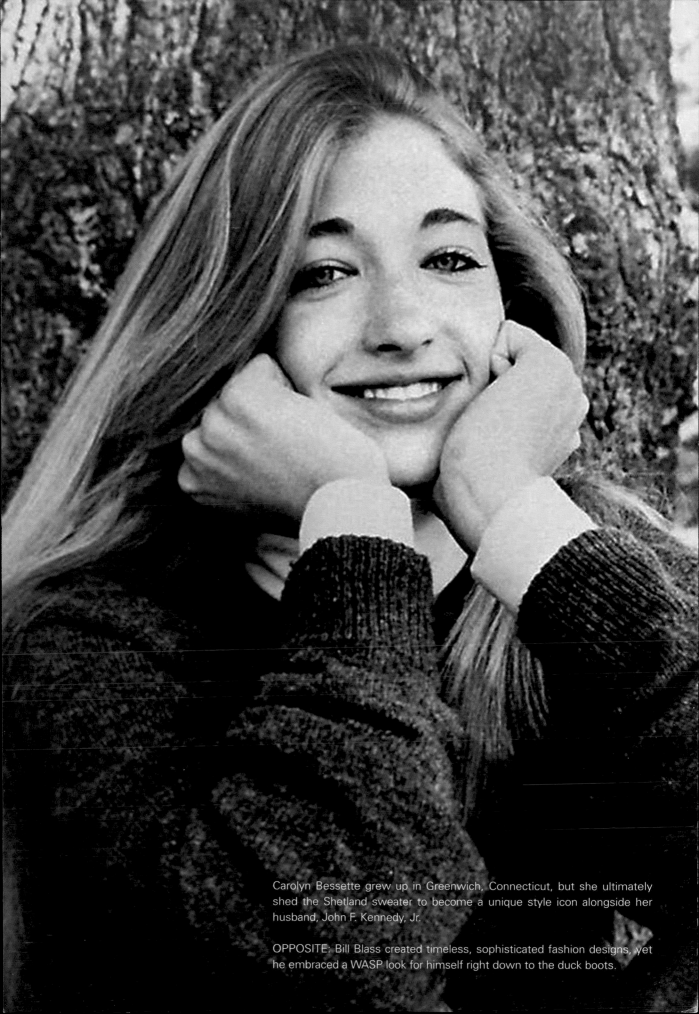

Carolyn Bessette grew up in Greenwich, Connecticut, but she ultimately shed the Shetland sweater to become a unique style icon alongside her husband, John F. Kennedy, Jr.

OPPOSITE: Bill Blass created timeless, sophisticated fashion designs, yet he embraced a WASP look for himself right down to the duck boots.

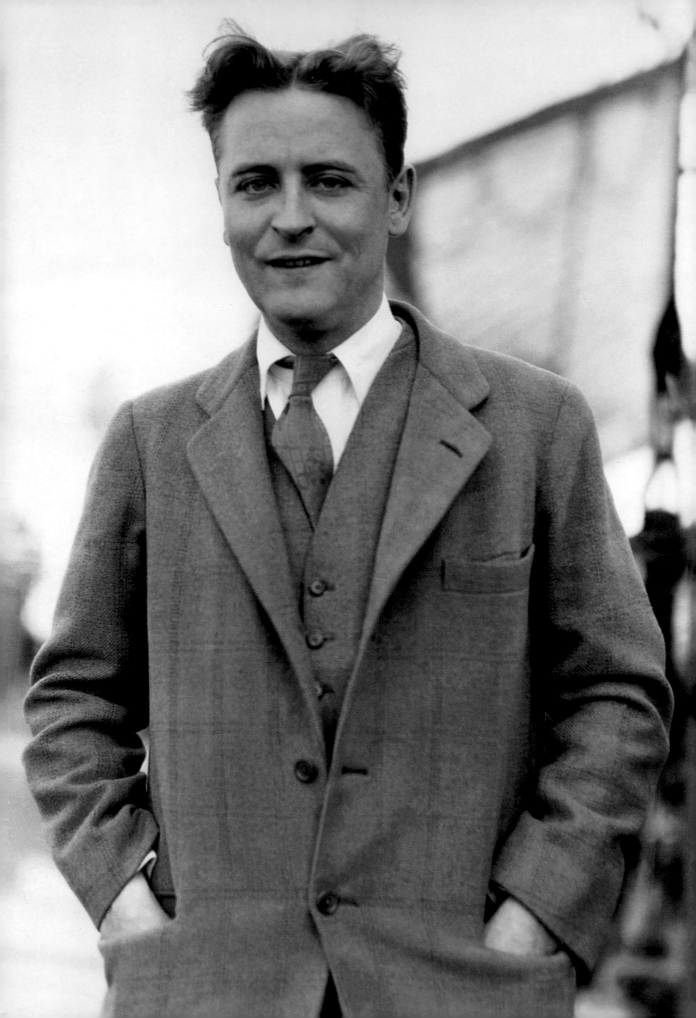

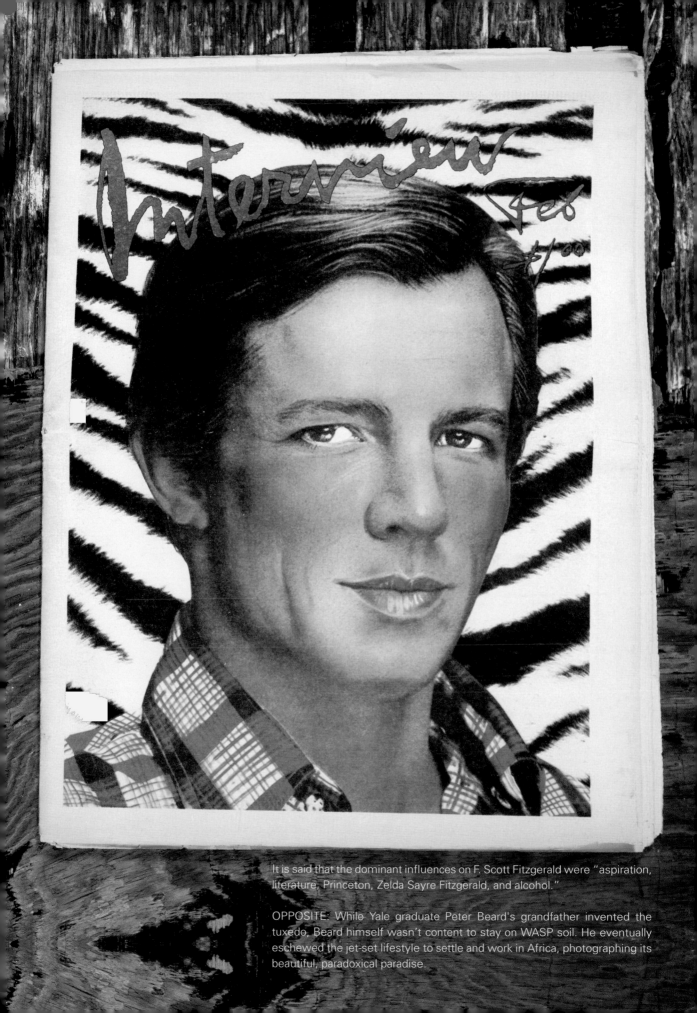

It is said that the dominant influences on F. Scott Fitzgerald were "aspiration, literature, Princeton, Zelda Sayre Fitzgerald, and alcohol."

OPPOSITE: While Yale graduate Peter Beard's grandfather invented the tuxedo, Beard himself wasn't content to stay on WASP soil. He eventually eschewed the jet-set lifestyle to settle and work in Africa, photographing its beautiful, paradoxical paradise.

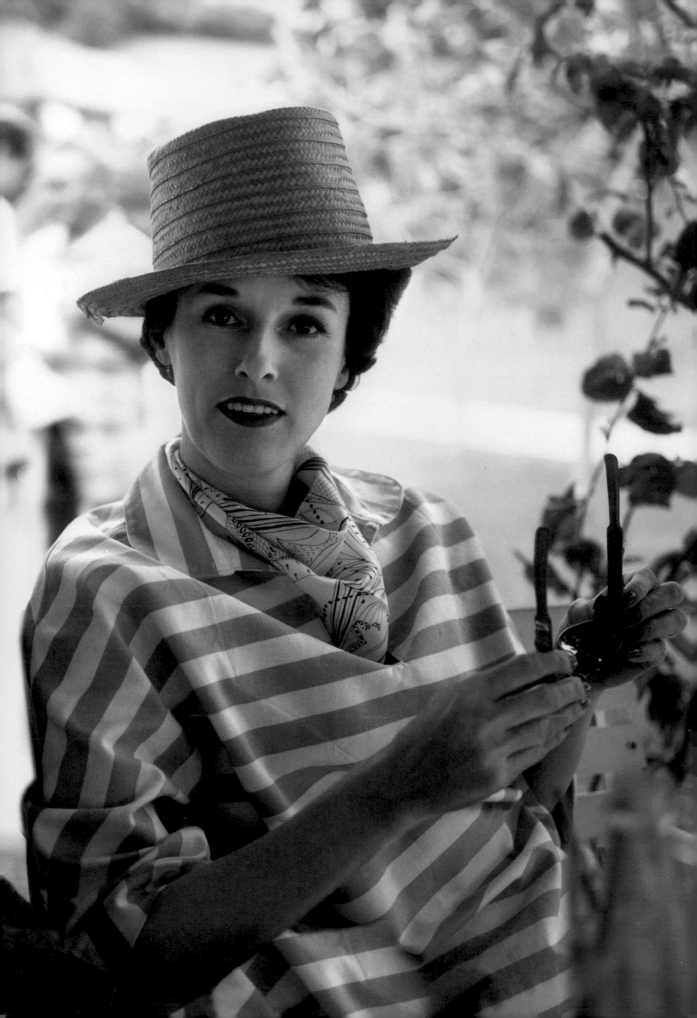

"... IN THEIR LEAKY WOODEN BOATS, AND ON THEIR ROCKY BEACHES,
THEY DID THE SAME THINGS THEY HAD ALWAYS DONE, AND WERE
THEREBY ALLOWED, IN A CERTAIN SENSE, TO STAY FOREVER YOUNG."
—GEORGE HOWE COLT, *THE BIG HOUSE*

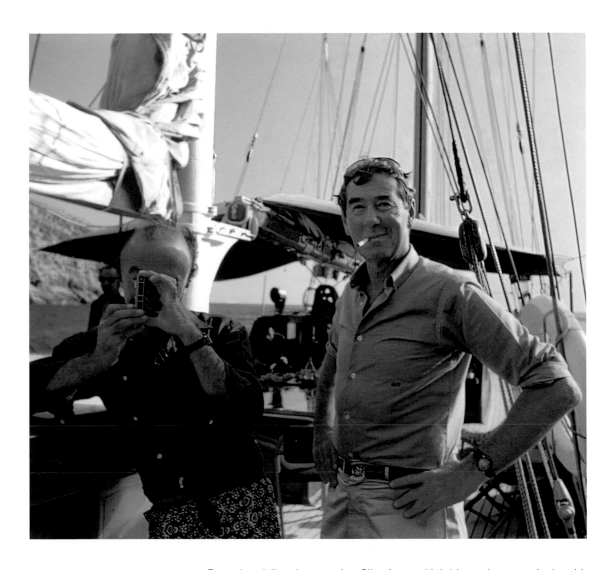

Famed socialite photographer Slim Aarons (right) knew how to mingle with
his WASP subjects as seamlessly as he photographed them.

OPPOSITE: Babe Paley was the epitome of the well-heeled WASP woman.
Born in Boston, Massachusetts, she was bred to marry a man of power and
society and achieved this with her marriage to CBS founder William Paley.

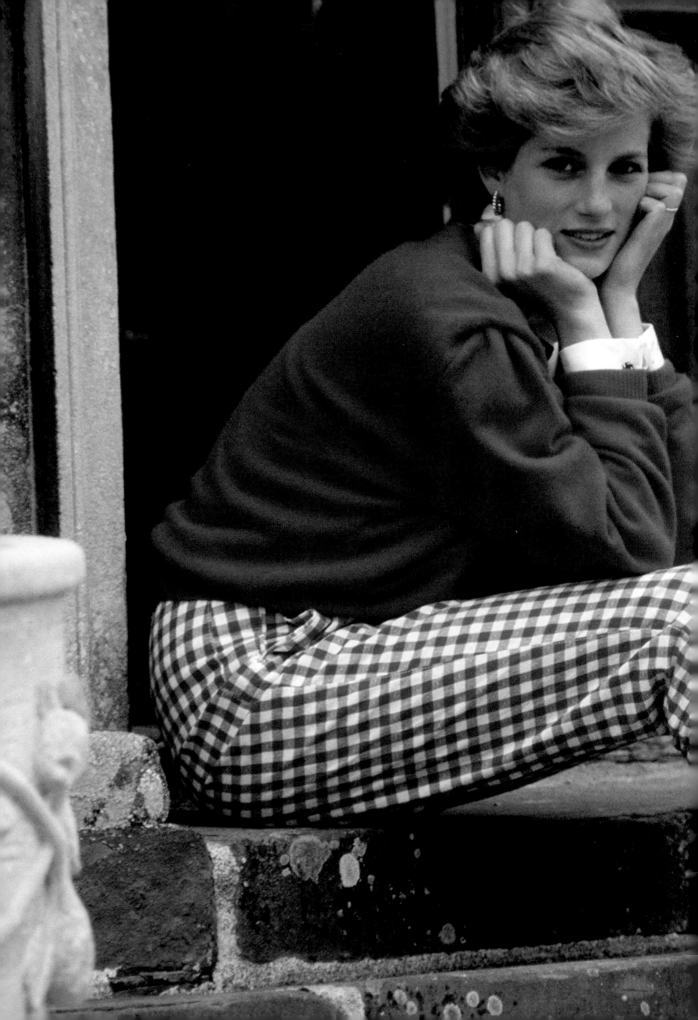

When the world first met Diana Spencer (shown here in 1986), she seemed suspended in Sloane Rangerdom, the British version of WASP style.

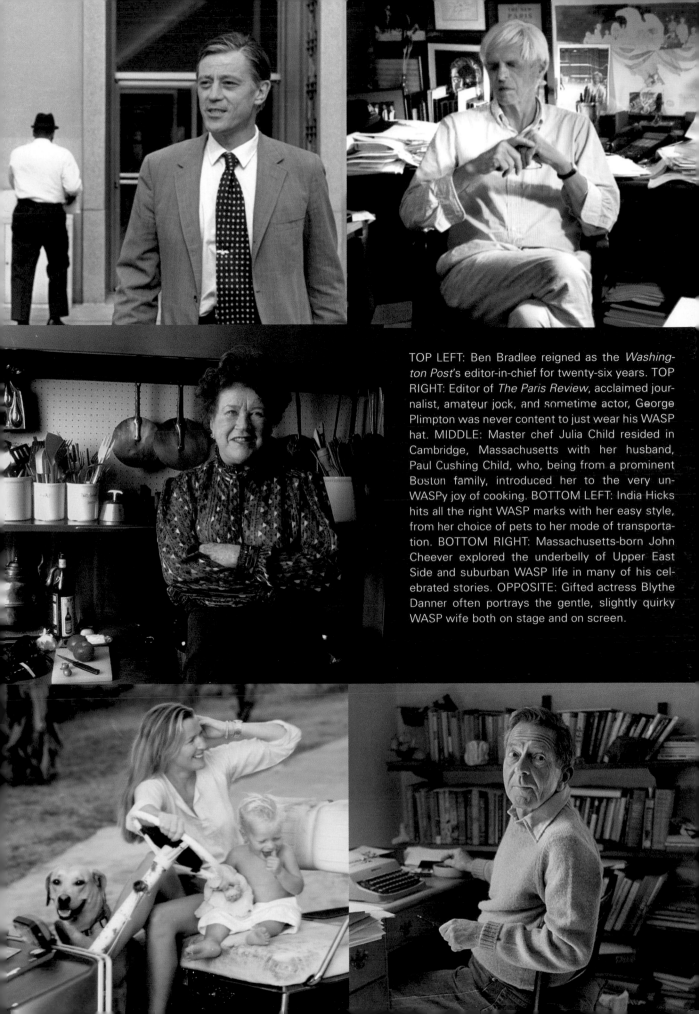

TOP LEFT: Ben Bradlee reigned as the *Washington Post*'s editor-in-chief for twenty-six years. TOP RIGHT: Editor of *The Paris Review*, acclaimed journalist, amateur jock, and sometime actor, George Plimpton was never content to just wear his WASP hat. MIDDLE: Master chef Julia Child resided in Cambridge, Massachusetts with her husband, Paul Cushing Child, who, being from a prominent Boston family, introduced her to the very un-WASPy joy of cooking. BOTTOM LEFT: India Hicks hits all the right WASP marks with her easy style, from her choice of pets to her mode of transportation. BOTTOM RIGHT: Massachusetts-born John Cheever explored the underbelly of Upper East Side and suburban WASP life in many of his celebrated stories. OPPOSITE: Gifted actress Blythe Danner often portrays the gentle, slightly quirky WASP wife both on stage and on screen.

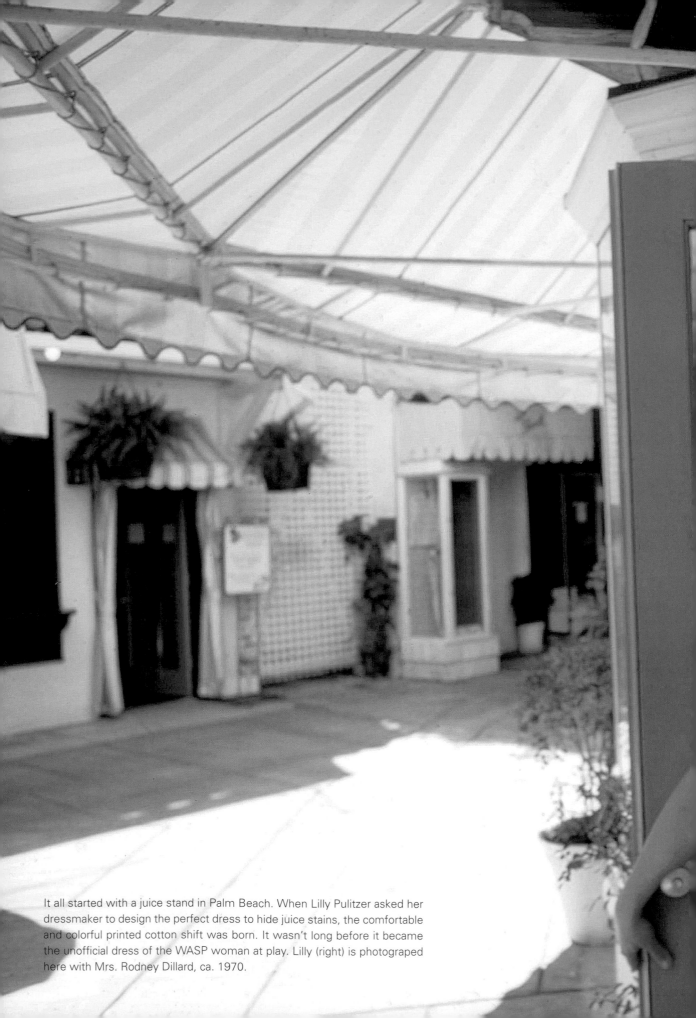

It all started with a juice stand in Palm Beach. When Lilly Pulitzer asked her dressmaker to design the perfect dress to hide juice stains, the comfortable and colorful printed cotton shift was born. It wasn't long before it became the unofficial dress of the WASP woman at play. Lilly (right) is photograped here with Mrs. Rodney Dillard, ca. 1970.

LIFESTYLE

Leisure is a time for accomplishment—social and athletic. And in the WASP tribe there is an inherited ethic of custom, costume, and code. Leisure time is formal but never fancy; it's a disciplined way of life devoted to a lifestyle that weaves its consistent yet often paradoxical thread throughout every season and sport. It's keeping up with your beloved Monday morning doubles game into your seventies while wearing tennis whites that are as old as your partner; it's adhering to cocktail hour on a boat even in the middle of a squall; it's dressing up for the country-club lunch of hot dogs and potato salad and wearing boat sneakers to tea; it's using your grandparents' key to enter Black Point Beach in Martha's Vineyard because today's membership costs more than what you'll make in one year.

So many of these lifestyle skills and traits are first learned at school where there's an emphasis on excelling at a variety of sports, and healthy competitiveness is coupled with rigorous decorum and dress code. As adults, the tradition continues because that familiar template is ubiquitous: the grown-up country-club experience echoes the stringent rules that a closed campus once did. Once practiced, WASP style becomes it's own omnipresent pastime.

And while sports and leisure are constant features of WASP style, indulgence is rare. Sipping champagne on plush lounge chairs poolside will never be considered truly leisurely. As Cleveland Armory wrote about the proper Bostonian: "If he is going to be at all happy from his work, he must be comfortably uncomfortable."

My Great Aunt Rosie and Uncle Mike aboard their sixteen-foot Thistle *Bagheera*, named after the magnificent black panther in Rudyard Kipling's *The Jungle Book*, ca. 1960.

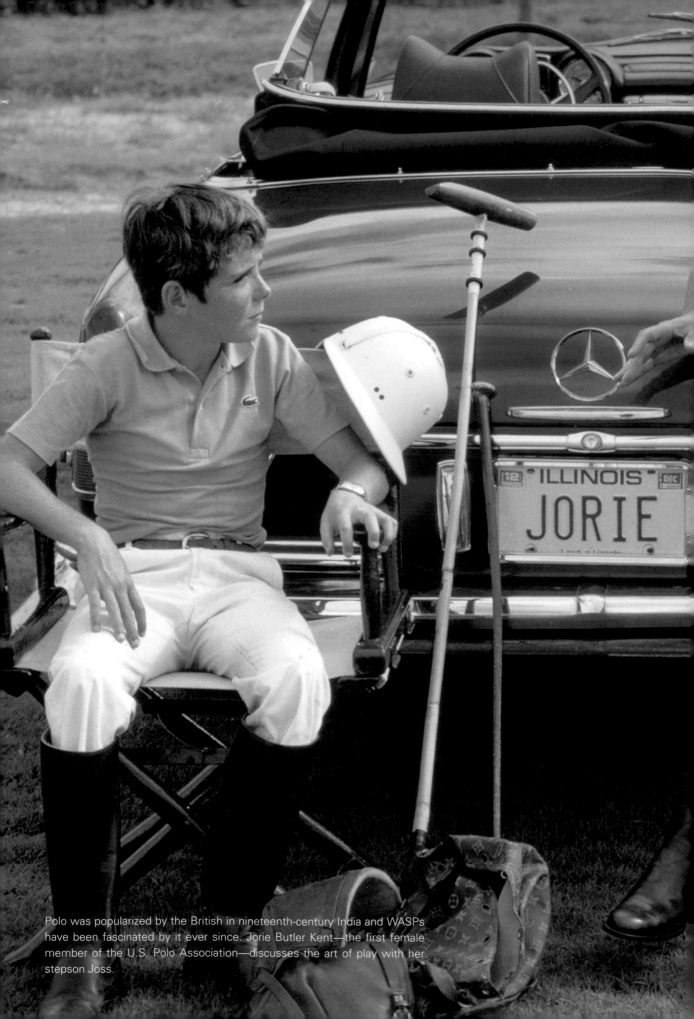

Polo was popularized by the British in nineteenth-century India and WASPs have been fascinated by it ever since. Jorie Butler Kent—the first female member of the U.S. Polo Association—discusses the art of play with her stepson Joss.

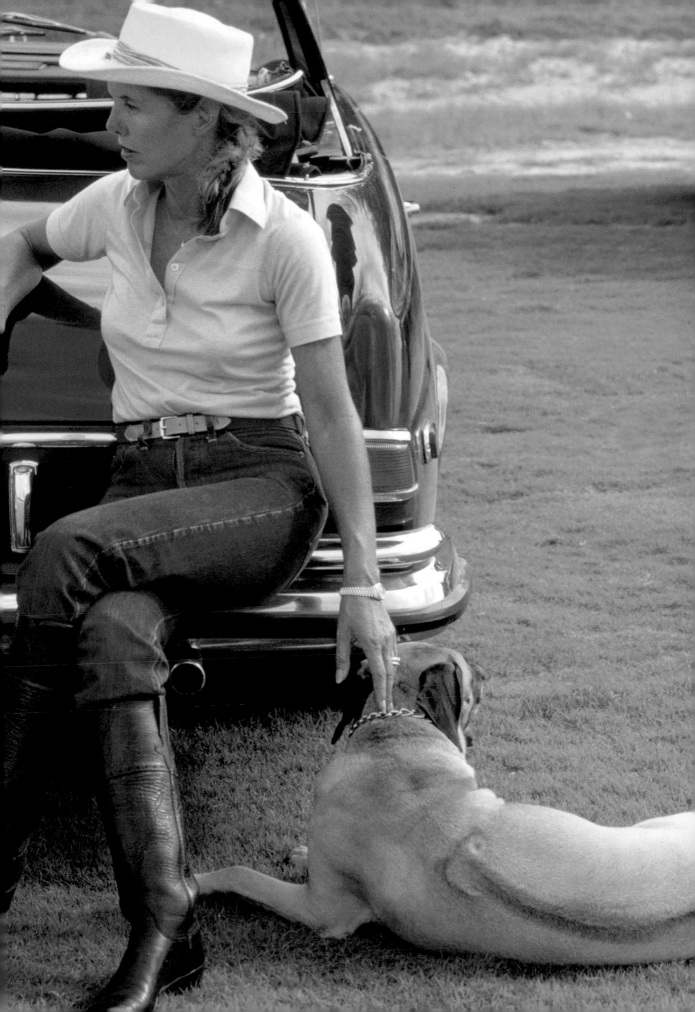

3 ▷ 3A 4 ▷ 4A 5 ▷ 5A 6 ▷ 6A
9 KODAK 5063 TX 10 KODAK 5063 TX 11 KODAK 5063 TX 12 KODAK 5063 TX

9 ▷ 9A 10 ▷ 10A 11 ▷ 11A 12 ▷ 12A
15 KODAK 5063 TX 16 KODAK 5063 TX 17 KODAK 5063 TX 18 KODAK 5063 TX

15 ▷ 15A 16 ▷ 16A 17 ▷ 17A 18 ▷ 18A
21 KODAK 5063 TX 22 KODAK 5063 TX 23 KODAK 5063 TX 24 KODAK 5063 TX

21 ▷ 21A 22 ▷ 22A 23 ▷ 23A 24 ▷ 24A
27 KODAK 5063 TX 28 KODAK 5063 TX 29 KODAK 5063 TX 30 KODAK 5063 TX

27 ▷ 27A 28 ▷ 28A 29 ▷ 29A 30 ▷ 30A
33 KODAK 5063 TX 34 KODAK 5063 TX 35 KODAK 5063 TX 36 KODAK 5063 TX

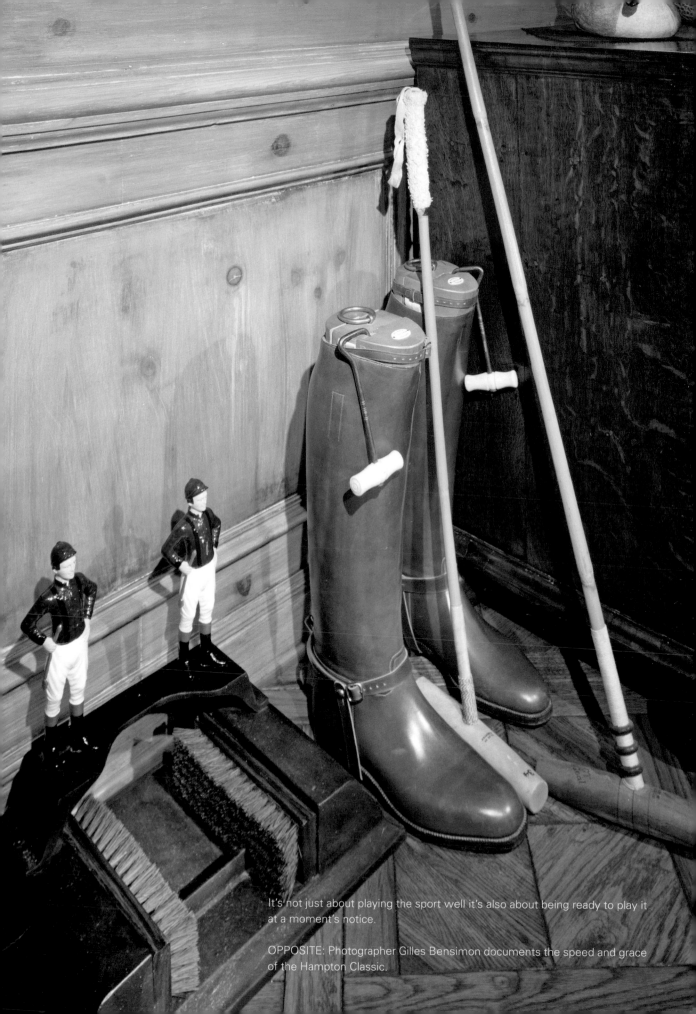

It's not just about playing the sport well it's also about being ready to play it at a moment's notice.

OPPOSITE: Photographer Gilles Bensimon documents the speed and grace of the Hampton Classic.

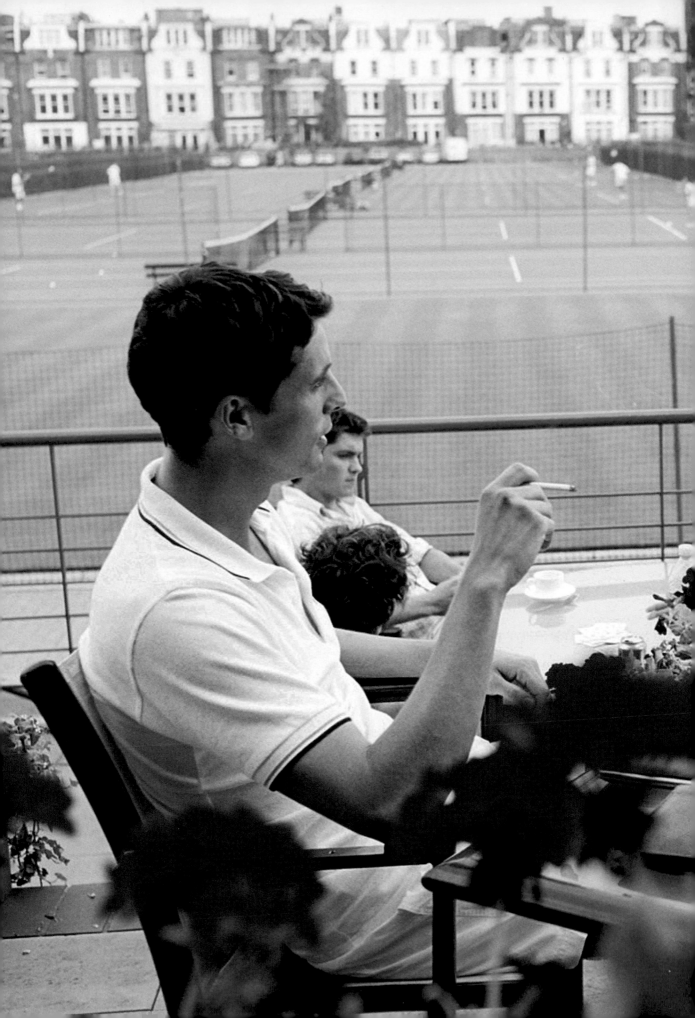

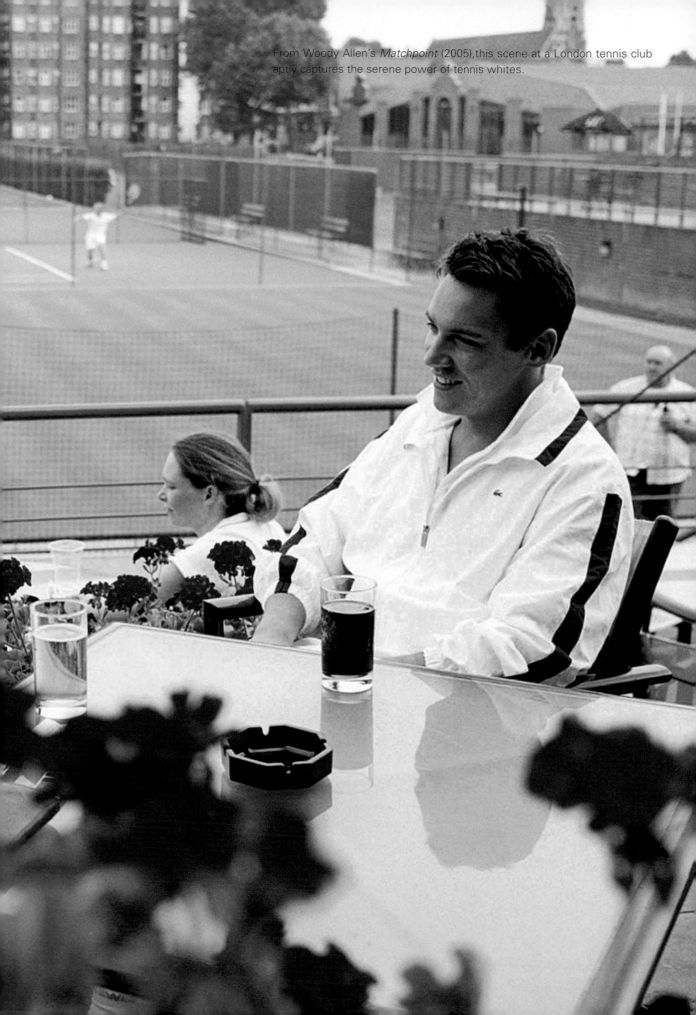

From Woody Allen's *Matchpoint* (2005), this scene at a London tennis club aptly captures the serene power of tennis whites.

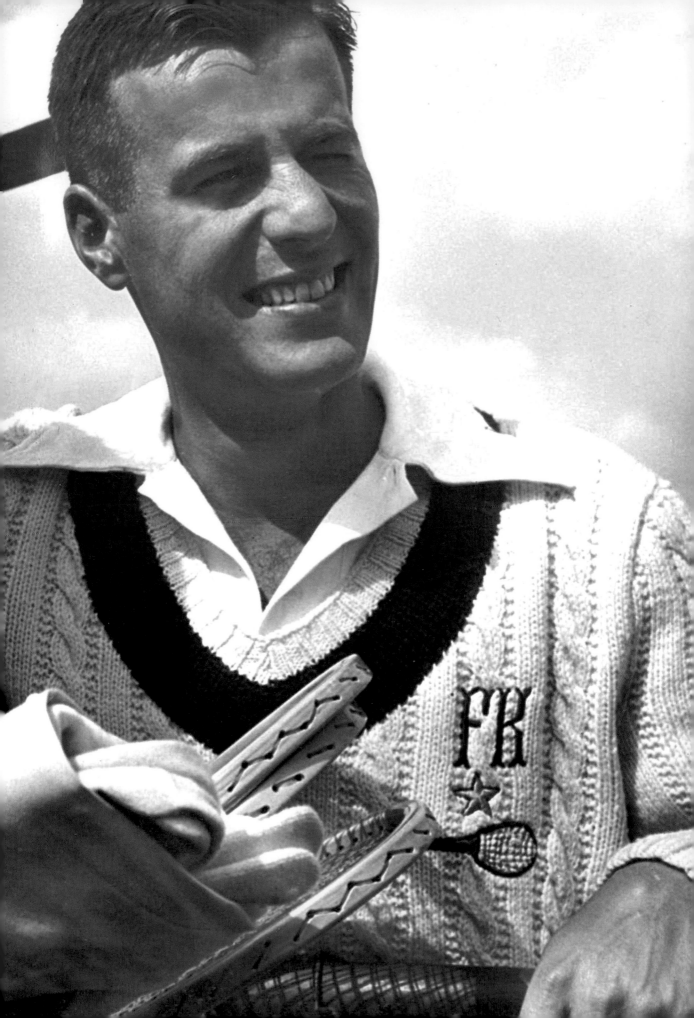

"WHAT A POLITE GAME TENNIS IS. THE CHIEF WORD IN IT SEEMS TO BE 'SORRY' AND ADMIRATION OF EACH OTHER'S PLAY CROSSES THE NET AS FREQUENTLY AS THE BALL."
—J.M. BARRIE

Celebrated decorator Sister Parish, at home on the tennis courts.

OPPOSITE: Portrait of Fred Perry at the peak of his career at Forest Hills in 1947. His monogrammed tennis sweater is the ultimate WASP touch.

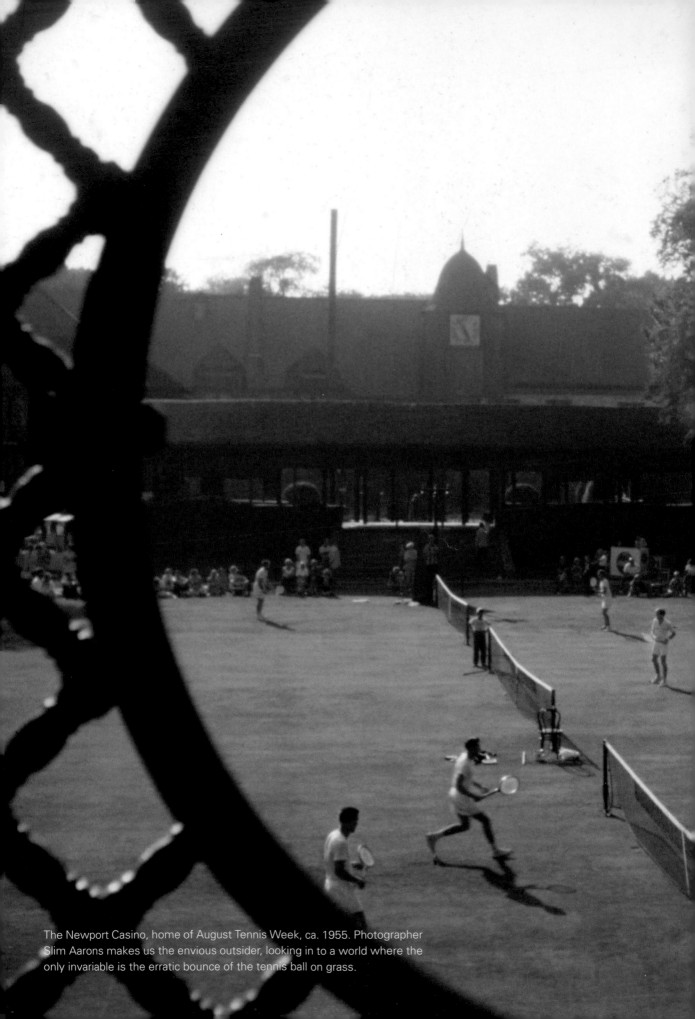

The Newport Casino, home of August Tennis Week, ca. 1955. Photographer Slim Aarons makes us the envious outsider, looking in to a world where the only invariable is the erratic bounce of the tennis ball on grass.

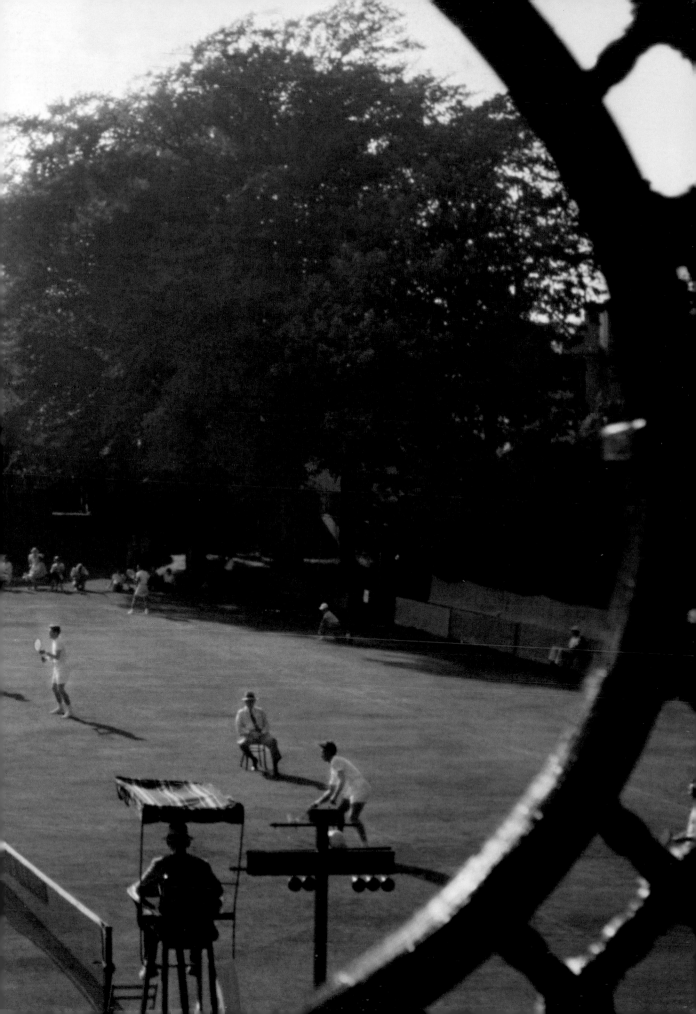

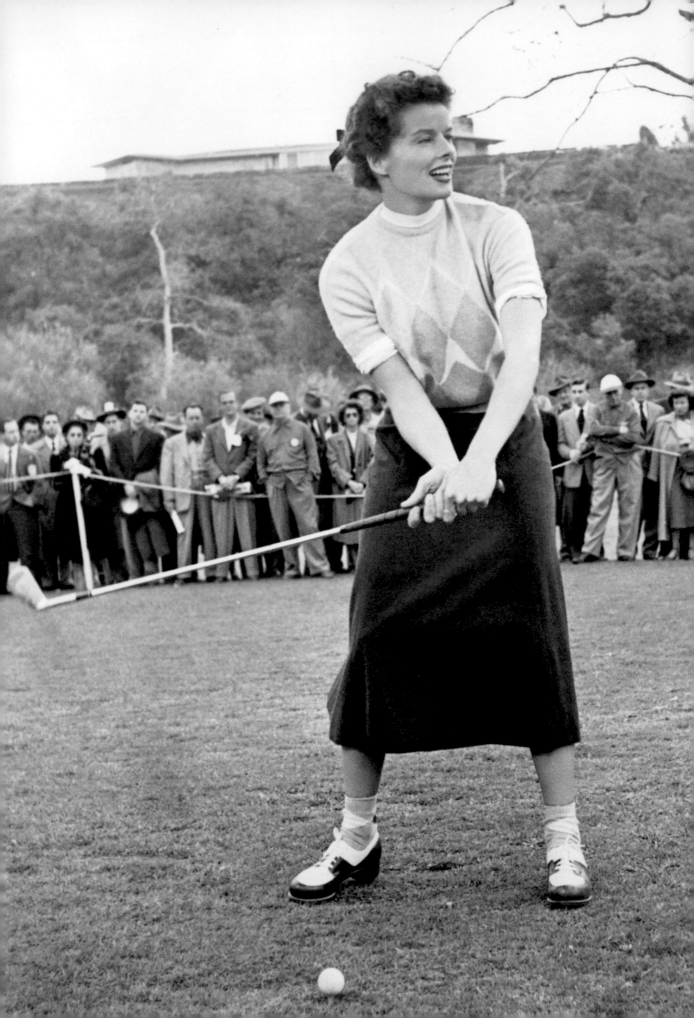

"WE WENT TO FENWICK IN THE
SUMMER WHERE THERE WAS A PRIVATE NINE-HOLE COURSE. DAD WAS A
DEADEYE DICK PUTTER . . . MOTHER STARTED ME ON LESSONS AT THE
HARTFORD GOLF CLUB FROM AN ENGLISHMAN NAMED JACK STRAIT."
—KATHARINE HEPBURN

Indian Neck Golf Club

LOCAL RULES.

HOLE PLAY AND MEDAL PLAY.

A ball in growing crops shall be treated as a lost ball.

Whins and underbrush are not regarded as hazards.

A ball landing in the ditch on the drive from the 5th hole may be taken out and dropped without penalty.

INDIAN NECK GOLF LINKS.

19

Mr. Mr.

HOLES			
1. READ'S . 132 Yards,			
2. FARM . . 266 "			
3. PASTURE . 155 "			
4. MUSHROOM 176 "			
5. ROCKY . . 243 "			
6. STOCKTON 295 "			
7. GARDEN . 350 "			
8. WOODS . . 180 "			
9. OWL . . . 253 "			
TOTAL for 9 Holes,			
10. HIGHLAND 153 Yards,			
11. LAND'S END 204 "			
12. MARSH . . 178 "			
13. BURNT . . 229 "			
14. BARN . . 223 "			
15. COVE . . 250 "			
16. QUINCY . 230 "			
17. READ'S . 137 "			
18. MINOT'S . 142 "			
TOTAL for 18 Holes,			
HANDICAP,			
NET SCORE,			

Scorer,

"Local Rules" from Indian Neck Golf Club, Wareham, Massachusetts. Club member General Stephen Minot Weld built a special road for the Sargeant, Stockton, Whiteside, Shaw, Cheever, and Fisher families so they could have exclusive access to the club.

OPPOSITE: There are many rules at country clubs. Fortunately, there are WASPs like Katharine Hepburn around to break them.

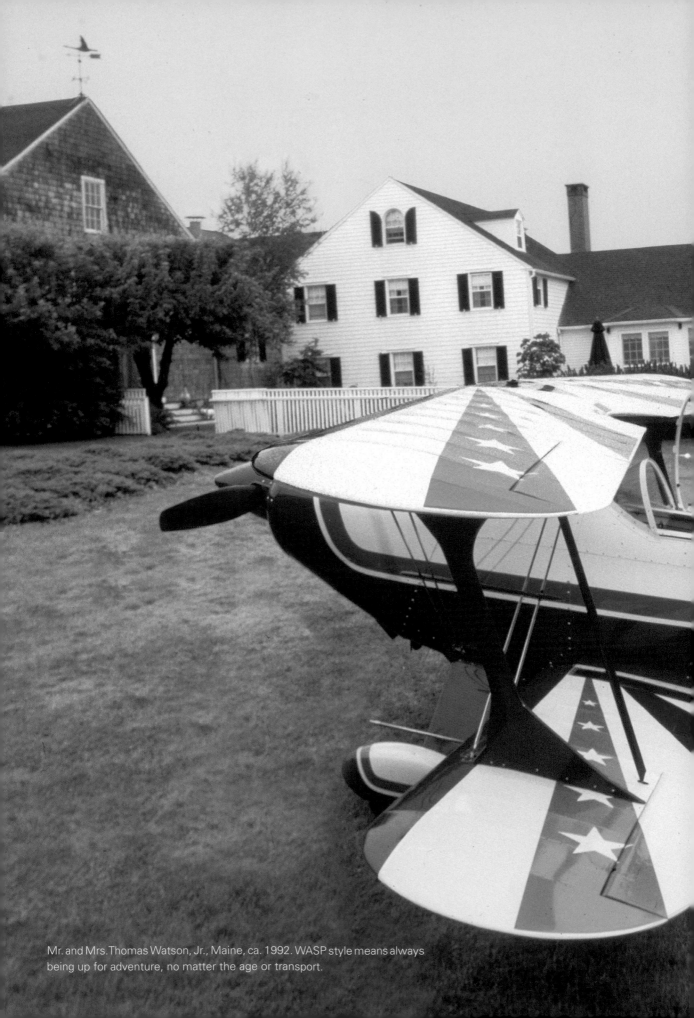

Mr. and Mrs. Thomas Watson, Jr., Maine, ca. 1992. WASP style means always being up for adventure, no matter the age or transport.

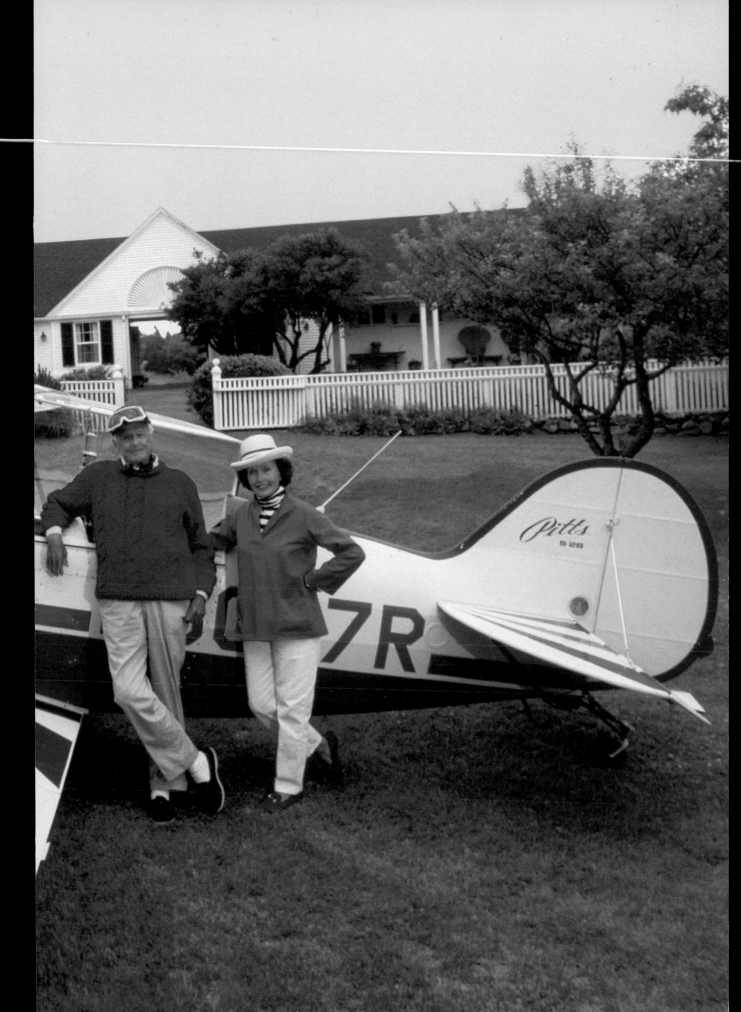

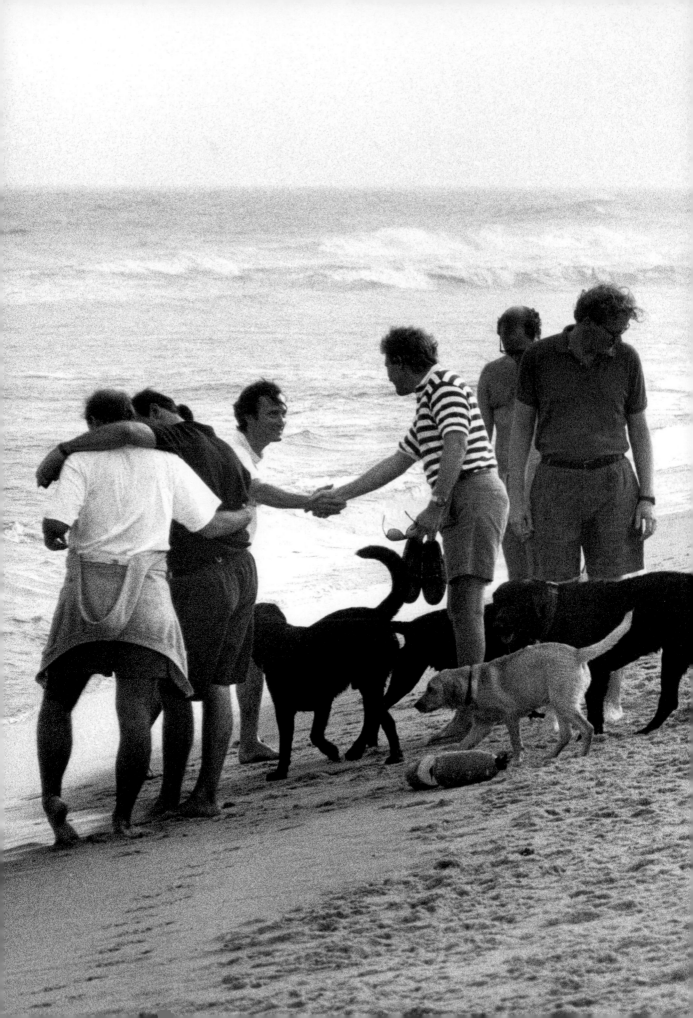

Whether it's Martha's Vineyard, Nantucket, or Point O'Woods, an important part of the WASP lifestyle is enjoying spectacular beaches with your dogs.

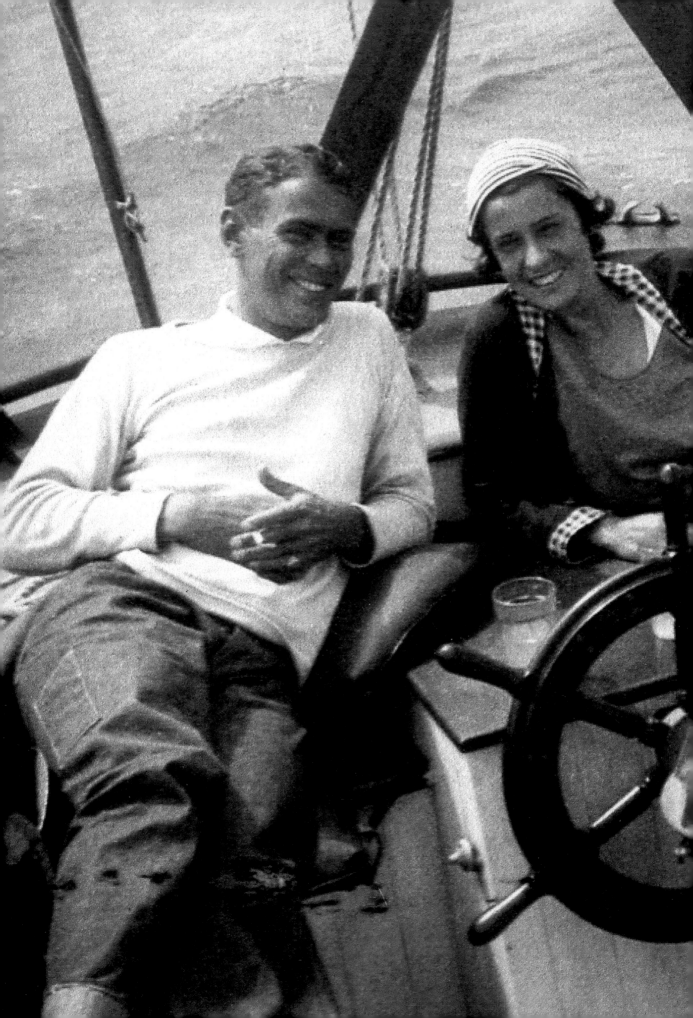

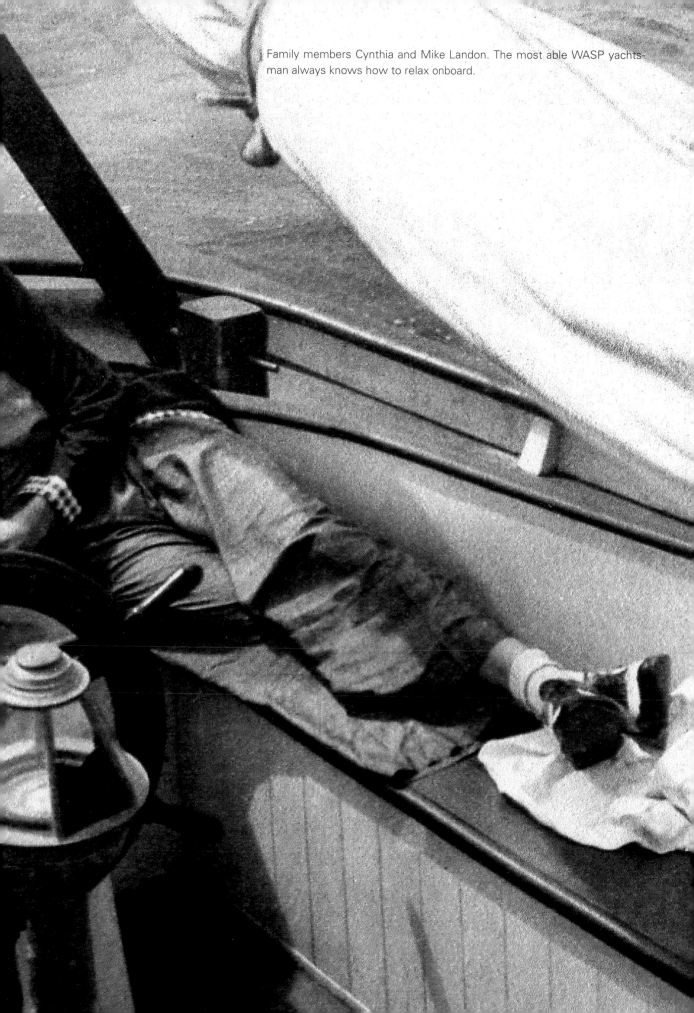

Family members Cynthia and Mike Landon. The most able WASP yachts-
man always knows how to relax onboard.

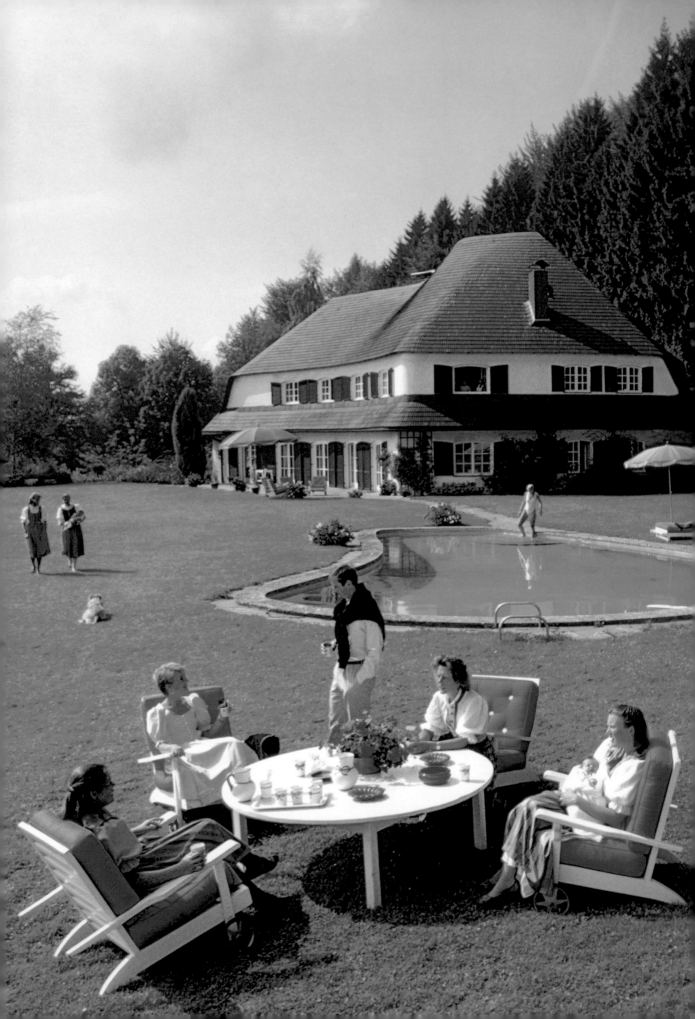

FOOD

Let's begin with the only WASP joke I know. Q: "What did the WASP go to the hospital for? A: "The food." For WASPs, food is to be eaten, not savored. You serve it to keep yourself going for conversation or sports, not to link generations together or to take center stage. To cook from scratch or to be tempted by complex recipes is simply too much trouble. There's a kind of Pilgrim frugality when it comes to the WASP menu: it starts with nursery school tastes and never graduates. A WASP pantry endures as much as a WASP closet; with its rows of canned vegetables, crackers, packaged cookies, peanuts, cans of tuna, and chocolate syrup for grown-up hot fudge sundaes, it is a haven from a world of unknown taste and spice.

In college, I accepted a summer job cooking for a very wealthy bon vivant on Martha's Vineyard. He and I both knew that I was lying completely when I said I knew how to cook. But he admired my youth and determination even though I didn't have the slightest idea what minced garlic was. (When a recipe called for two cloves of it, I simply stuck whole segments straight into the dish, almost killing his new girlfriend when she tasted it.) But I persevered. So what if I never had a grandmother with a secret spaghetti sauce? I was armed with my family recipe of Creamed Corn Casserole, which I devoured every time my mother made it for me. Unfortunately, it was met with less enthusiasm when I served it to forty guests who had sailed in on their yachts from culinary ports far more exotic. By summer's end, however, I was cooking lime-marinated swordfish in the fireplace with my eyes closed, and I have not looked back since.

But the familiar labels of my childhood kitchen still beckon me whenever I see them: Mr. Peanut, Skippy, Pepperidge Farm, Deviled Ham, and Betty Crocker wave like old classmates who miraculously never grow old and who tempt my now-sophisticated taste buds with their cozy reliability. To this day, when I feel sick I regress to the ultimate WASP snack of melted cheese on English muffins. And I instantly feel better.

Johanna Von Oswald's friends and garden, ca. 1986.

COCKTAILS

BLOODY BULL

1 OUNCE VODKA
$^{1/2}$ CUP TOMATO JUICE
$^{1/2}$ CUP BEEF BOUILLON
1 SLICE OF LIME
1 LEMON WEDGE

POUR VODKA, TOMATO JUICE, AND BEEF BOUILLON OVER ICE AND STIR. ADD THE SLICE OF LIME AND THE LEMON WEDGE. SERVE WITH HANGOVER AND KHAKIS AND GARNISH WITH CELERY STALK (OPTIONAL).

To attend a WASP cocktail hour is to witness a tribal dance as ritualistic as any other. The setting should be homey and never grand (and no music, please): a boat, summer porch, or apartment living room are ideal. The costume should never be too casual nor too formal yet always cheerful. As far as food is concerned, preparation and presentation kowtow to familiarity and convenience. The guest list? Why settle for six degrees of separation when two is so much more convivial. And, finally, there is the issue of the cocktail itself. It should be carefully yet jubilantly prepared and presented with style and know-how. WASPs take their cocktail seriously but not without a sense of fun. This is the one time during their day when there is pause—when ceremony supersedes commitment, sports, and chores. It's a rare time for frivolity and WASPs pay stylish homage to its moment in their day.

When my cousin Natalie entered Harvard her freshman year, her father gave her a blender so she could make Bloody Bulls for her roommates on Sunday mornings. The ritual dance begins early and always with inherited style.

OPPOSITE: Charles Dana, Jr., manages to wear purple without making it metrosexual. Men's WASP cocktail attire is best accessorized with the perfect drink, tan, and sockless loafers.

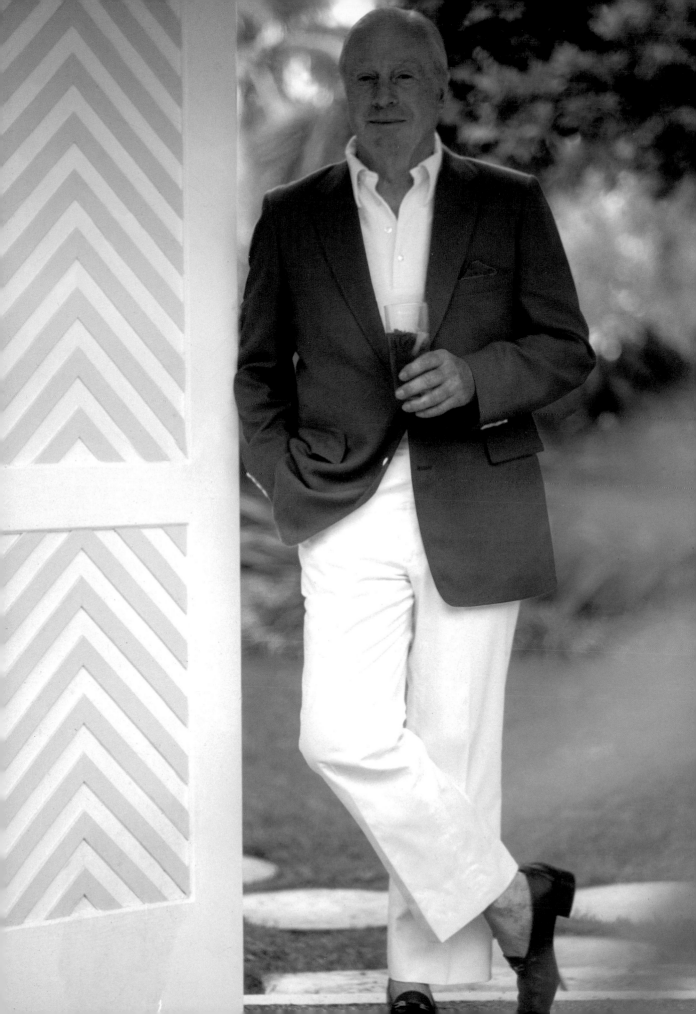

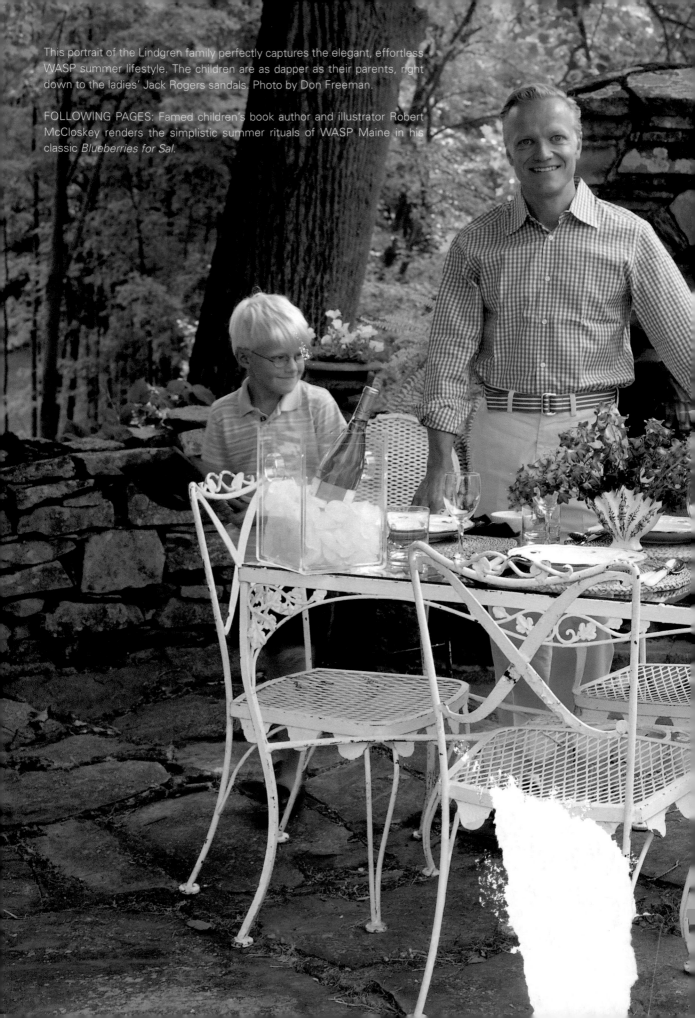

This portrait of the Lindgren family perfectly captures the elegant, effortless WASP summer lifestyle. The children are as dapper as their parents, right down to the ladies' Jack Rogers sandals. Photo by Don Freeman.

FOLLOWING PAGES: Famed children's book author and illustrator Robert McCloskey renders the simplistic summer rituals of WASP Maine in his classic *Blueberries for Sal*.

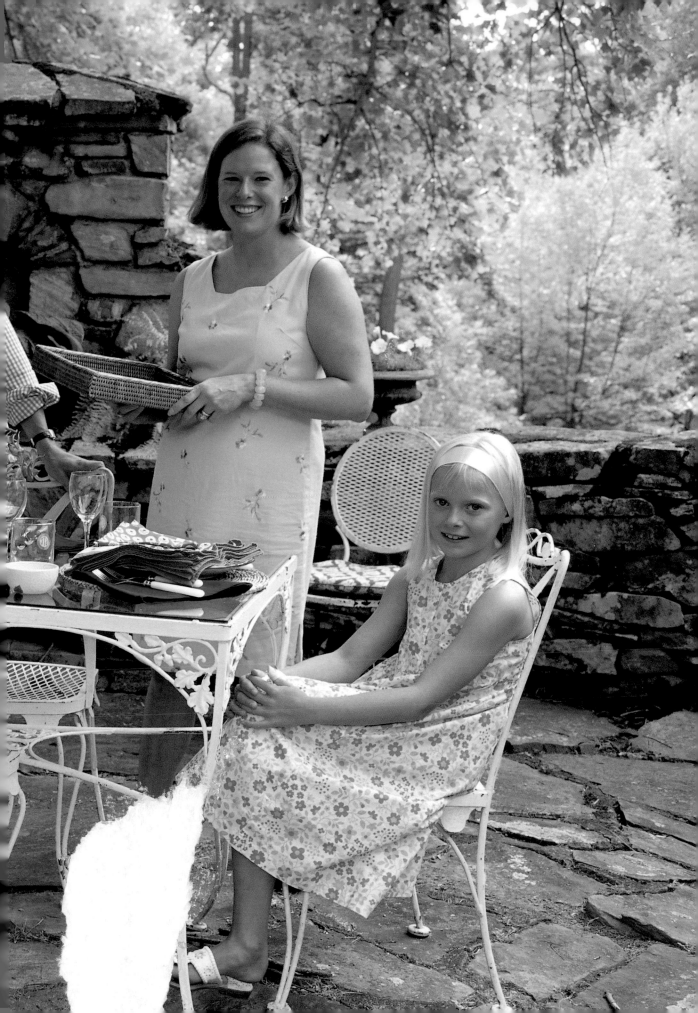

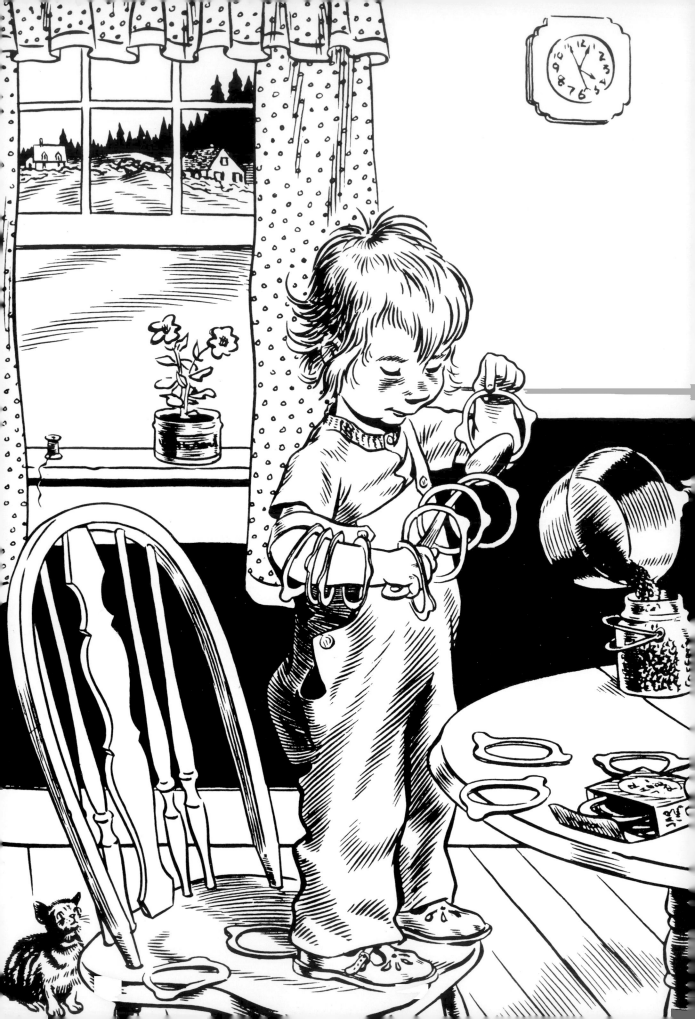

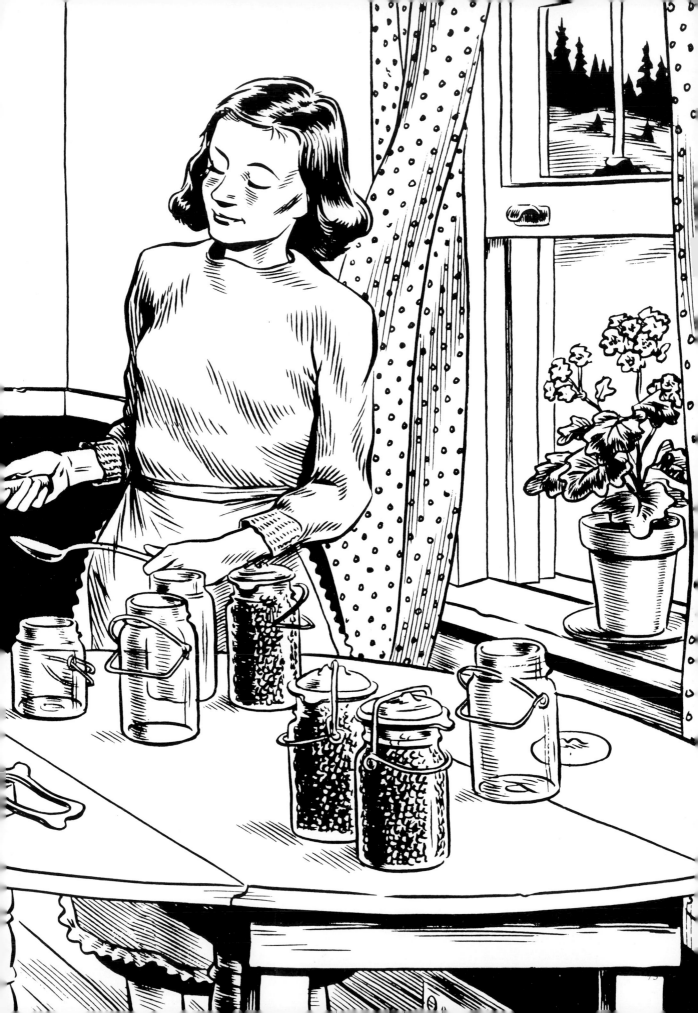

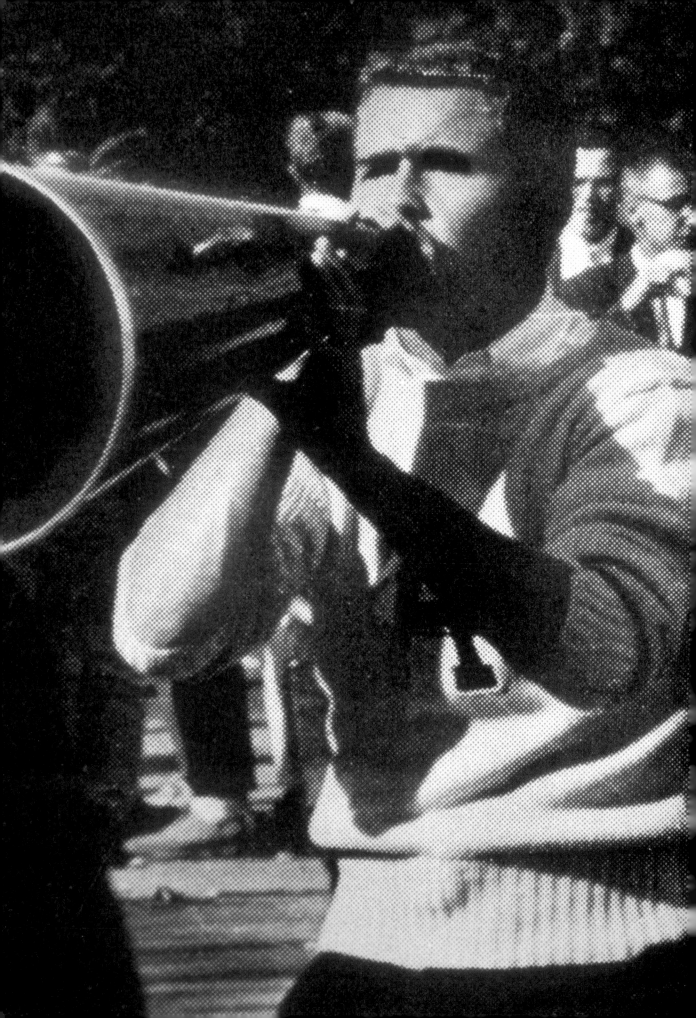

IVY LEAGUE

From the moment you are admitted into Ivy League's contained world, its cliched characteristics swirl around you like autumn leaves: afternoon sunlight slanting across ivy-laced buildings, a professor pedaling to class on a cycle that's as old as his tweed blazer, the exclamation of a whistle signaling halftime, the distant rattling of silverware as Sunday dinner is set. Like a living fossil, the layers of the past, present, and future are simultaneously preserved through multiple legacies and you are very much aware of the Ivy League footprints of those who came before you and those who will follow.

Much of WASP style owes its heritage to the college and prep school traditions born back as far as the seventeenth century: the blue blazer dress code, the passion for sports, dedication to knowledge, and forbidden revelry. The codes originally mastered at school cling to and thrive within many students' lives long after they have graduated. It's not just about cultivating the illusion of being in the prime of one's youth. There is a distinct decorum and style here that can keep the changing world at bay as long as you adhere to it. Meeting with your Princeton eating club twenty years after graduation and religiously attending the Head of the Charles races (even though you no longer crew for Harvard) is more a tribute to Ivy League style's powerful impression than to the graduate's immaturity.

Ivy League style resolutely sets its tone with the paradoxical presence of frugality and grandeur. Where else can a man wearing a twenty-year old orange-and-blue-striped knit

George W. Bush at Phillips Academy in 1964, exemplifying why some WASPS are better cheerleaders than they are players.

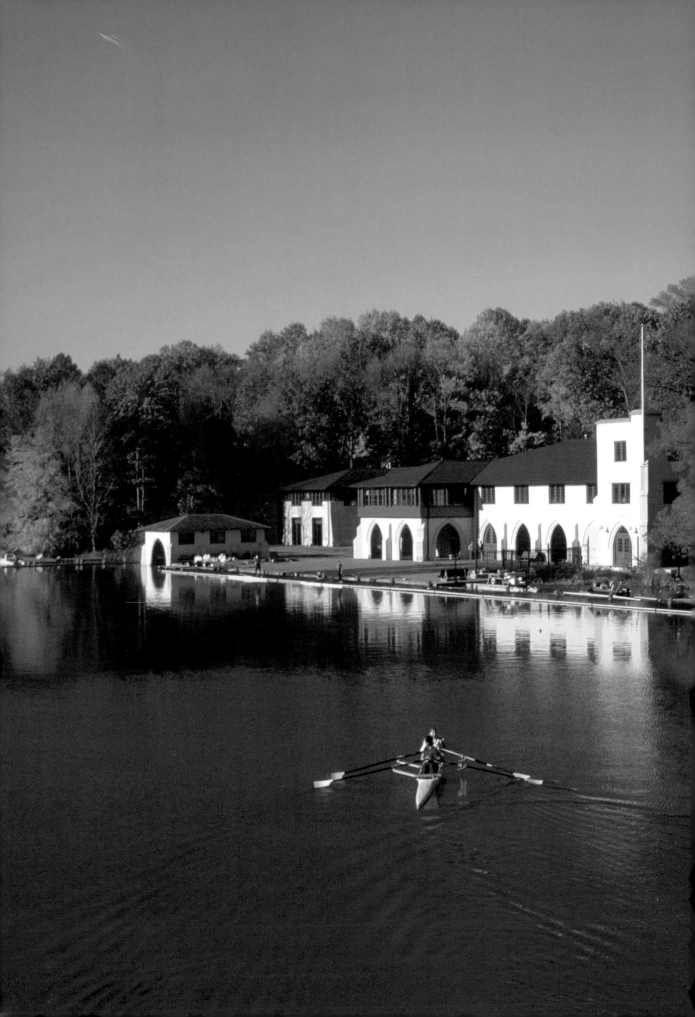

tie look distinguished? Things and people work here and nowhere else. In my Milton Academy yearbook, I examine the photographs of some of the faculty I never expected to be nostalgic about—many of them never warranted more than a greeting from me in the hallway while I was in high school. But now I stare at their faces in wonderment: Mr. Bisbee, Mr. Perry, Mr. Millet, and Miss Thatcher. From their crisp Oxford shirts, juvenile hairstyles, and unflinching expressions, they seem as durable, practical, and game for endeavor as a newly sharpened Number 2 pencil—and elegant in the way only a new pencil can be.

Over time, however, the once-monochromatic student and faculty bodies have thankfully been mixed, shaken, and stirred. And how can Miss Thatcher tie her scarf the same way knowing only unisex bathrooms remain in her once hallowed halls? She may not, but her determined ethos will endure. These walls are no longer a fortress but a means to pass to and from what awaits outside. Many times when dressing for an important meeting, I have found myself reaching to tie a silk scarf around my neck and wishing I hadn't lost my pearl studs. So while the Ivy League walls are no longer a fortress, they bank a shore of memories that influence our present hours. And while the outside has finally changed much of what lies within them, the school colors will never fade, nor will the passion, grace, and perseverance of Ivy League style.

The historic Princeton Boathouse, built in 1887 on the north shore of Carnegie Lake.

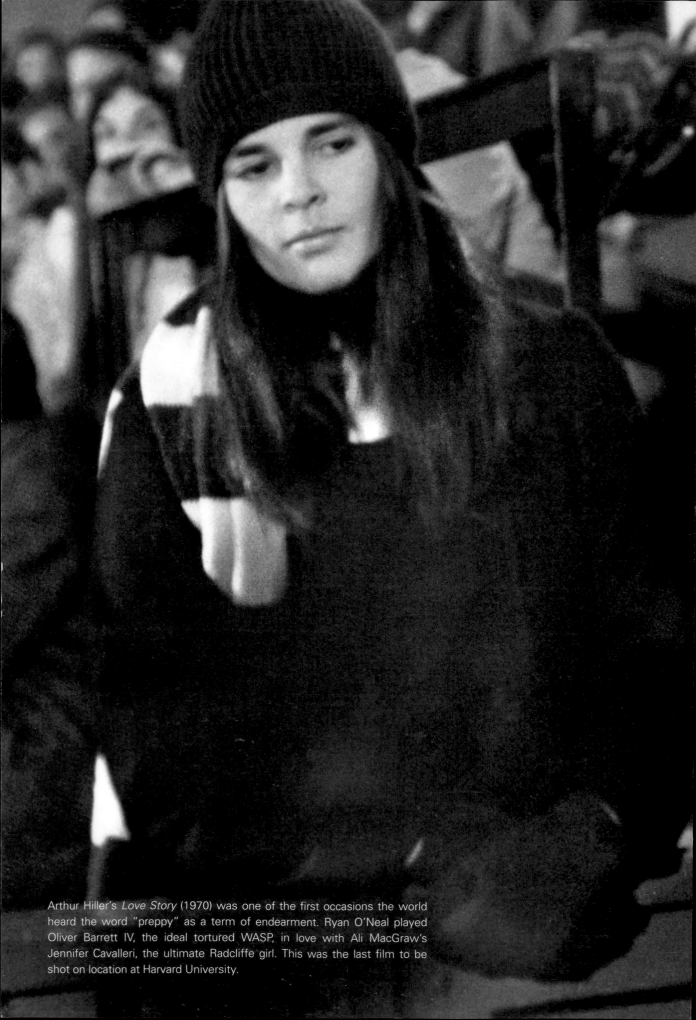

Arthur Hiller's *Love Story* (1970) was one of the first occasions the world heard the word "preppy" as a term of endearment. Ryan O'Neal played Oliver Barrett IV, the ideal tortured WASP, in love with Ali MacGraw's Jennifer Cavalleri, the ultimate Radcliffe girl. This was the last film to be shot on location at Harvard University.

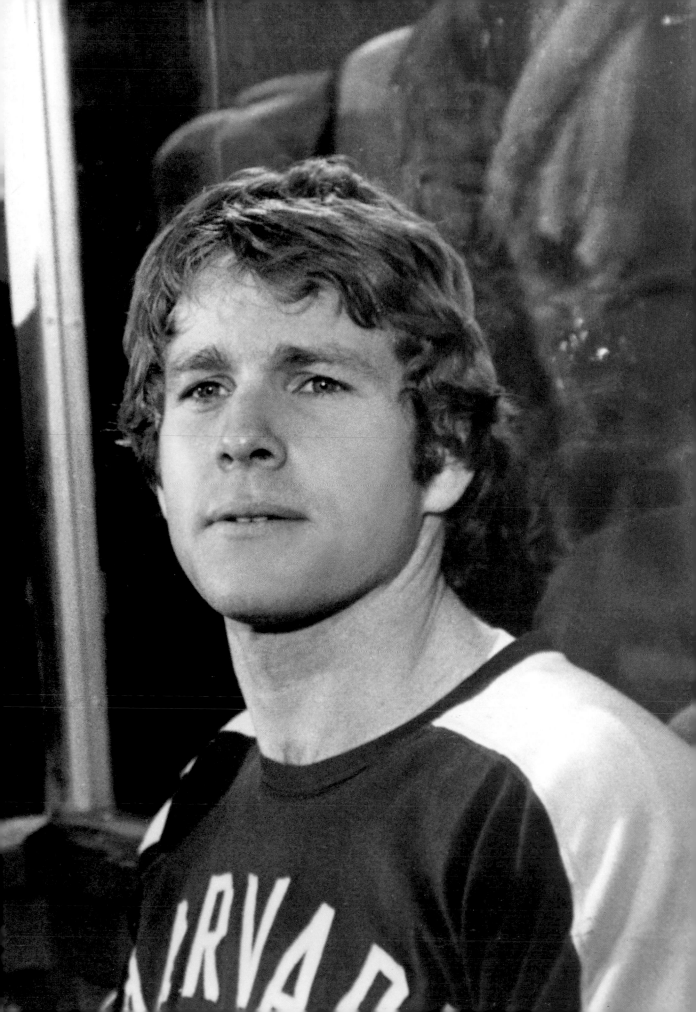

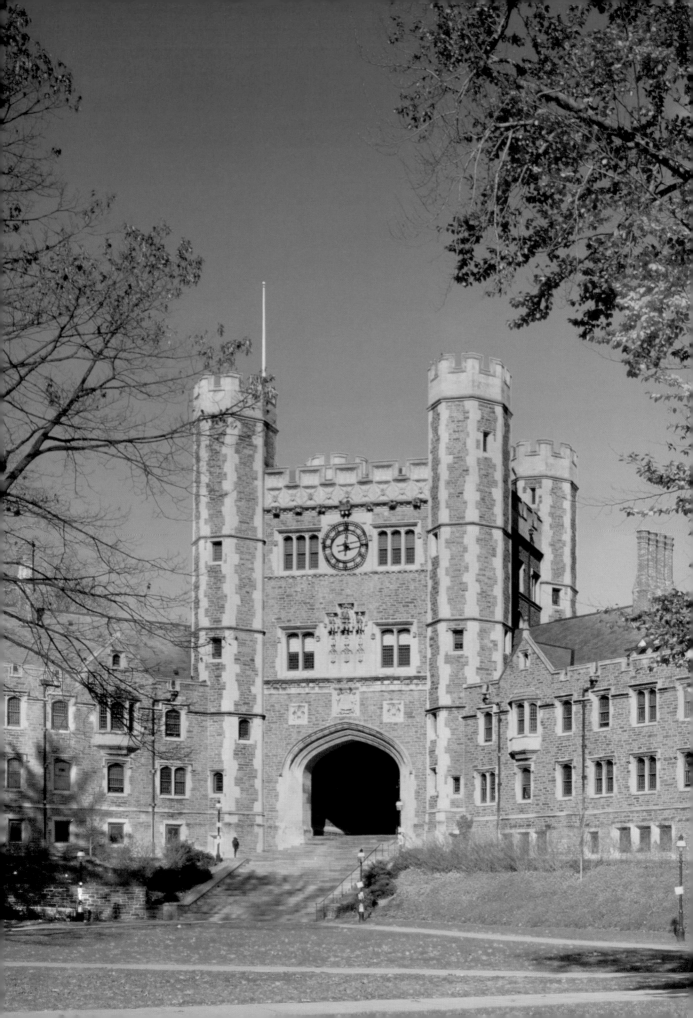

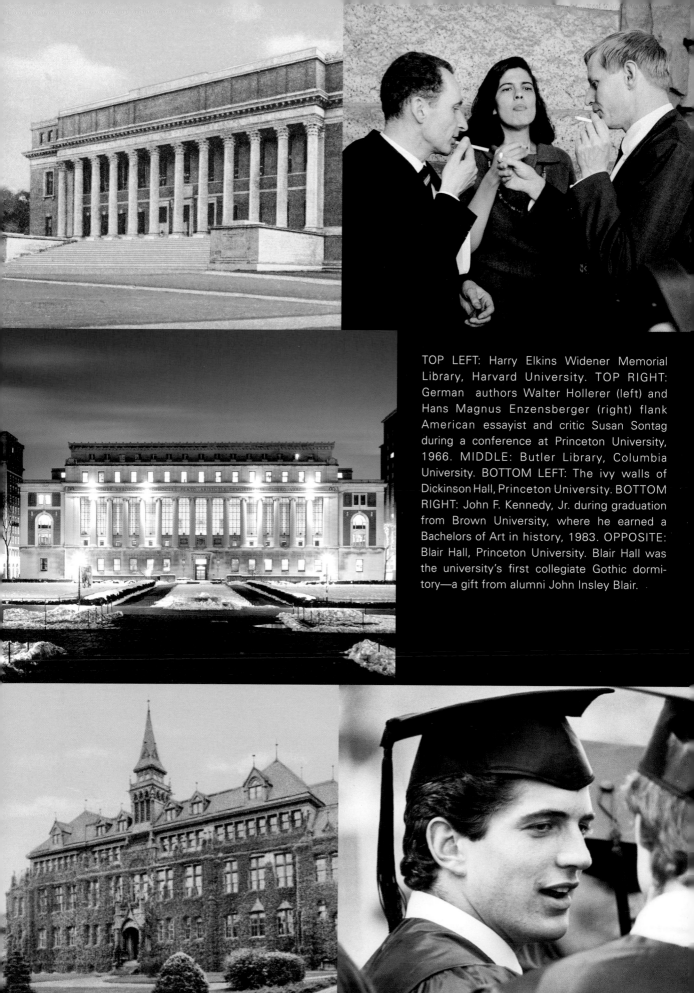

TOP LEFT: Harry Elkins Widener Memorial Library, Harvard University. TOP RIGHT: German authors Walter Hollerer (left) and Hans Magnus Enzensberger (right) flank American essayist and critic Susan Sontag during a conference at Princeton University, 1966. MIDDLE: Butler Library, Columbia University. BOTTOM LEFT: The ivy walls of Dickinson Hall, Princeton University. BOTTOM RIGHT: John F. Kennedy, Jr. during graduation from Brown University, where he earned a Bachelors of Art in history, 1983. OPPOSITE: Blair Hall, Princeton University. Blair Hall was the university's first collegiate Gothic dormitory—a gift from alumni John Insley Blair.

Harvard's Ben Ticknor and Yale's Fay Vincent—rival baseball captains, Soldier's Field. The Harvard-Yale football, hockey, and crew face-offs are just as intense today as the schools' baseball rivalry from the late nineteenth century.

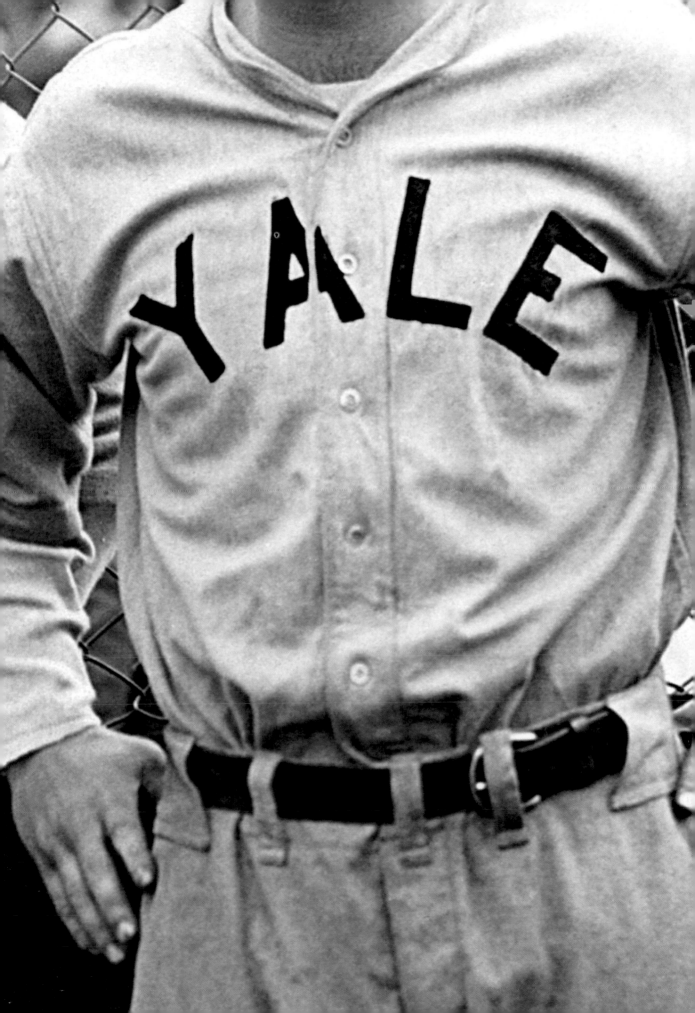

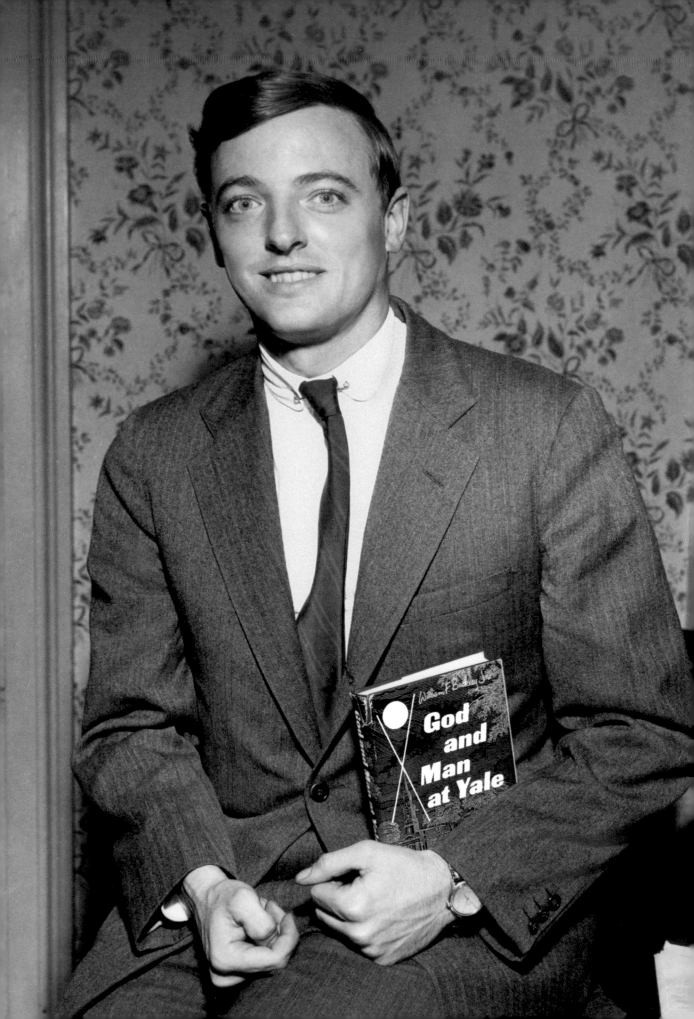

> "THE YALE PRESIDENT MUST BE A YALE MAN. NOT TOO FAR TO THE RIGHT, TOO FAR TO THE LEFT, OR A MIDDLE-OF-THE-ROADER . . . YOU MAY HAVE GUESSED WHO THE LEADING CANDIDATE IS, BUT THERE IS A QUESTION ABOUT HIM: IS GOD A YALE MAN?"
> —WILMARTH S. LEWIS, SELECTIONS COMMITTEE, YALE

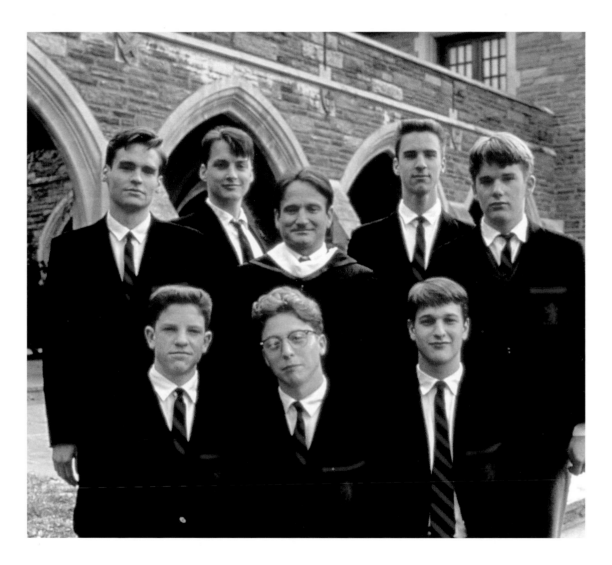

Peter Weir's *Dead Poet's Society* (1989) was filmed at St. Andrews, a private boarding school in Delaware. The film was loosely based on the experiences of private school students with Samuel Pickering, a professor of English at the University of Connecticut.

OPPOSITE: American author, journalist, and conservative commentator, William F. Buckley, Jr. proudly displays his first book, *God and Man at Yale*, ca. 1951. Notice key WASP decor of chintz wallpaper.

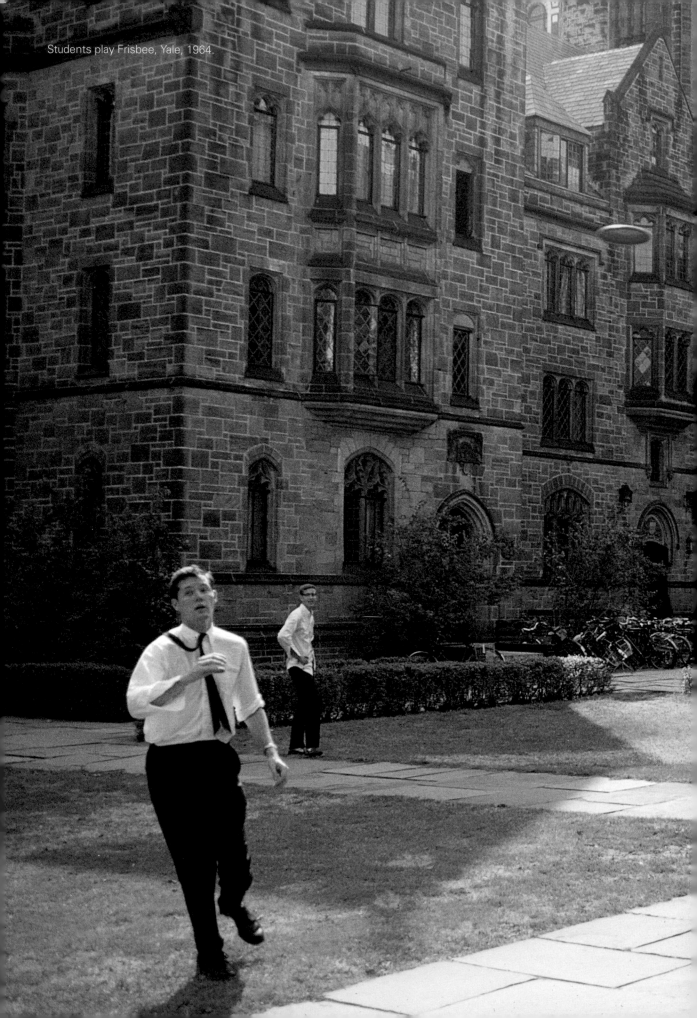

Students play Frisbee, Yale, 1964.

I HAVE BUT ON

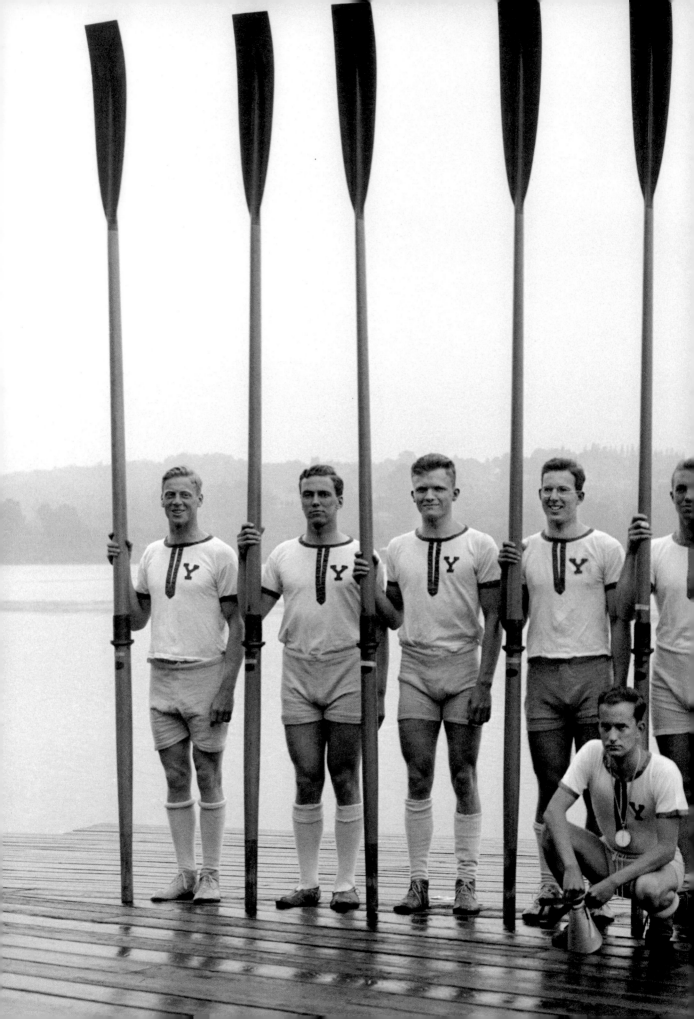

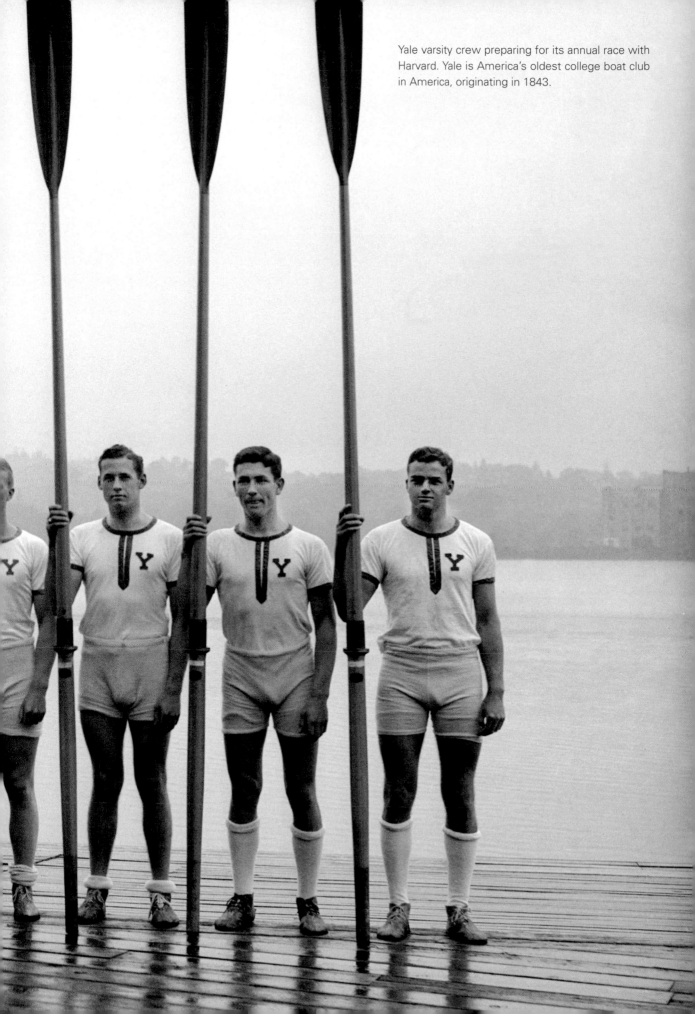

Yale varsity crew preparing for its annual race with Harvard. Yale is America's oldest college boat club in America, originating in 1843.

"My grandfather told his children that, by the end of his freshman year at Harvard, he could walk down Commonwealth Avenue as far as Hereford Street and know the name of the family behind each door."
—George Howe Colt, *The Big House*

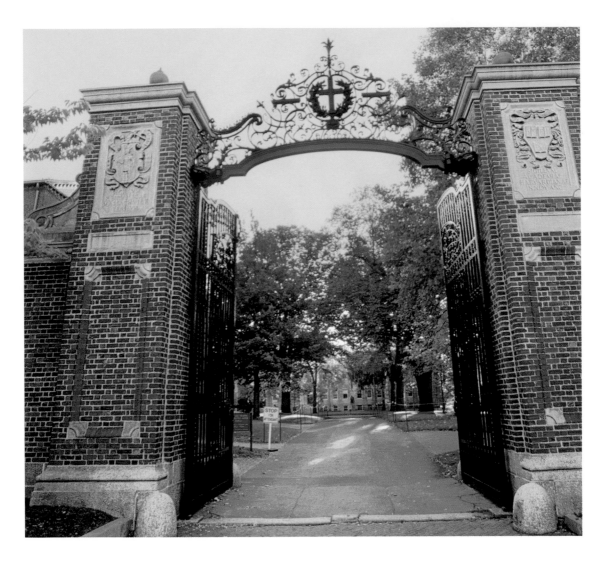

The Johnson Gate entrance to Harvard Yard, the central and most historic part of the university. The gate is named for alumni Samuel Johnson.

OPPOSITE: Robert F. Kennedy (front, right) with members of the Harvard football team sitting outside the Varsity Club, October 30, 1946.

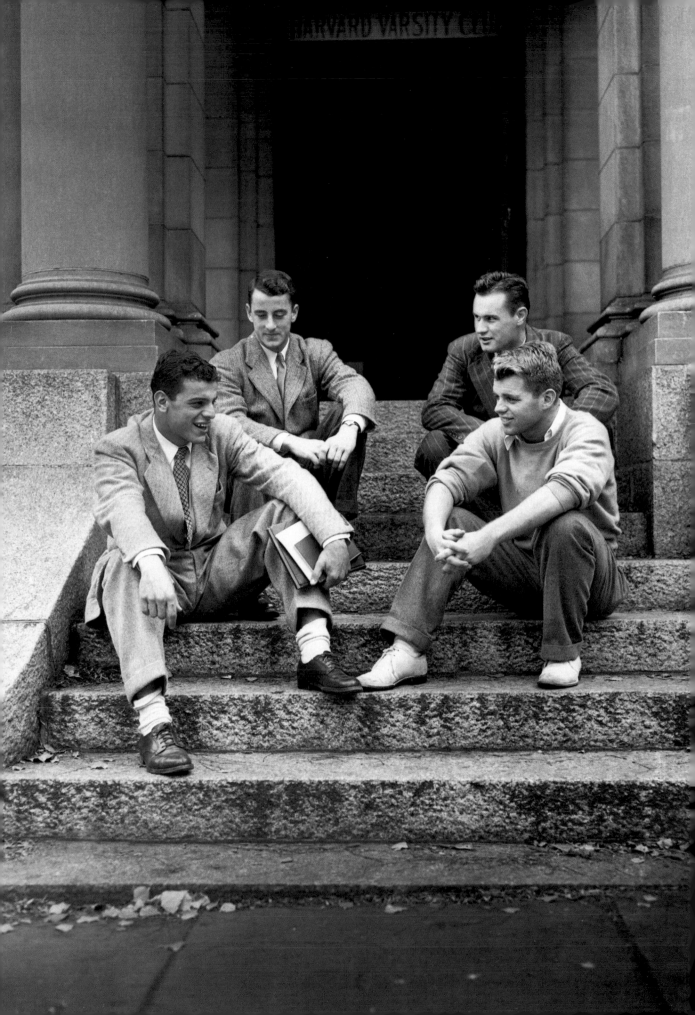

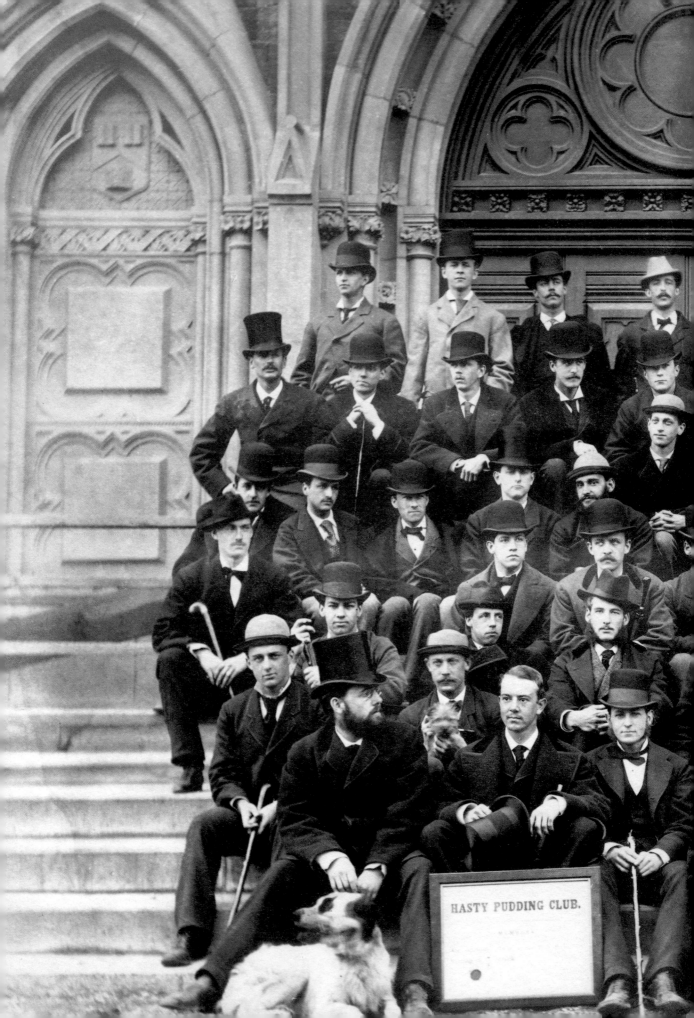

HASTY PUDDING CLUB.

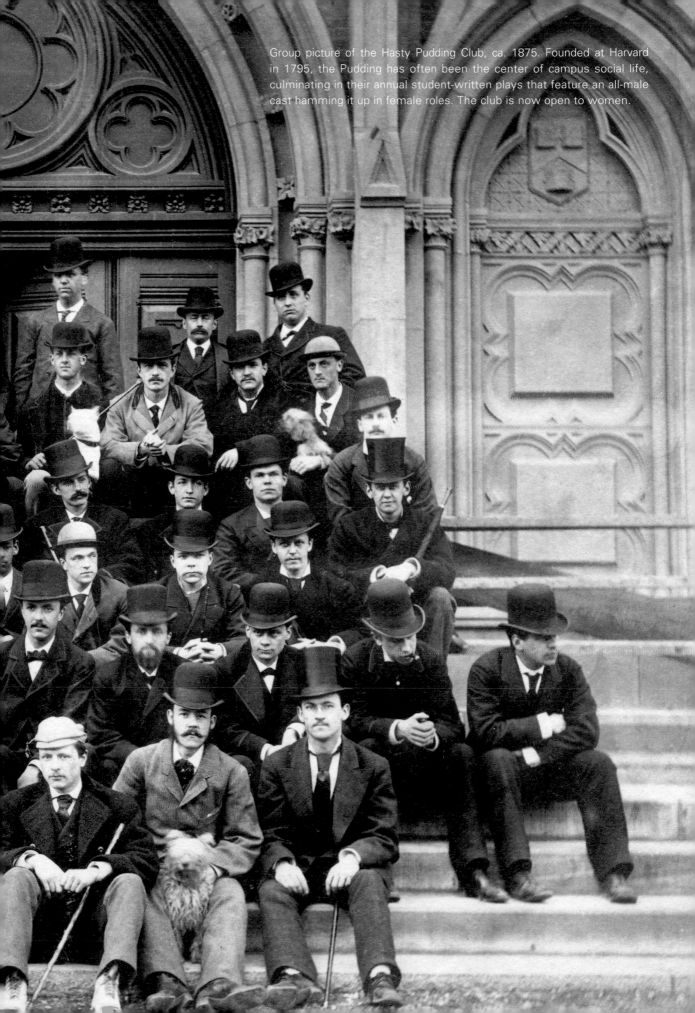

Group picture of the Hasty Pudding Club, ca. 1875. Founded at Harvard in 1795, the Pudding has often been the center of campus social life, culminating in their annual student-written plays that feature an all-male cast hamming it up in female roles. The club is now open to women.

"LOOKING BACK OVER A DECADE ONE SEES THE IDEAL OF A UNIVERSITY
BECOME A MYTH, A VISION . . . YET PERHAPS IT IS THERE AT PRINCETON."
—F. SCOTT FITZGERALD

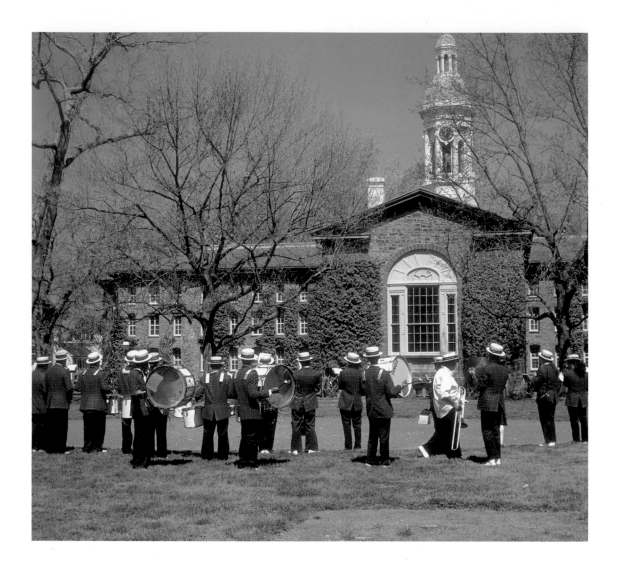

Princeton marching band outside of Nassau Hall. Ever-present at all home
and away games, their unique scramble style of "marching" has been ad-
opted by most Ivy League bands.

OPPOSITE: A university student watches a crew pass by on the river, ca.
1954. Nothing creates the idealized crew personae better than a perfectly
draped university scarf.

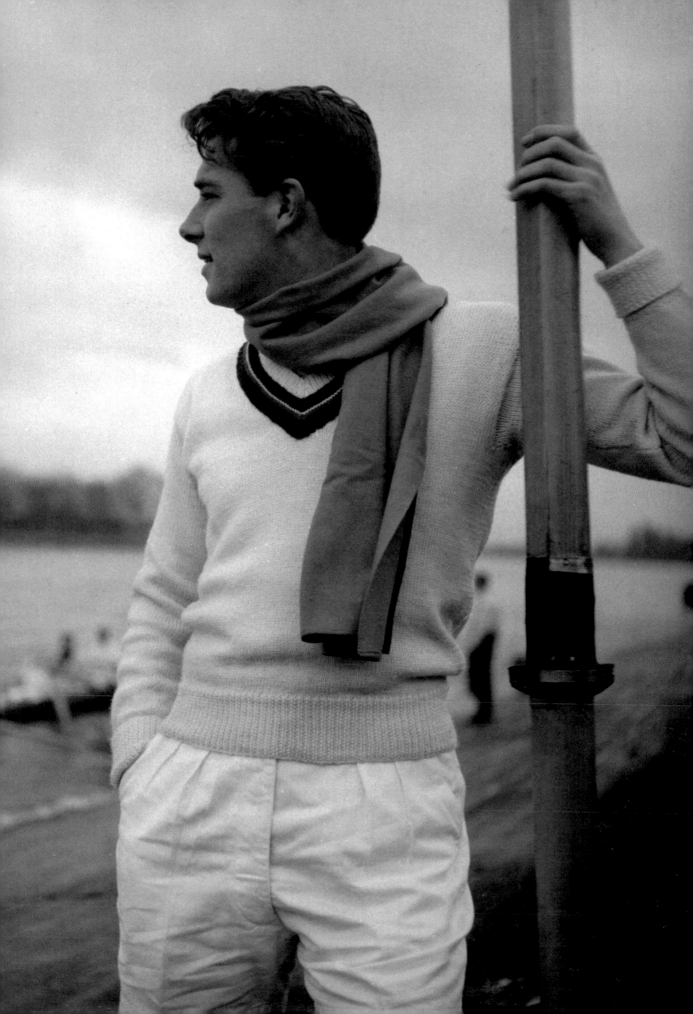

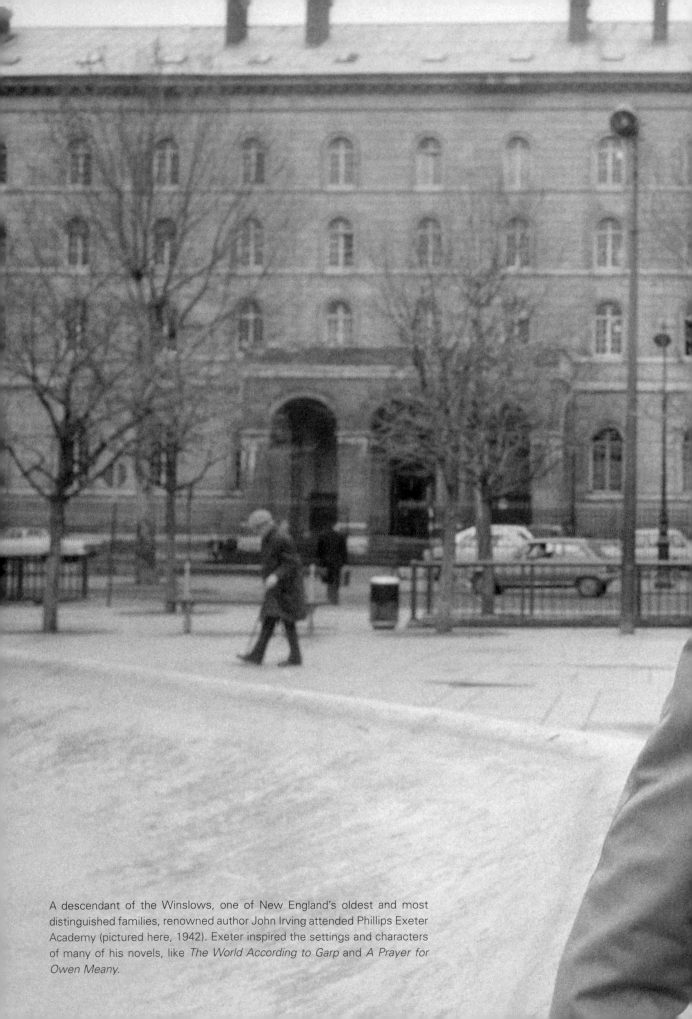

A descendant of the Winslows, one of New England's oldest and most distinguished families, renowned author John Irving attended Phillips Exeter Academy (pictured here, 1942). Exeter inspired the settings and characters of many of his novels, like *The World According to Garp* and *A Prayer for Owen Meany*.

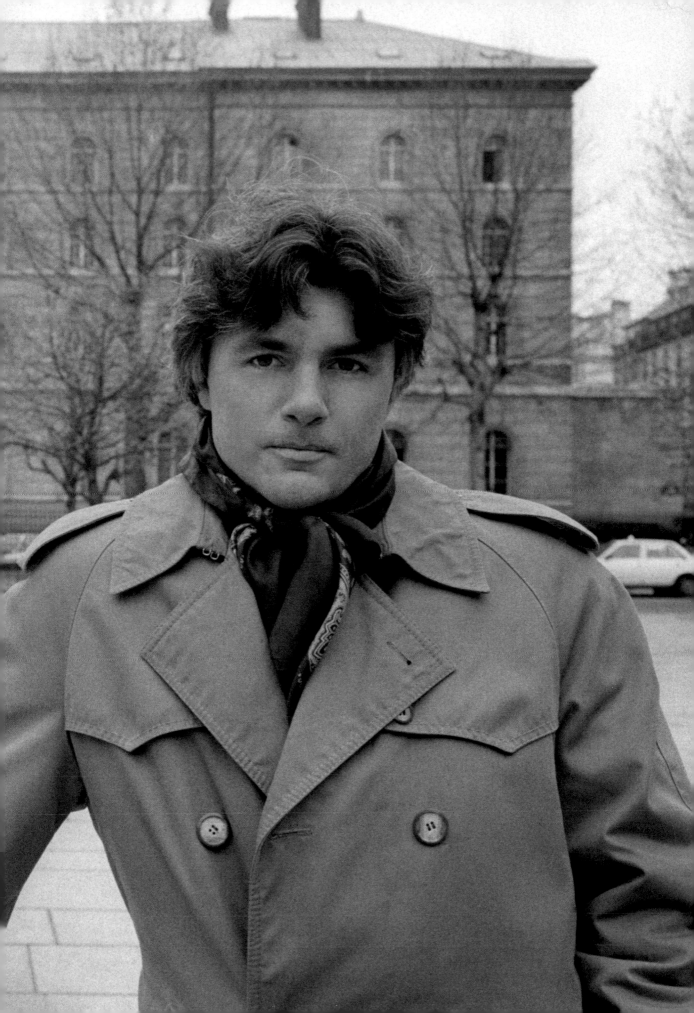

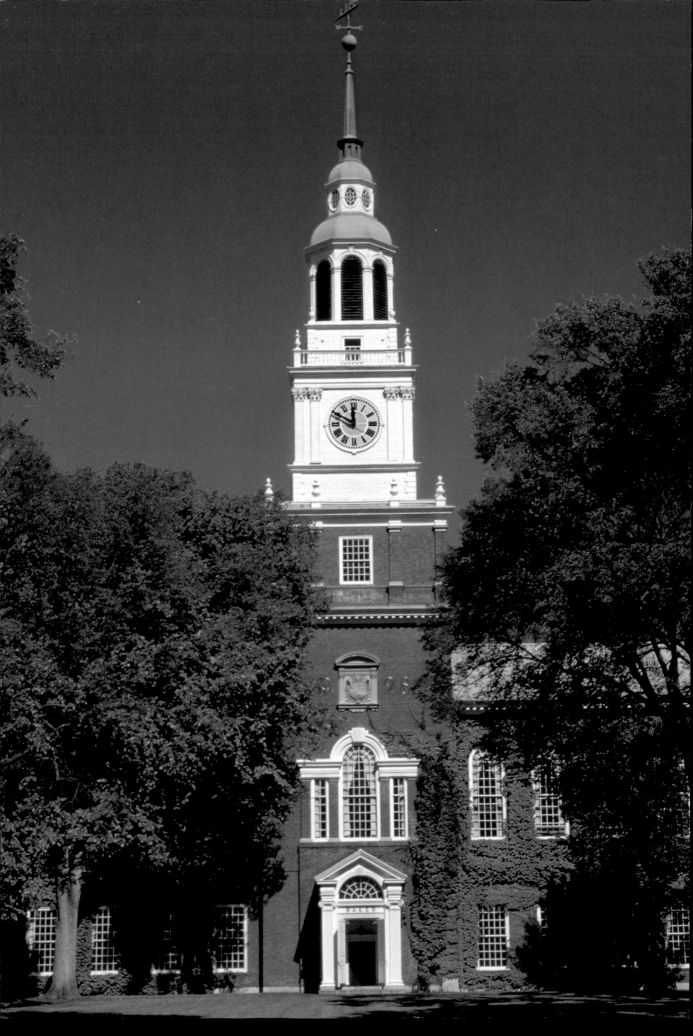

"Ogden, could you pull a string and get me one of those pictures of you naked at Yale?"

For forty years *New Yorker* cartoonist William Hamilton has rendered WASP ethos, humor, and angst with pitch-perfect exactitude. His fascination, he says, "comes from being near money, but far enough away that I couldn't quite get my fingers around it."

OPPOSITE: The Baker Memorial Library, which is a copy of Philadelphia's Independence Hall, at Dartmouth College, Hanover, New Hampshire.

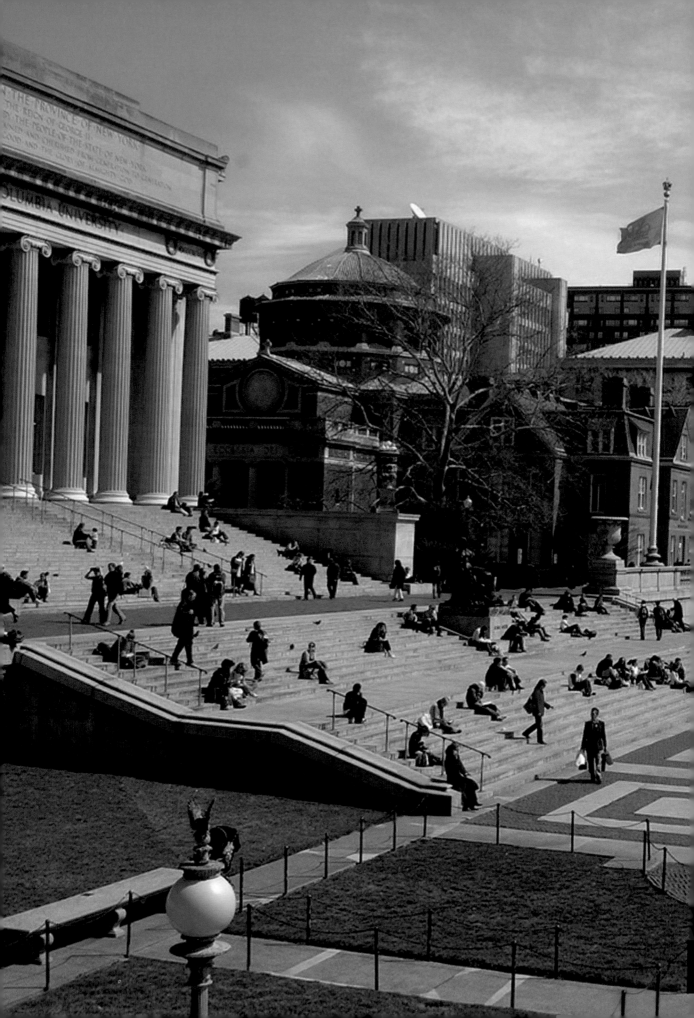

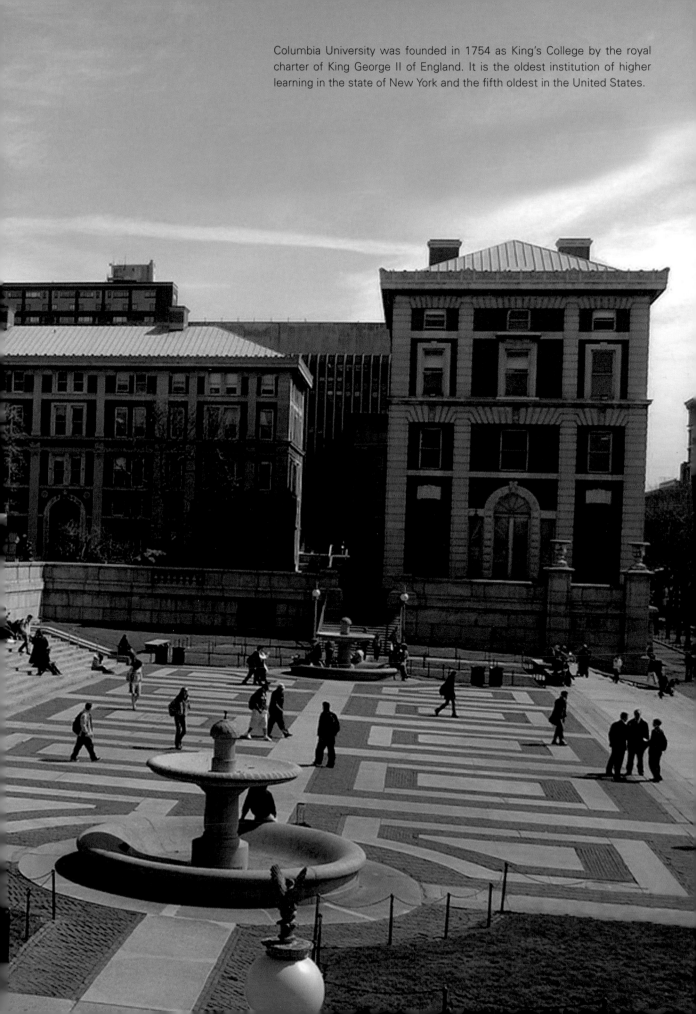

Columbia University was founded in 1754 as King's College by the royal charter of King George II of England. It is the oldest institution of higher learning in the state of New York and the fifth oldest in the United States.

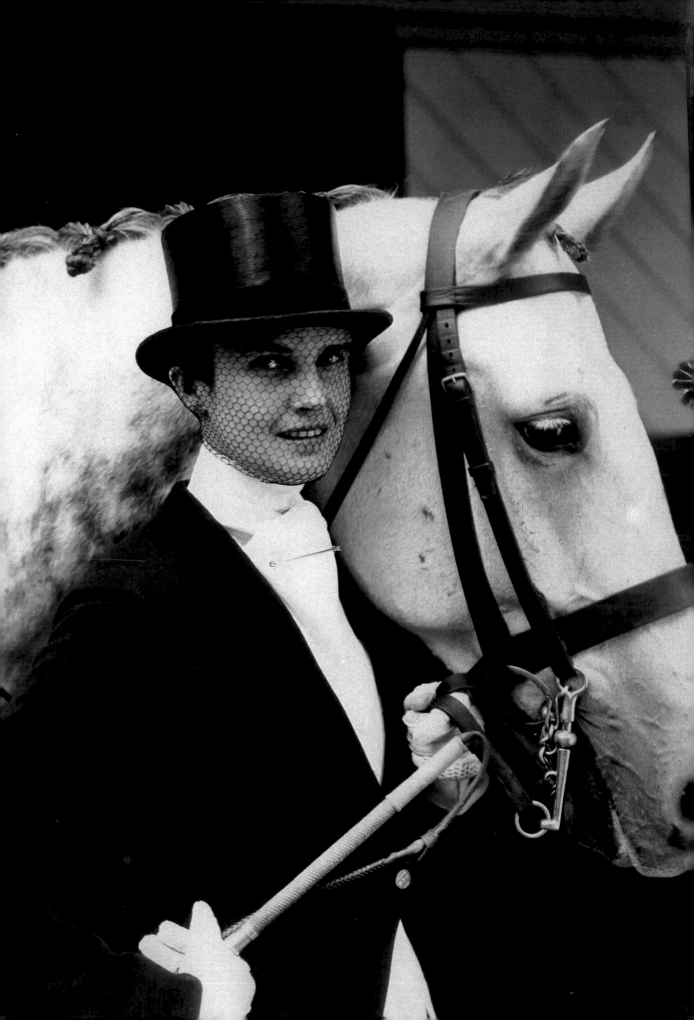

FASHION

Fashion is about so much more than pink and green. That ostentatious-yet-strangely compatible color combination exists in the WASP world, yes. But it is more cliché than truth. WASP style is easy to replicate yet trickier to truly emulate. It's not just about pairing a madras blazer with khakis. The constant classics are essential, but don't let those friendly whale belts fool you; there's as much serious attitude behind WASP style's casual formality as in the latest looks that strut down Fashion Week's runways. But unlike the manic barometer Seventh Avenue sets each season, WASP style never strays from its code of spiffy practicality and its followers are the most loyal customers around.

I recently attended a football game in Harvard Stadium. There amongst the cheering undergraduates sat a couple in their seventies. He sat erect on the cold cement in his slightly worn herringbone blazer with a wool scarf carefully tucked inside the lapels. His beige corduroy pants were neatly pressed, and a dapper tweed touring cap donned his head. His wife wore blue-and-green tartan wool pants underneath a camel hair coat (that was probably forty years old), and her pretty face was unadorned except for quiet earrings and a small barrette. They both wore boat sneakers. And while they possessed their current selves with steely dignity, I instantly visualized them in their forties, twenties, even as toddlers. I imagined the Subaru they would drive home in and NPR playing on the radio. I knew that they would spend the rest of the afternoon puttering in their garden, their overweight Labrador retriever by their side. This is what WASP fashion does best: it opens a window onto a very private world. Rather than express individuality, its clothes express a way of living.

My cousin Peggy Thayer Talbott and her horse, Phantom, ca. 1933.

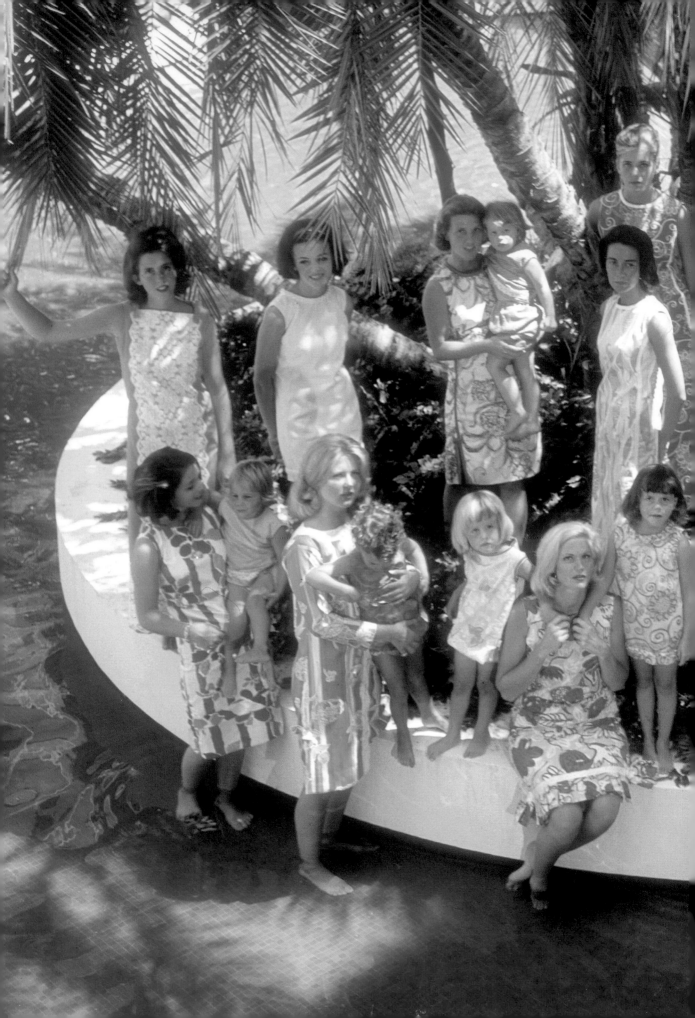

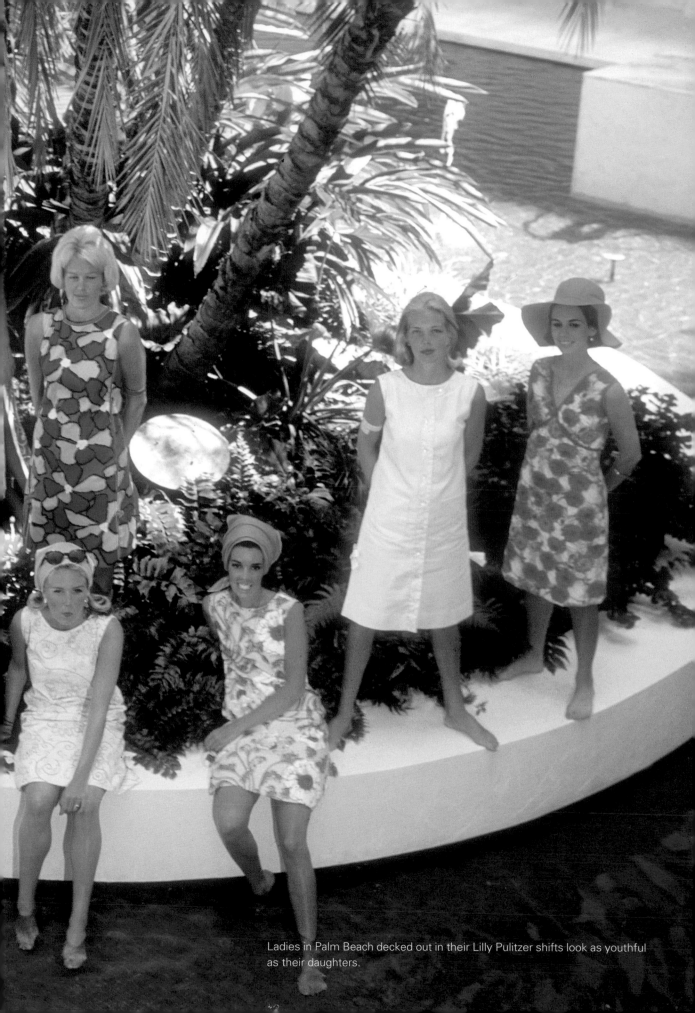

Ladies in Palm Beach decked out in their Lilly Pulitzer shifts look as youthful as their daughters.

Many say WASP style was born in the Northeast preparatory schools in the 1950s. The bright hues so embraced by both sexes may have taken its cue from the fashion of Bermuda, where many old-moneyed vacationers frequented. Wherever it came from, once it planted its sockless shoes on American soil, the preppy look thrived, and ever since it has danced along the edge of mainstream fashion without ever being edgy, hopping in and out of the spotlight without being trendy.

And while many of us have bought a rugby shirt or a Lilly Pulitzer skirt or have worn Jack Rogers sandals to the office in July, there has always been, and will continue to be, zealots. For women, fashion is frozen in the girlish styles of childhood à la Peter Pan collars, preppy cardigans, headbands, and loafers. For men, playful formality transcends age when a Toggle coat is paired with a university scarf.

When I was in eighth grade, my friends and I—the teachers, too—wore Fair Isle sweaters and wide wale corduroys. And despite its conducive location, I doubt the kids at this same school now adhere to such rigid preppie principles as we did; there are too many competing fashion influences these days, from MTV to *Teen Vogue*. A thirteen year old is far more likely now to have Ugg boots than those made by L. L. Bean.

Does this mean that fifty years from now the couple in the stadium will no longer exist? While Gap and J. Crew constantly keep the flame alive by offering the classics, they do so with a twist. Now, lime green and blue grosgrain belts are paired with flared, low-rise blue jeans and madras blazers with miniskirts. While the older WASP generation clings to the wholesome classics, their grandchildren are welcoming popular culture into the club and celebrating the edgy mix with stylish nonchalance. And the infiltration works both ways. Fashion designers like Ralph Lauren, Michael Kors, and Isaac Mizrahi have long sent WASP-inspired clothes down their runways, and Kate Spade has offered the pitch-perfect handbags and shoes to accompany them. They understand the constant allure of WASP style: with its optimistic colors, elegantly smooth lines, and sensible materials, it is as timeless as a box of Crayola crayons.

So the dance between old and new has begun, and it is unlikely to stop and unravel itself. Scant few of us—with the exception of the very young and the very old—can pull off head-to-toe Lilly Pulitzer. Nor do we want to. There are too many stylish options out there to hang in our closets. However, I challenge any of the latest fashions to stand next to a true WASP couple on their way to a summer cocktail party in their dandy, crisp attire. Sometimes dashing confidence is the ultimate accessory.

My dear Aunts Annie and Katharine (as children) with their rambunctious friend Rupert. Love the white ankle socks and the madras bow tie.

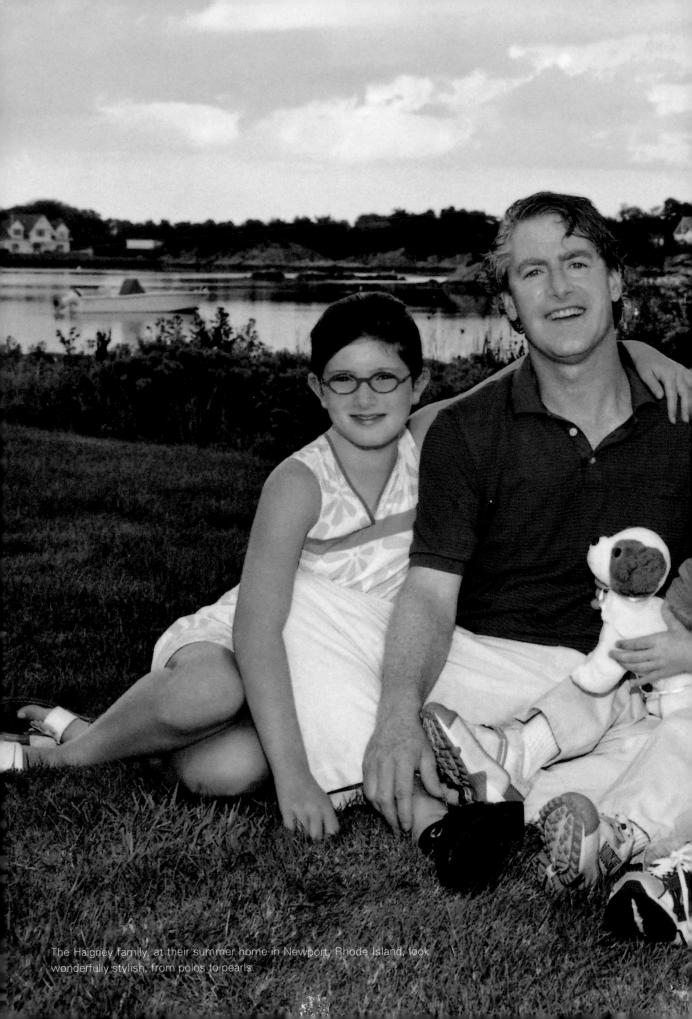

The Haigney family, at their summer home in Newport, Rhode Island, look wonderfully stylish, from polos to pearls.

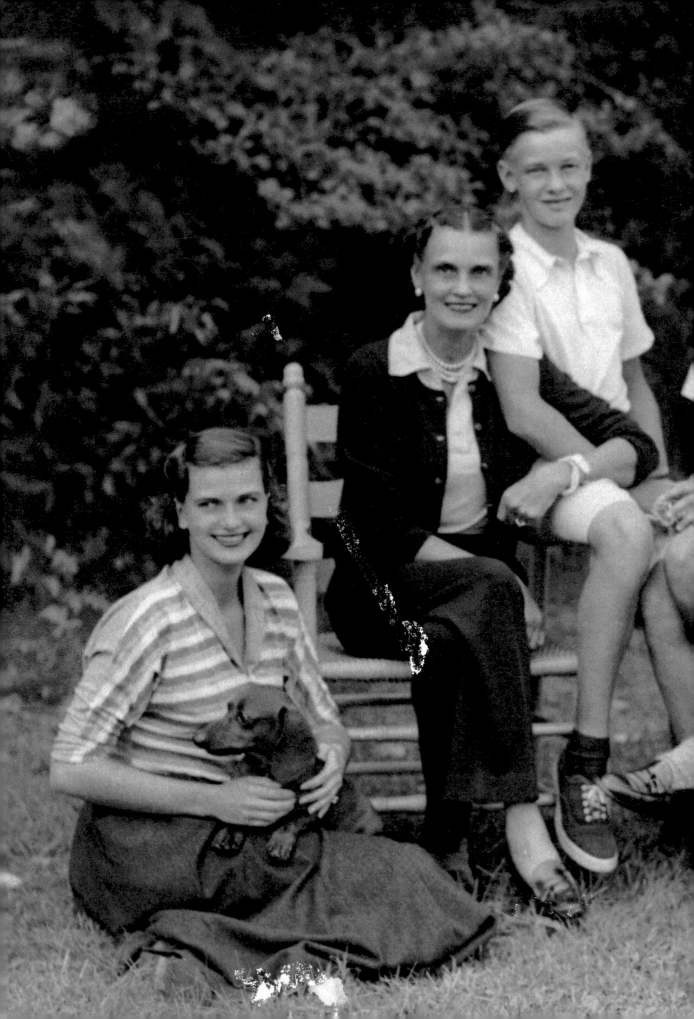

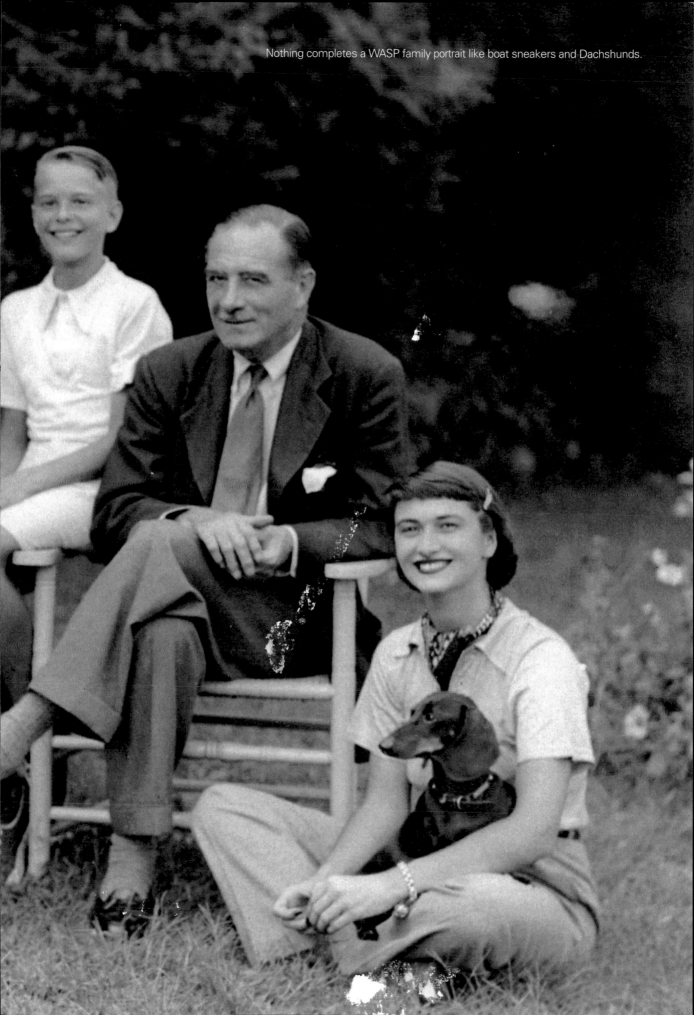

Nothing completes a WASP family portrait like boat sneakers and Dachshunds.

"BENEATH THE PYRAMID OF YACHTING
FLAGS WERE FAMILIAR TENNIS HATS AND FADED SALMON
SHORTS, WARPED TOPSIDERS, AND YELLOWING SOCKS . . ."
—SUSAN MINOT, *MONKEYS*

John Lindsay proves that WASP attire never grows more casual as it gets older, but freer to take more risks.

OPPOSITE: John F. Kennedy, Jr., knew how to add a slight edge to his preppie wardrobe, which always gave him a distinct style no matter how casually he was dressed, ca. 1977.

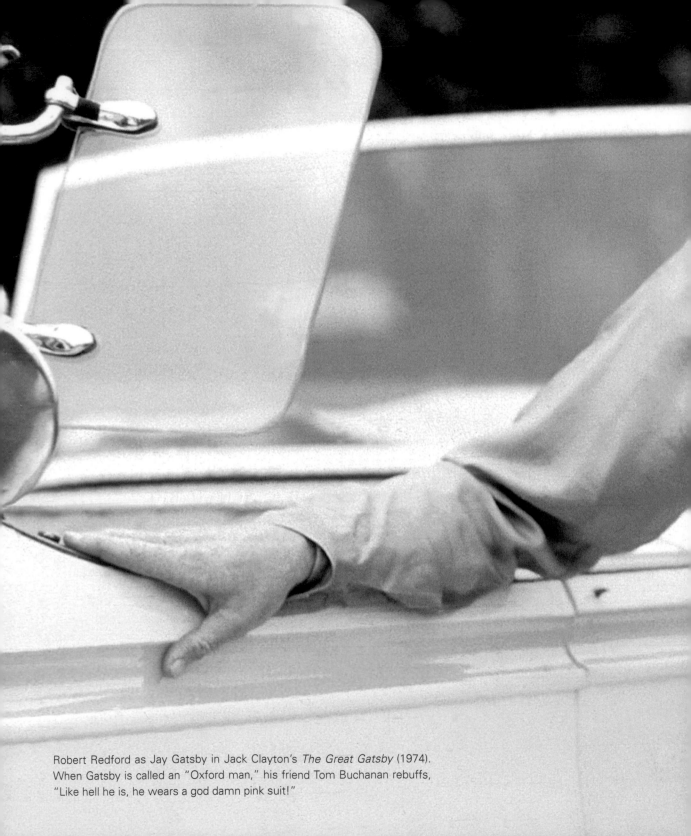

Robert Redford as Jay Gatsby in Jack Clayton's *The Great Gatsby* (1974). When Gatsby is called an "Oxford man," his friend Tom Buchanan rebuffs, "Like hell he is, he wears a god damn pink suit!"

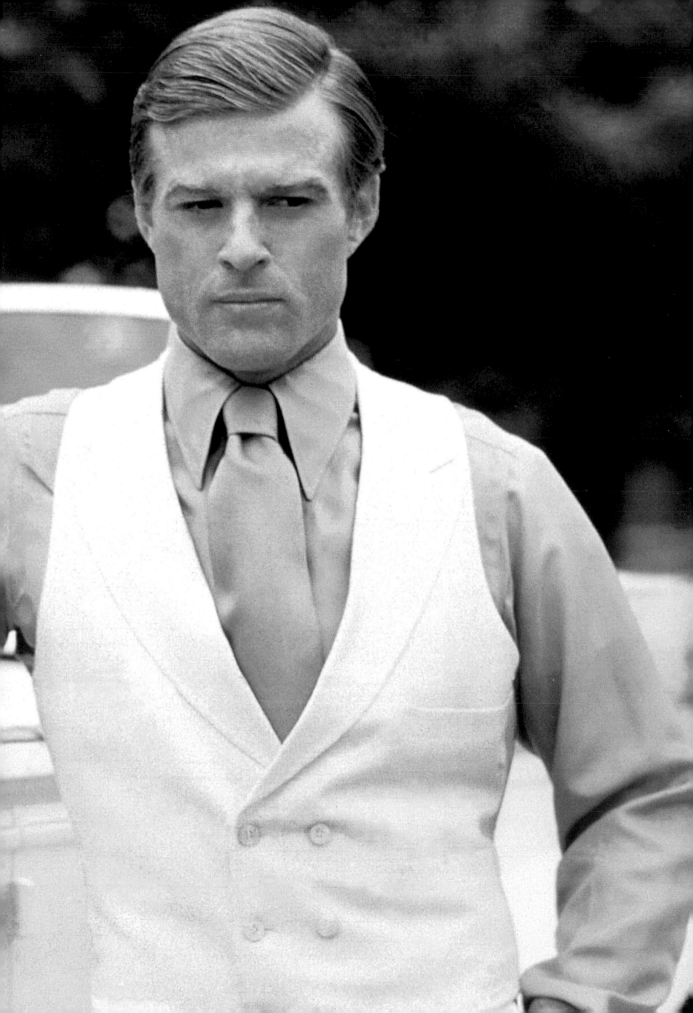

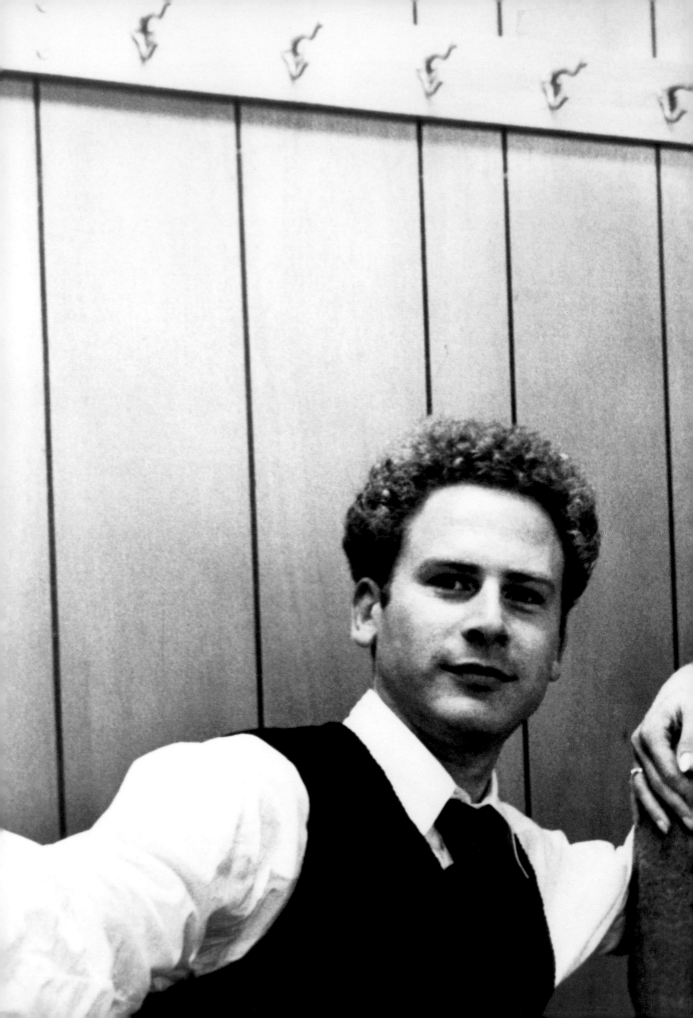

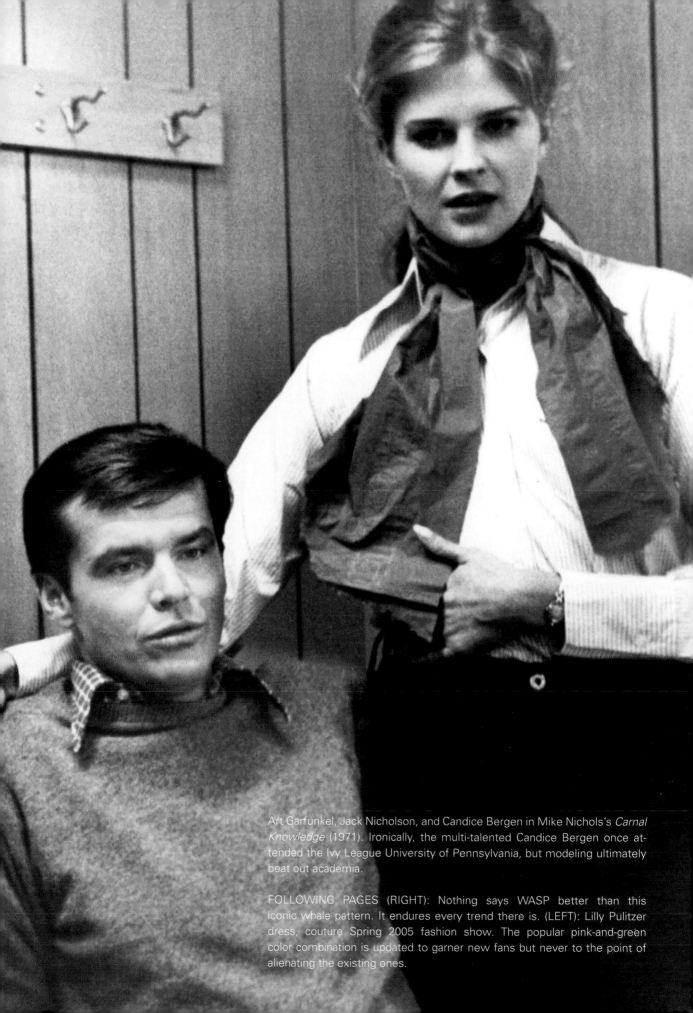

Art Garfunkel, Jack Nicholson, and Candice Bergen in Mike Nichols's *Carnal Knowledge* (1971). Ironically, the multi-talented Candice Bergen once attended the Ivy League University of Pennsylvania, but modeling ultimately beat out academia.

FOLLOWING PAGES (RIGHT): Nothing says WASP better than this iconic whale pattern. It endures every trend there is. (LEFT): Lilly Pulitzer dress, couture Spring 2005 fashion show. The popular pink-and-green color combination is updated to garner new fans but never to the point of alienating the existing ones.

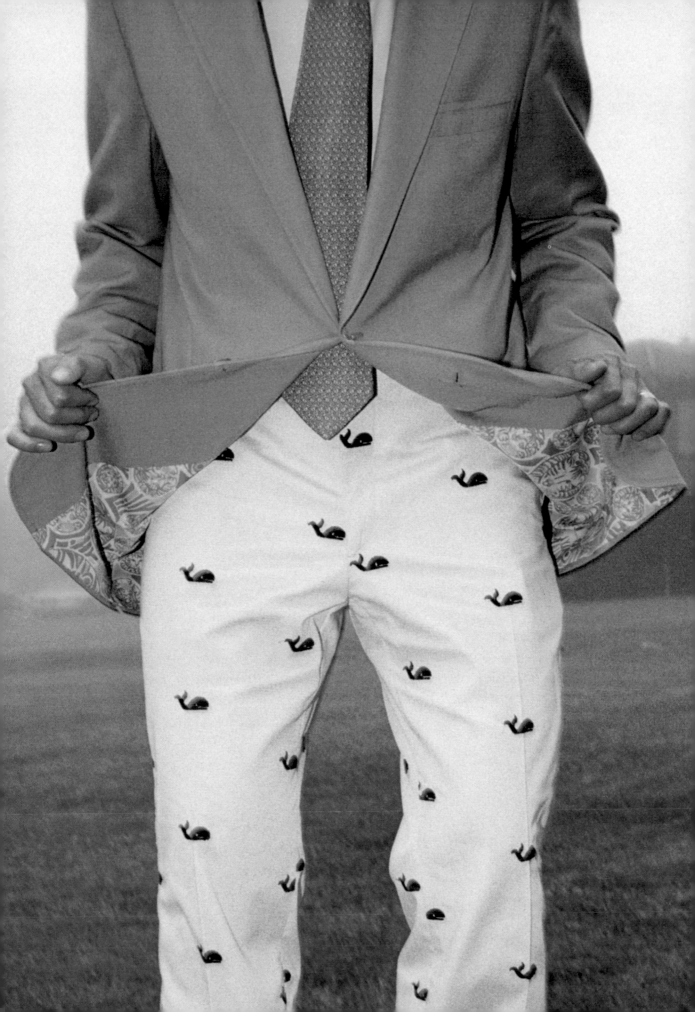

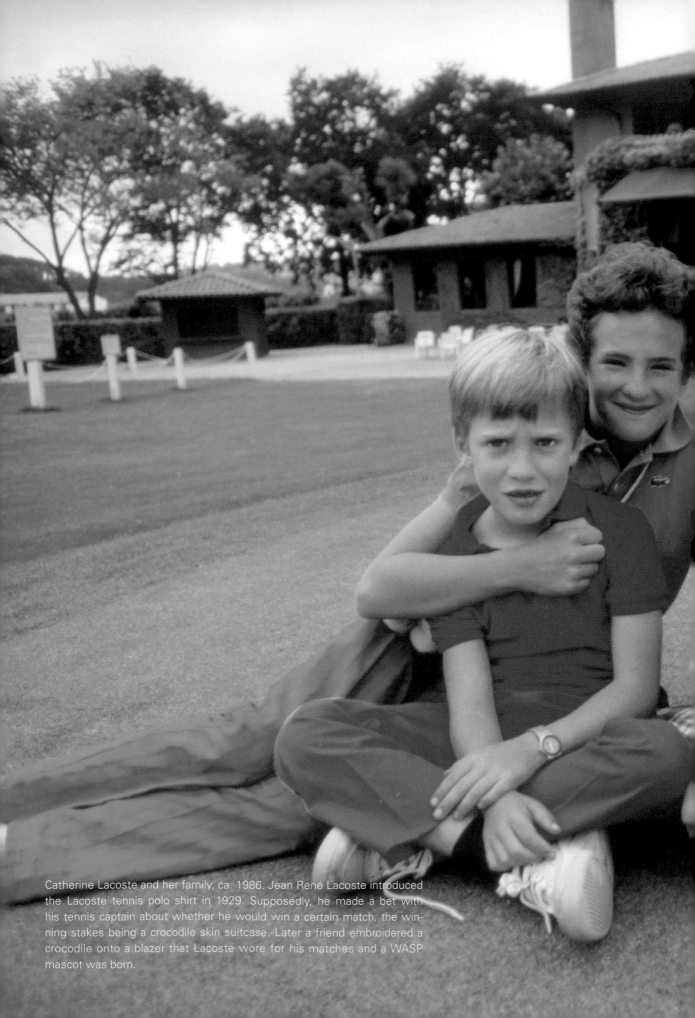

Catherine Lacoste and her family, ca. 1986. Jean René Lacoste introduced the Lacoste tennis polo shirt in 1929. Supposedly, he made a bet with his tennis captain about whether he would win a certain match, the winning stakes being a crocodile skin suitcase. Later a friend embroidered a crocodile onto a blazer that Lacoste wore for his matches and a WASP mascot was born.

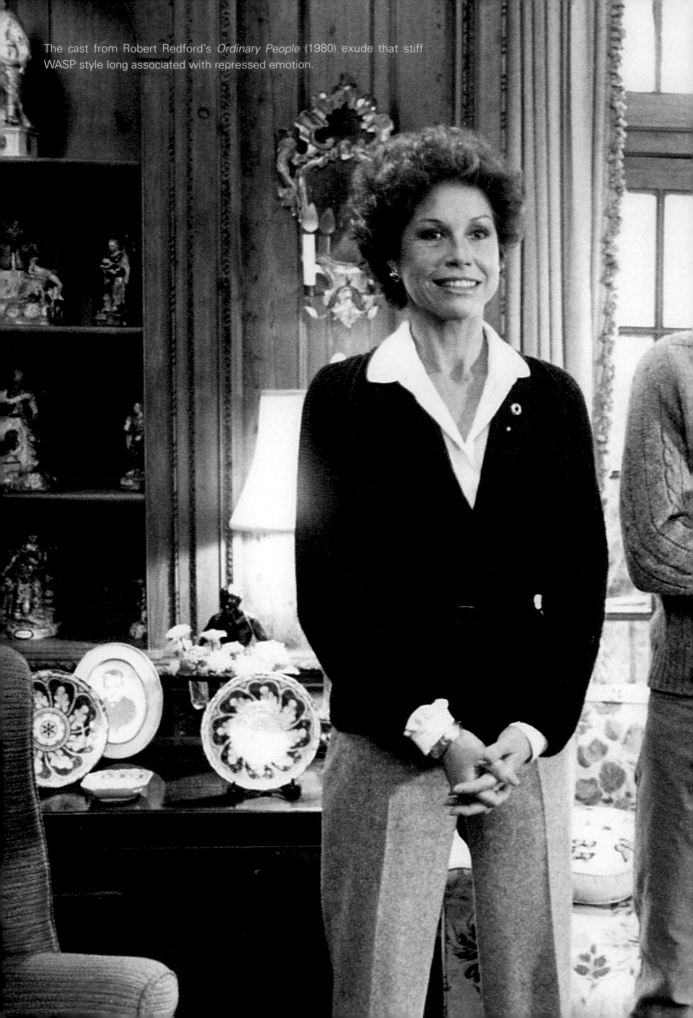

The cast from Robert Redford's *Ordinary People* (1980) exude that stiff WASP style long associated with repressed emotion.

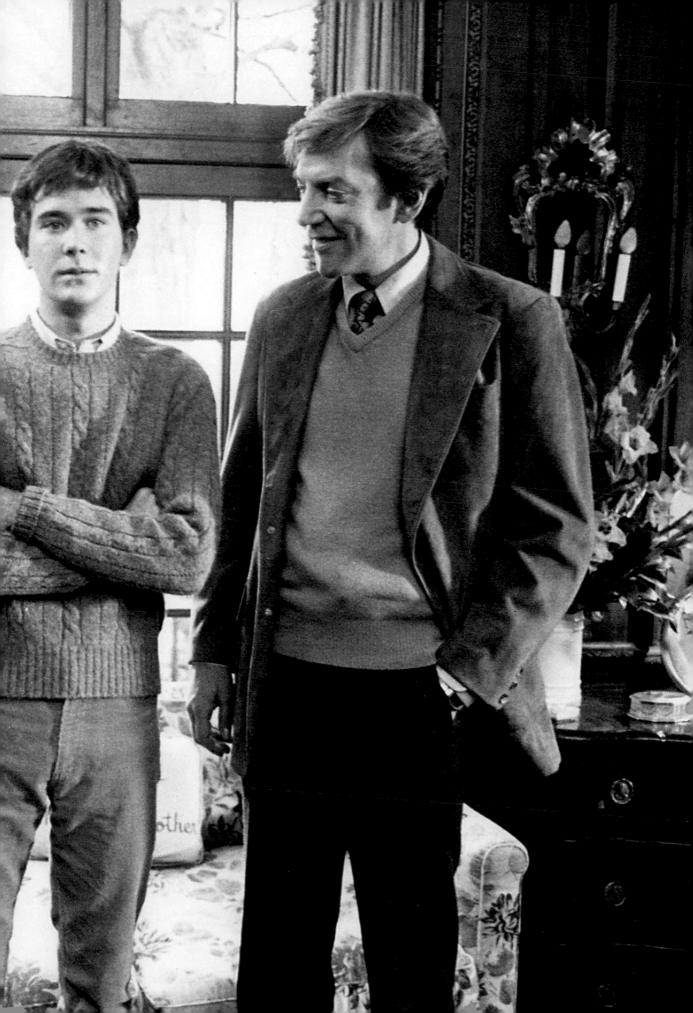

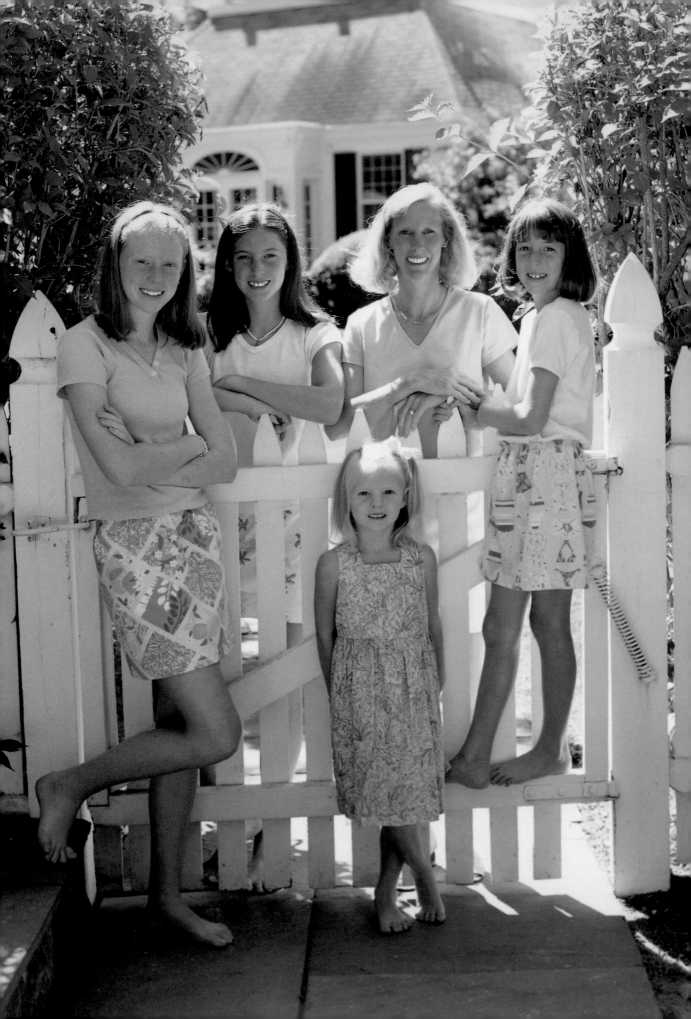

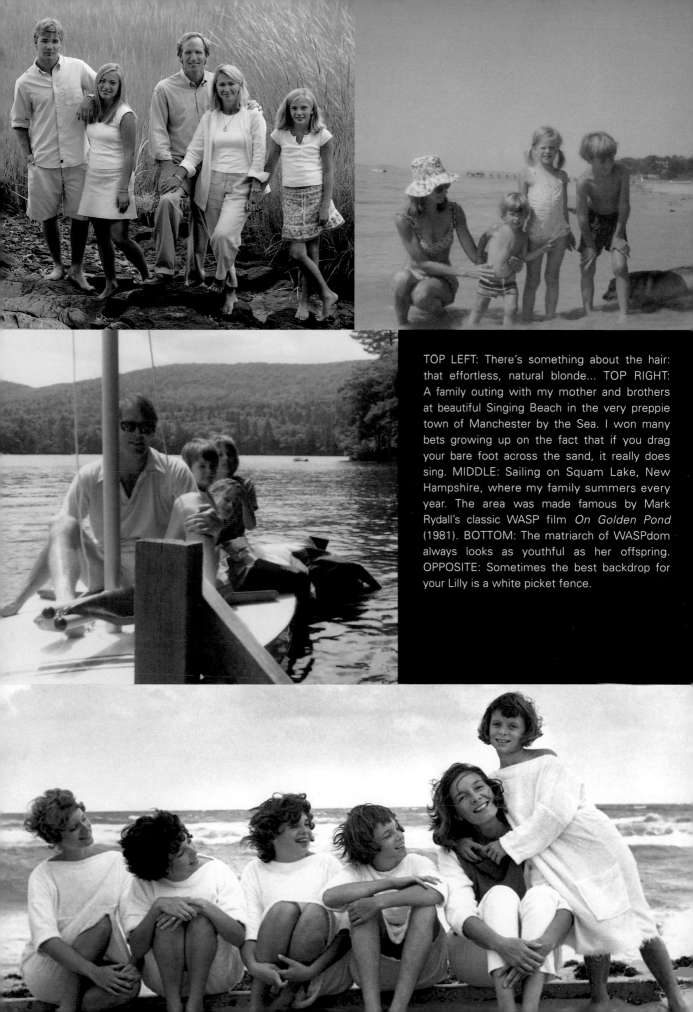

TOP LEFT: There's something about the hair: that effortless, natural blonde... TOP RIGHT: A family outing with my mother and brothers at beautiful Singing Beach in the very preppie town of Manchester by the Sea. I won many bets growing up on the fact that if you drag your bare foot across the sand, it really does sing. MIDDLE: Sailing on Squam Lake, New Hampshire, where my family summers every year. The area was made famous by Mark Rydall's classic WASP film *On Golden Pond* (1981). BOTTOM: The matriarch of WASPdom always looks as youthful as her offspring. OPPOSITE: Sometimes the best backdrop for your Lilly is a white picket fence.

"WHEN WE GET HOME WE'RE GOING TO HAVE CLAM CHOWDER FOR LUNCH!"
—ROBERT MCCLOWSKY, *ONE MORNING IN MAINE*

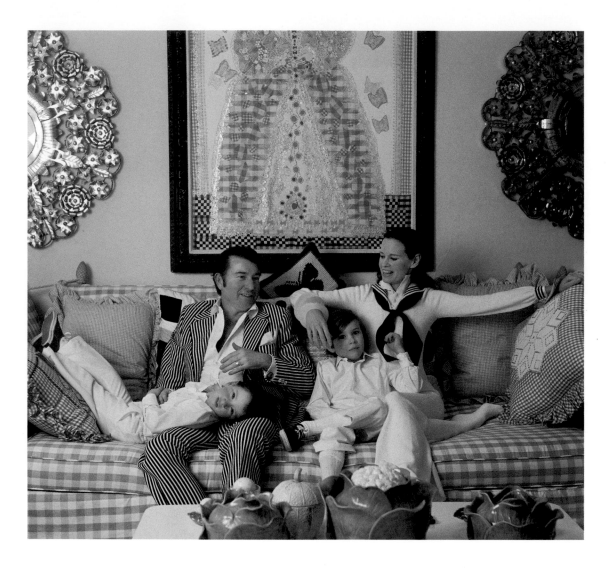

The Vanderbilt family, New York, 1970. While Gloria Vanderbilt went on to launch her own celebrated jeans line, her outfit here is by designer Adolfo.

OPPOSITE: Photographer Betty Kuhner's Palm Springs family portrait has Gothic undertones.

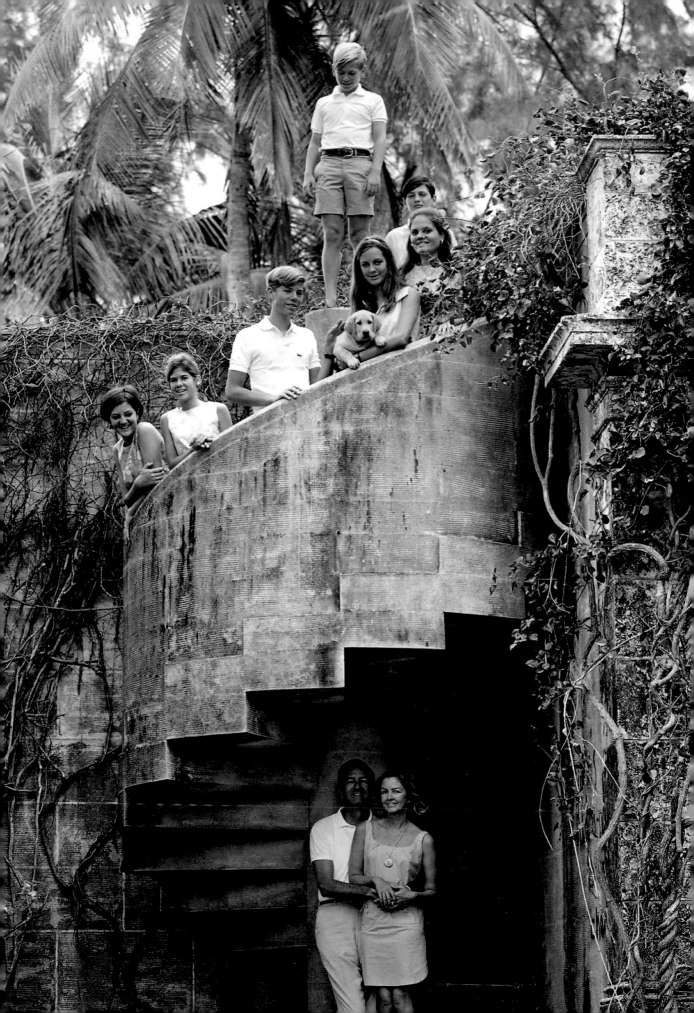

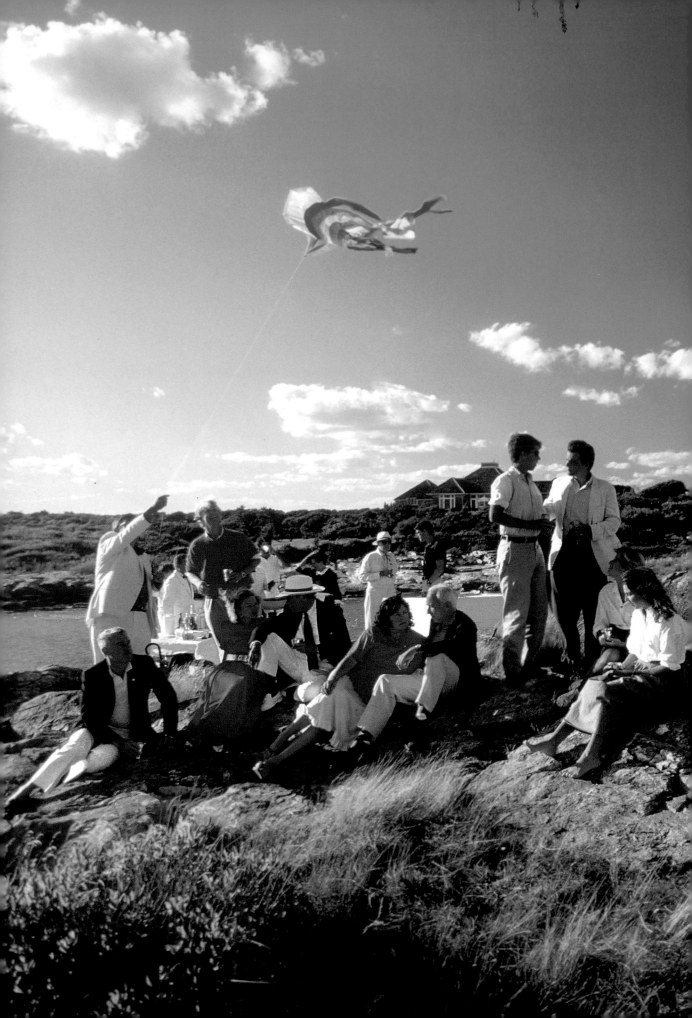

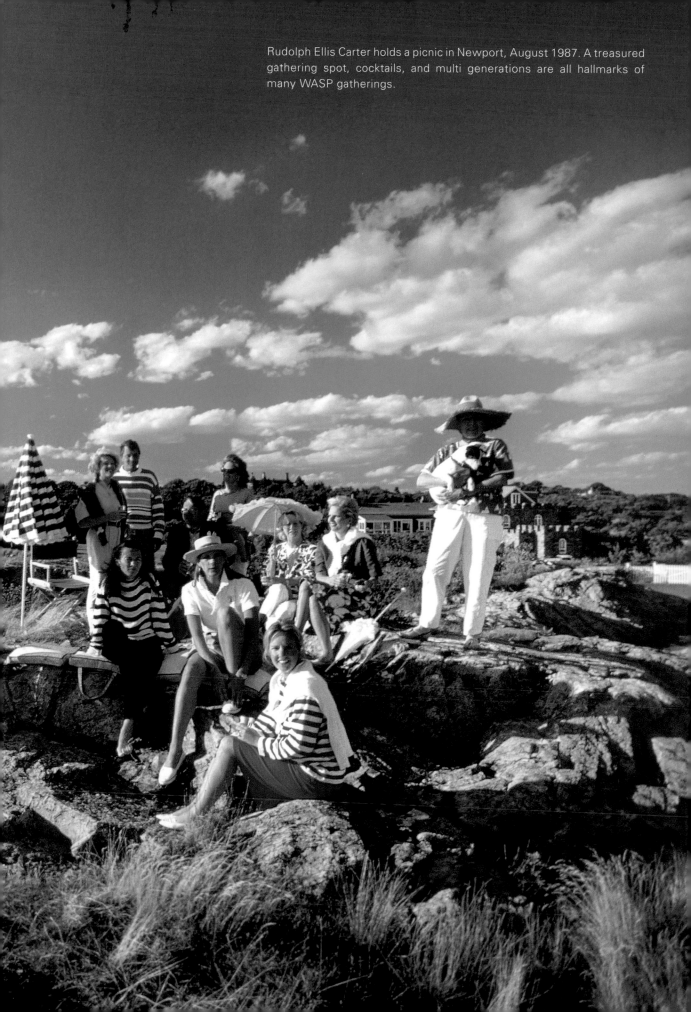

Rudolph Ellis Carter holds a picnic in Newport, August 1987. A treasured gathering spot, cocktails, and multi generations are all hallmarks of many WASP gatherings.

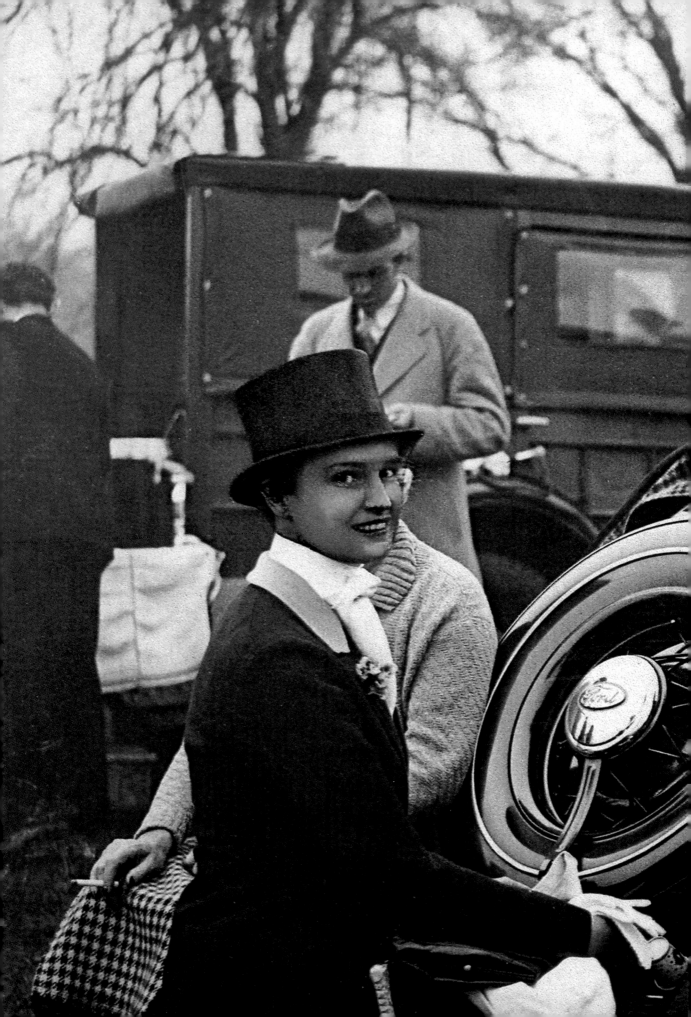

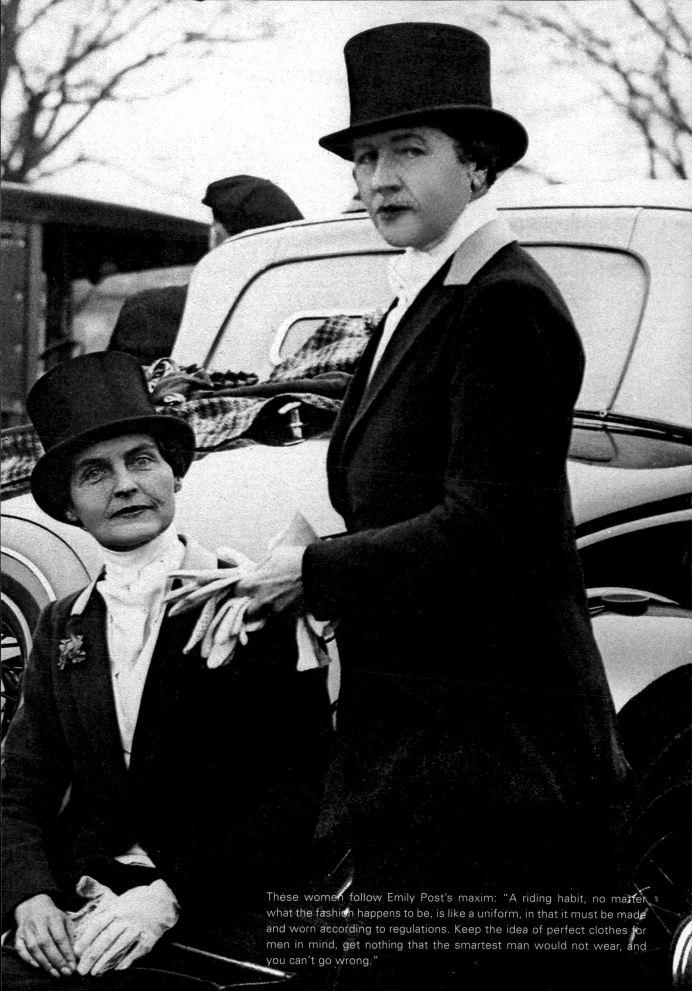

These women follow Emily Post's maxim: "A riding habit, no matter what the fashion happens to be, is like a uniform, in that it must be made and worn according to regulations. Keep the idea of perfect clothes for men in mind, get nothing that the smartest man would not wear, and you can't go wrong."

> "THE MOST IMPORTANT THING IS TO ENJOY
> YOURSELF AND HAVE A GOOD TIME."
> —C.Z. GUEST

Patsy Pulitzer shows how elegant blonde and cashmere can be, Palm Beach, ca. 1955.

OPPOSITE: WASP fashion is about letting the classics do their job well, again and again.

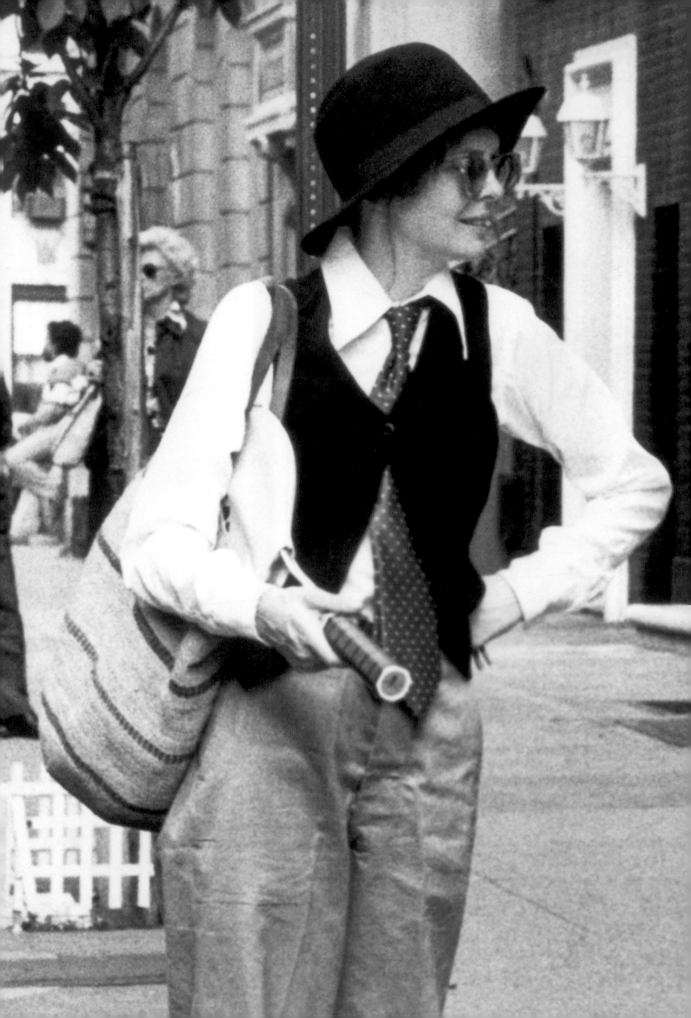

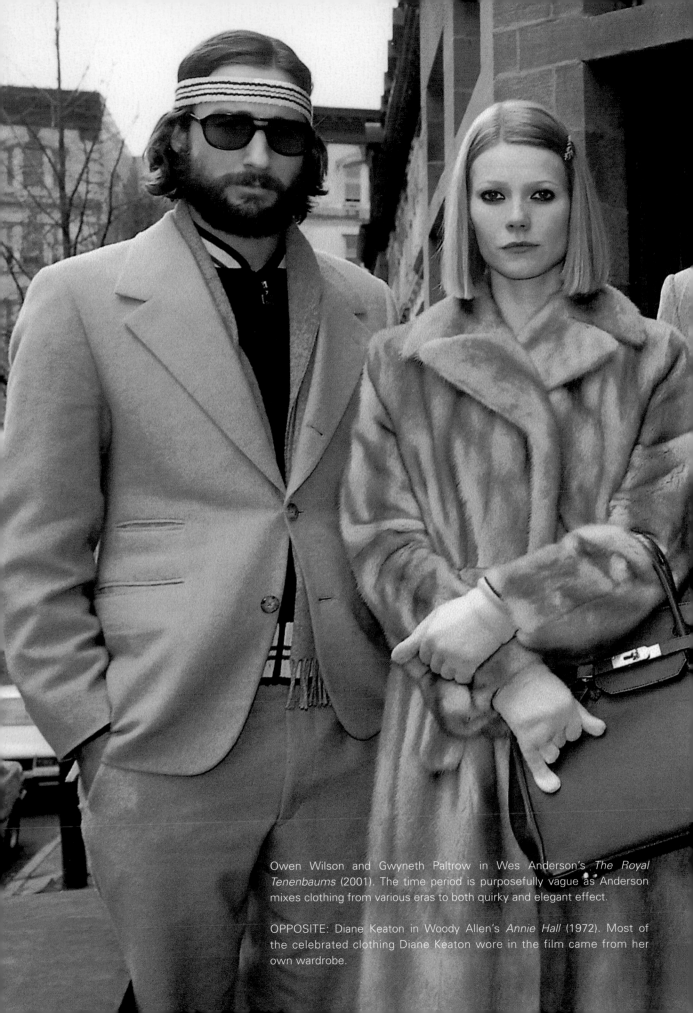

Owen Wilson and Gwyneth Paltrow in Wes Anderson's *The Royal Tenenbaums* (2001). The time period is purposefully vague as Anderson mixes clothing from various eras to both quirky and elegant effect.

OPPOSITE: Diane Keaton in Woody Allen's *Annie Hall* (1972). Most of the celebrated clothing Diane Keaton wore in the film came from her own wardrobe.

"THE ONLY REAL ELEGANCE IS IN THE MIND; IF YOU'VE GOT THAT, THE REST REALLY COMES FROM IT."
—DIANA VREELAND

My grandparents out on the town in Boston. I love the casual loop of Granny's pearl bracelet.

OPPOSITE: Actress Tea Leoni—seen here at Cannes—updates her grandmother's pearls with WASP panache.

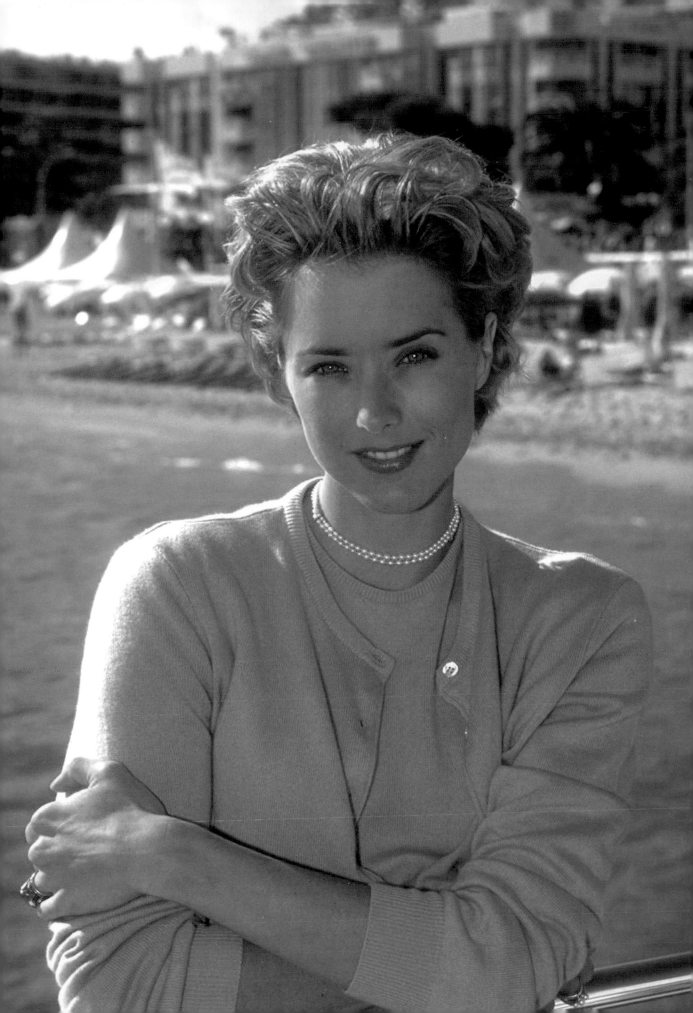

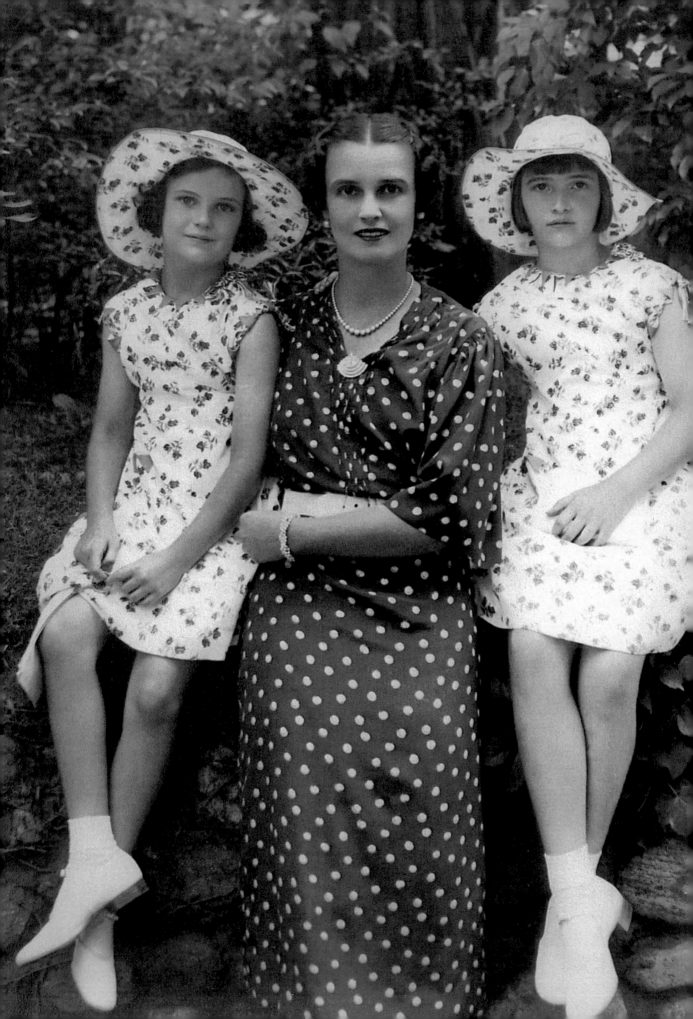

> "WHAT MAKES A BRILLIANT PARTY? CLOTHES. GOOD CLOTHES."
> —EMILY POST

A true WASP party often means dressing finer that the fabrics you lounge upon.

OPPOSITE: My cousin Peggy Thayer Talbott and her two daughters Polly and Peggy show how to match their dresses in style.

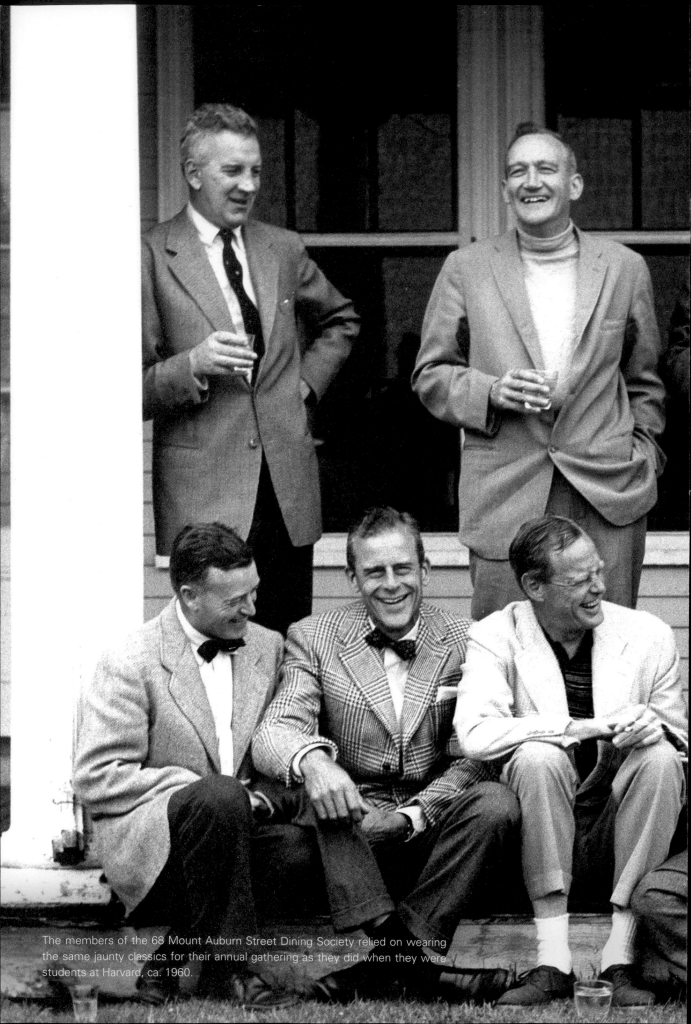

The members of the 68 Mount Auburn Street Dining Society relied on wearing the same jaunty classics for their annual gathering as they did when they were students at Harvard, ca. 1960.

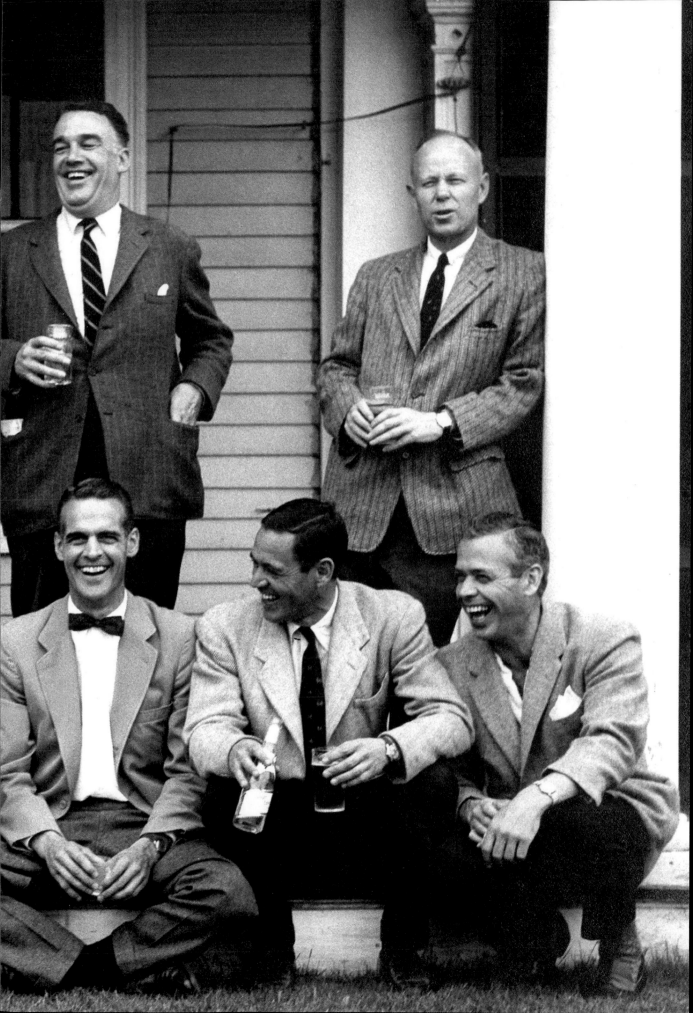

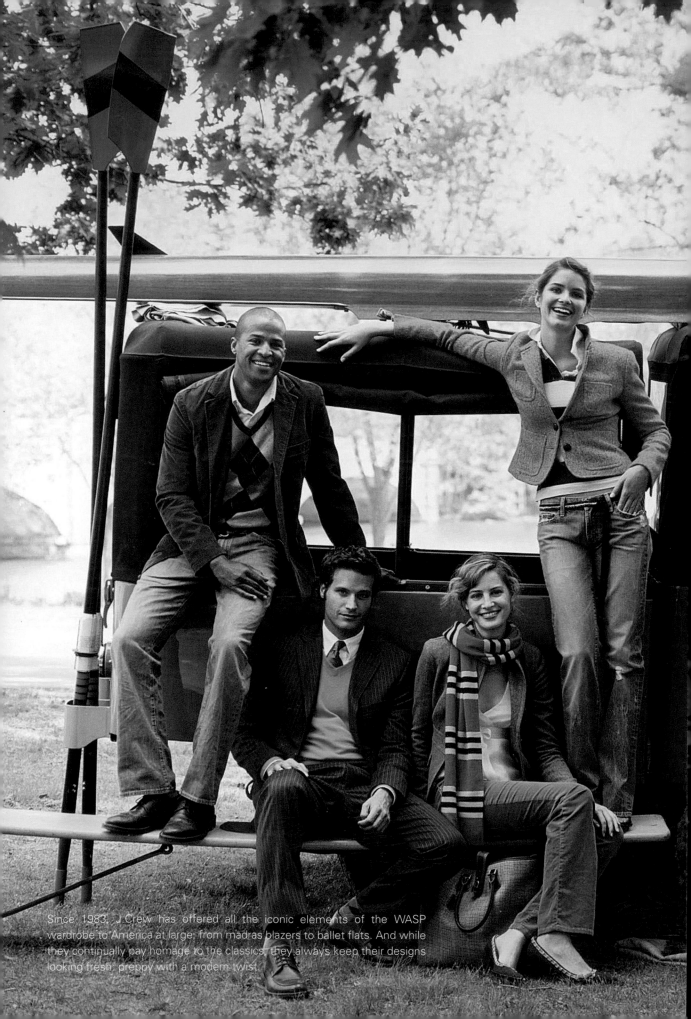

Since 1983, J.Crew has offered all the iconic elements of the WASP wardrobe to America at large: from madras blazers to ballet flats. And while they continually pay homage to the classics, they always keep their designs looking fresh: preppy with a modern twist.

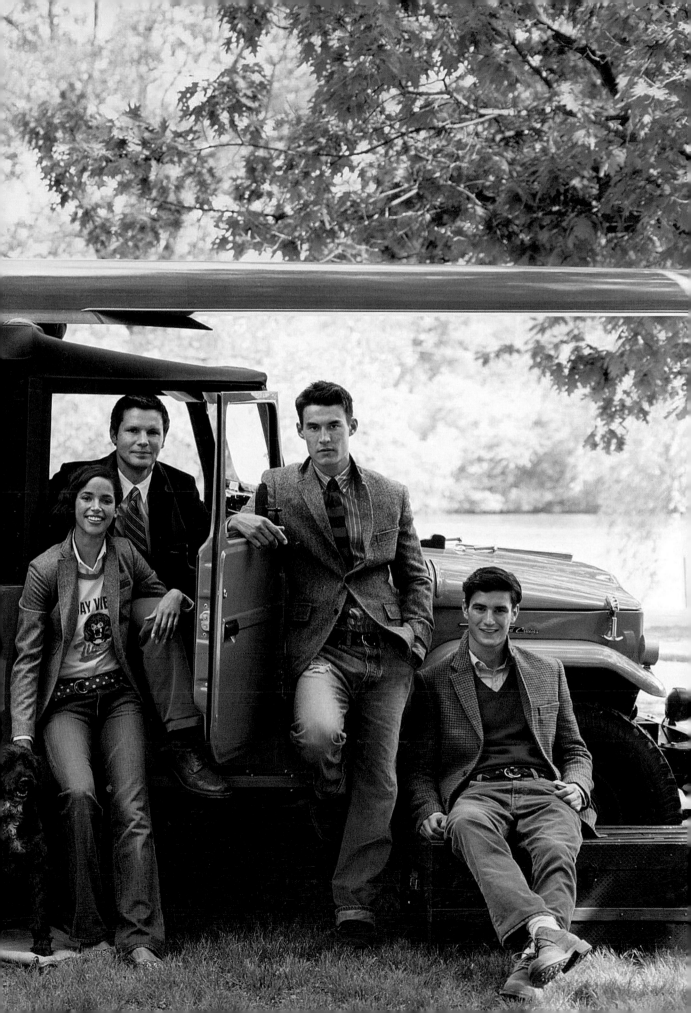

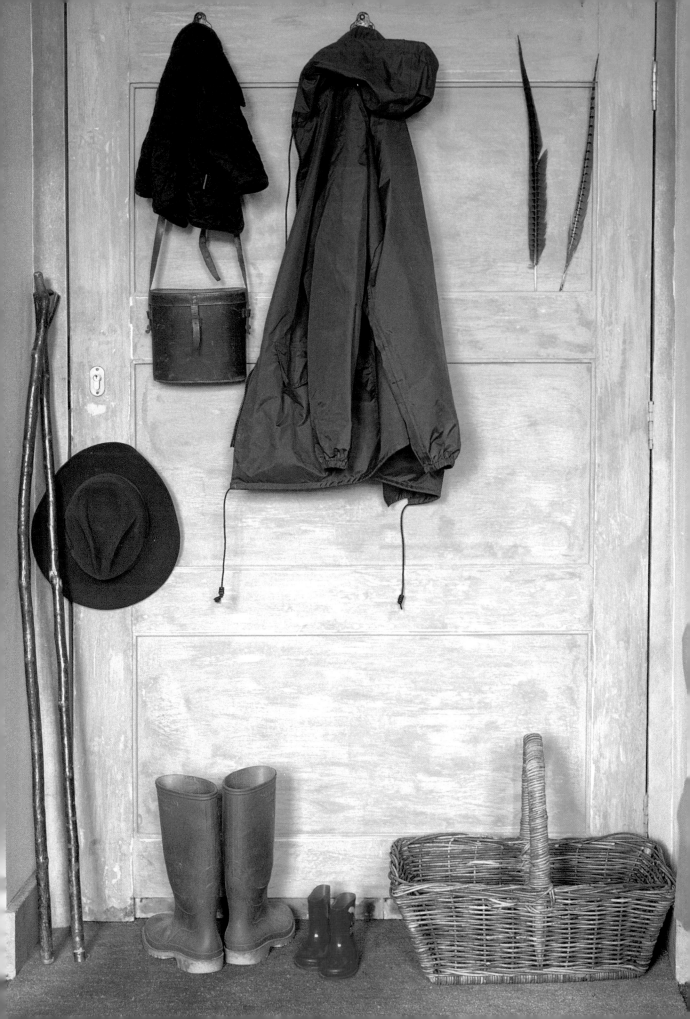

HOMES

A true WASP home has all the fading glamour of an aging movie star. It's usually on a spectacular piece of property (passed down from ancestors), but the house is as practical and classic as a beloved pair of khakis. Whether in Greenwich, Kennebunkport, or Beacon Hill, WASP style translates into timeless rooms that are done right the first time and are then meant to endure that way—untouched—for generations of children, paw prints, and cocktail parties. Style takes its cues from comfort but is never upstaged by it. In fact, it is the very marriage of quality and practicality that is so distinctive in the WASP home. Every item in every room means something. WASPs never decorate just to fill a space. There is a stubborn dignity to their choices, a practical zest for living life as it should be lived.

In her rambling brick house in Old Westbury, New York, the WASP doyenne C.Z. Guest displayed her exotic orchids in plastic pots. And in legendary WASP decorator Sister Parish's home, her friend Patsy Preston remembers that "she made the room feel ageless. It was old-fashioned and warm but also modern . . . there was nothing stiff about it." Poet Rose Styron describes George Plimpton's East River living room, saying, "In all the years of going to their fabulous parties, its simple style never changed no matter who was visiting—royalty or rock star. We were always squashed on endless couches, and hors d'oeuvres were set on the nearby pool table."

In a WASP home, there are no flashy brands or electronics. A comfortable sofa, a good bar, a view of the ocean, a freshly plowed field, or the East River will do just fine. And while a WASP home inspires generations to live within its quarters, little time is spent admiring, tinkering, or maintaining the domain; there are too many walks to be taken, sports to be played, and good books to read. (After all, why go out and buy a new radio when it's so much easier to wrap tinfoil around the antenna?)

The mud room in a WASP house echoes the love for the outdoors, no matter the season.

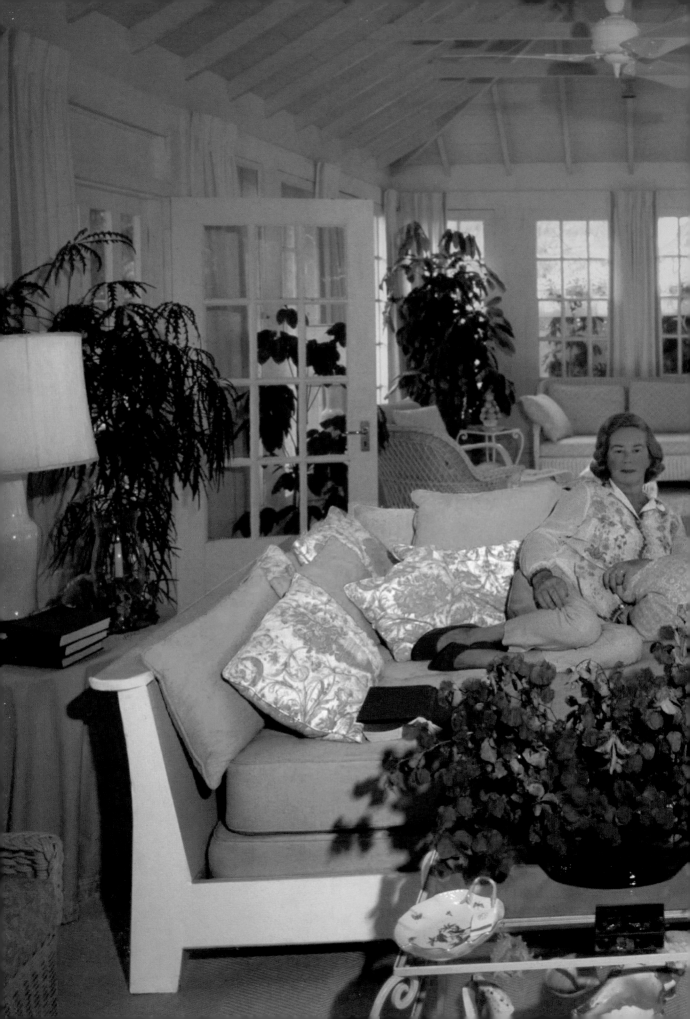

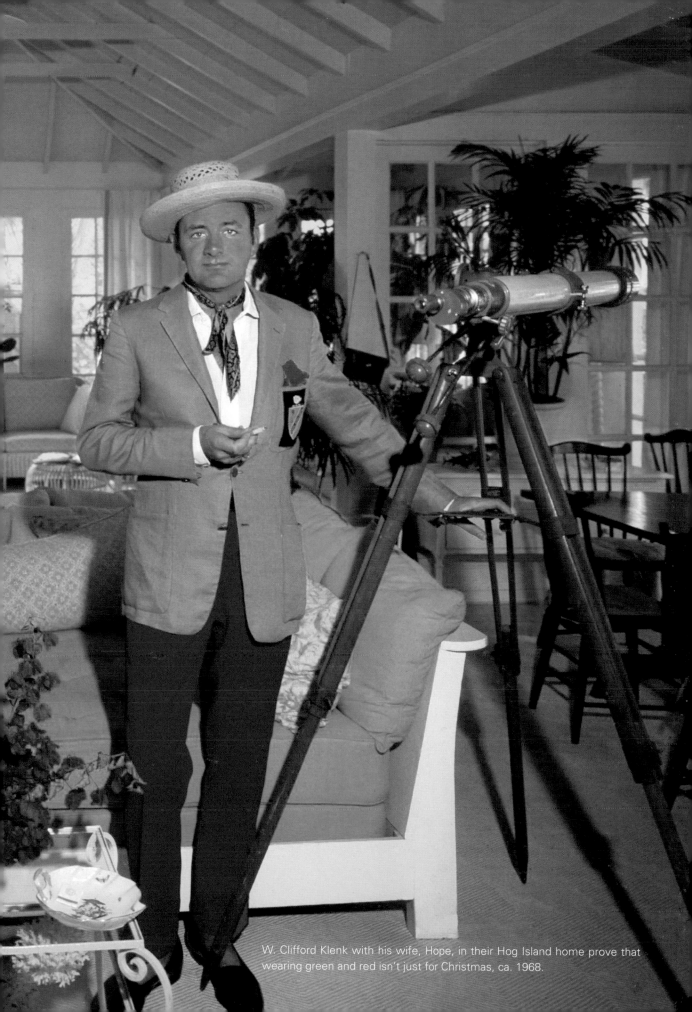

W. Clifford Klenk with his wife, Hope, in their Hog Island home prove that wearing green and red isn't just for Christmas, ca. 1968.

Inside and out there are as many hallmarks as there are hallways. From the luxurious crunch of the beige gravel as you pull up the driveway, to the yapping of dogs underfoot as you cross the threshold, elegant chaos is more at home here than order. For some, a WASP home is rarely decorated but rather it contains the elements necessary for its inhabitants to live in the manner they wish. The living room is filled with furniture one is supposed to sit on. Beds squeak, carpets are both grand and mildewy. The kitchen is a place for preparation, not passion, while the garden seems to contain all the unexpressed sentiment that often is not verbalized within the house.

My own childhood home was the same one in which my mother grew up in. When my grandparents moved closer to the ocean, it was bequeathed to my newlywed parents who went on to raise three children there and where they still summer to this day. It is comfortably large and sits high on a hill with a view of the sea beyond thickets of pine trees. There is a grand simplicity to its location, design, and decoration. Most apt is our swimming pool. Before it became home to my father's rigorous laps, it was the foundation of an old house. Each June we'd fill it with cold well water and keep it going until pungent autumn crab apples dropped and bobbed on its surface. There were never any filters or heaters and there were no chairs to lounge upon despite the naturally beautiful setting. My parents eventually spent many years renovating the house room by room to make it reflect their own styles, filling it with artwork from their travels. But when it came time to modernize the pool, filters were added but no heat. Or chairs.

Some WASP homes of my childhood friends remain untouched, and whenever I enter them, I feel indulged from the moment I sit on the faded chintz love seat. In George Howe Colt's *The Big House*—an elegant ode to his beloved childhood summer house on Cape Cod—he writes that, if preserved in a museum, the WASP room of his youth would display "a familiar iron bedstead with flaking white paint, sagging springs, and a horsehair mattress; a small pine dresser, painted green, with sticky drawers; a folding suitcase stand; a wrought-iron floor lamp, its shade stippled with burns; a worn set of Thomas Hardy on a swaybacked shelf; a lamp made from an Almaden wine bottle, filled with sea glass, on a rickety bedside table; a handful of jingle shells on the sill." There is an intense familiarity in the WASP home. Even if you've never been here, it does not rebuff you, but rather ushers you in. You hear its walls speak familiar conversation and you smell and sense the presence of those who have been before you; the home becomes part of your cherished memory even before the moment of leaving its doors has past.

At home with the WASP man's best friends: a good dog, a good book, and good tweed.

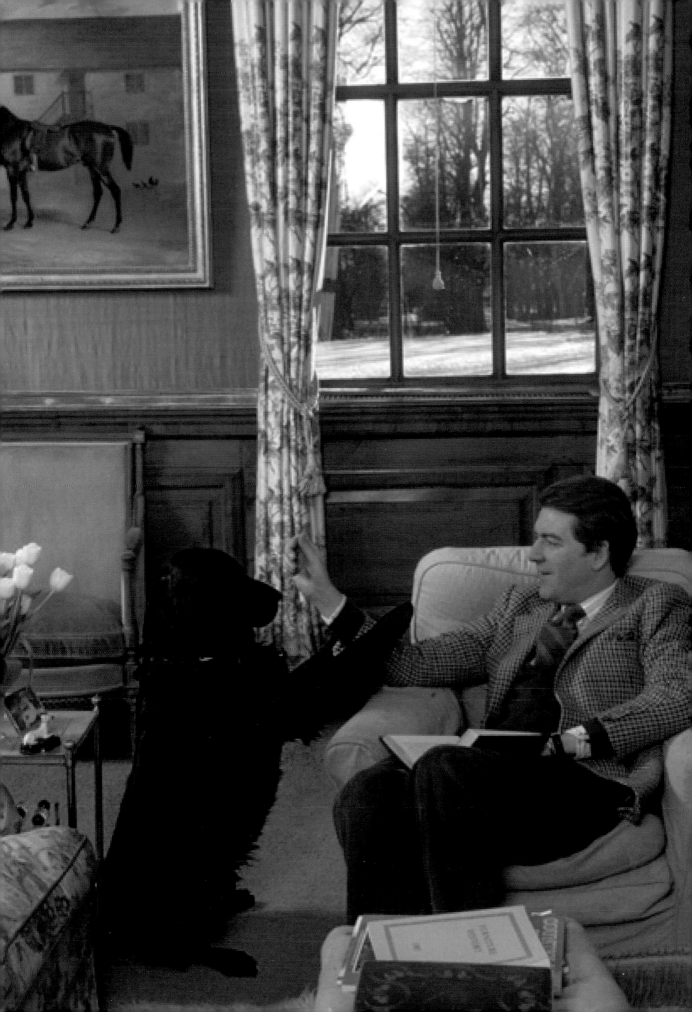

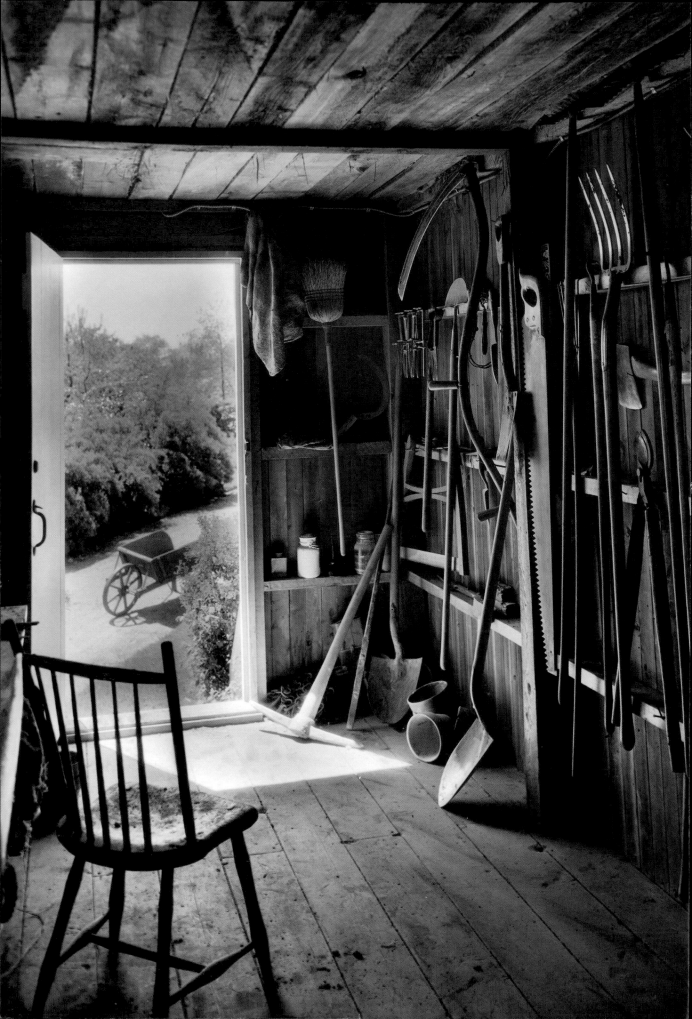

"In the living room, the grown ups stirred drinks at the red-leather bar stand; then they sat down . . . three walls were covered with books, and over the mantelpiece was a portrait of Dr. Vincent, so dark and shiny the lights reflected off it."
—Susan Minot, *Thanksgiving Day*

There's very little need to go inside a church to have a spiritual experience during fall in Connecticut.

OPPOSITE: The kitchen isn't always the heart of a WASP home; more often, it's the garden shed.

"I DON'T KNOW HOW WE'RE GOING TO EXPLAIN TO OUR FRIENDS THAT WE
SPENT SEVERAL YEARS WITH PEOPLE WHO AREN'T IN THE SOCIAL REGISTER."
—LOVEY HOWELL, *GILLIGAN'S ISLAND*

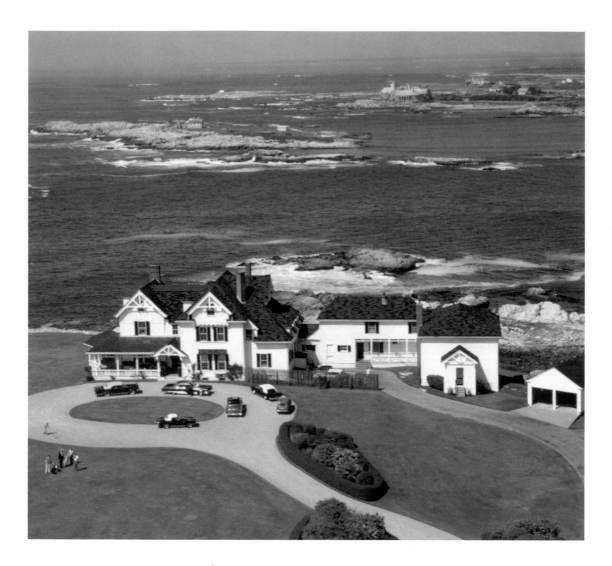

The Ledges, the Newport summer retreat built by Robert Maynard
Cushing, is a classic example of how the WASP home can be both grand
and intimate.

OPPOSITE: India Hicks and her family at their home on Harbour Island,
Bahamas. No matter how exotic the locale, white and khaki are always the
compass that point towards WASP style.

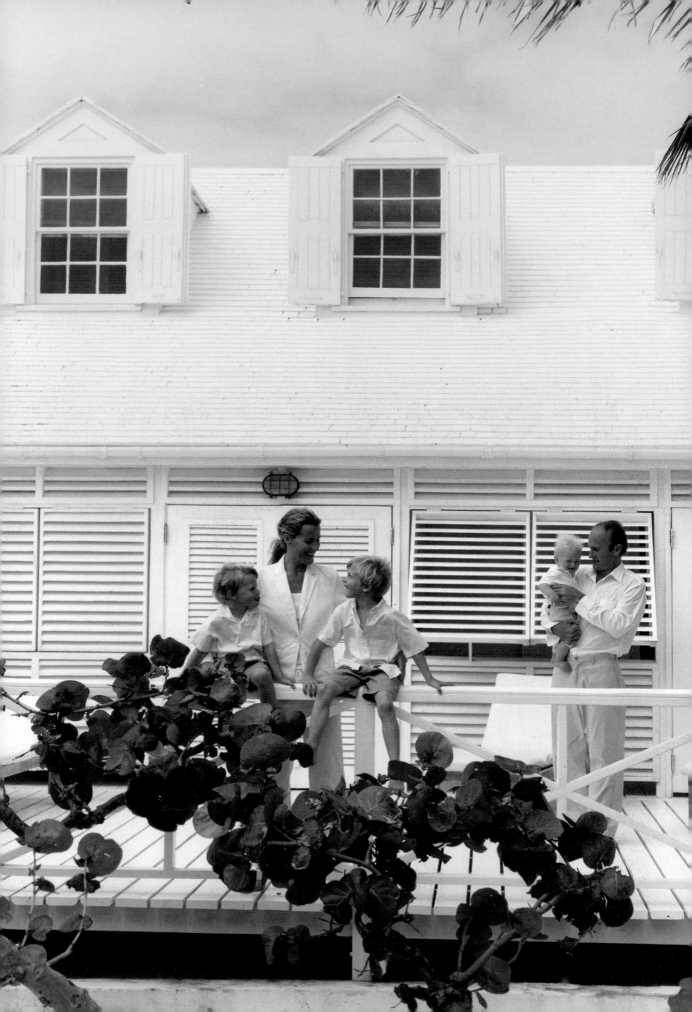

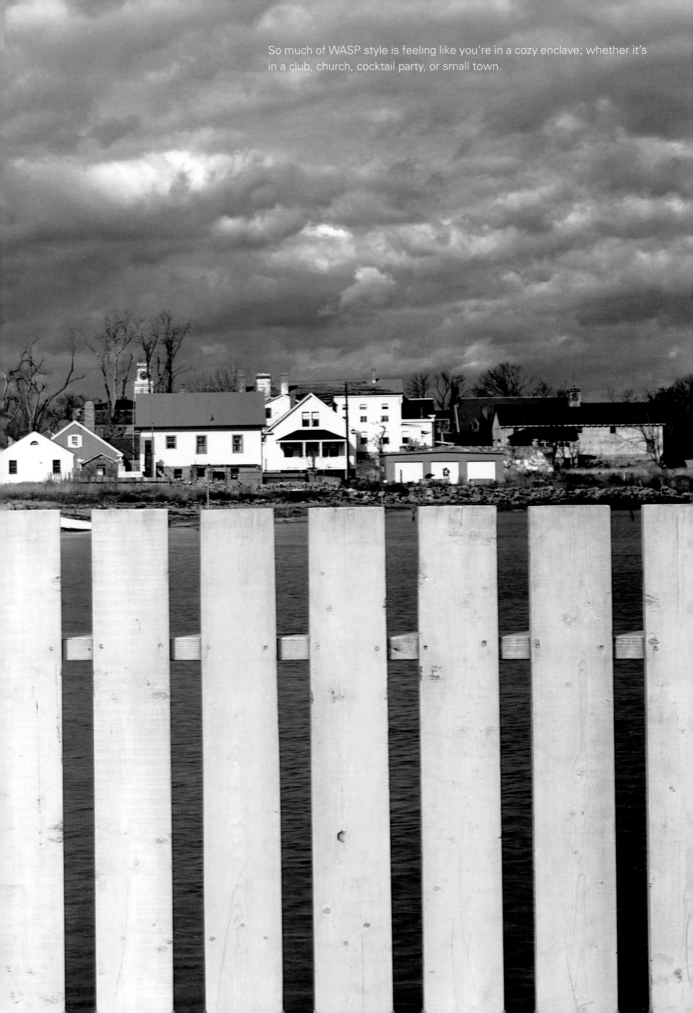

So much of WASP style is feeling like you're in a cozy enclave; whether it's in a club, church, cocktail party, or small town.

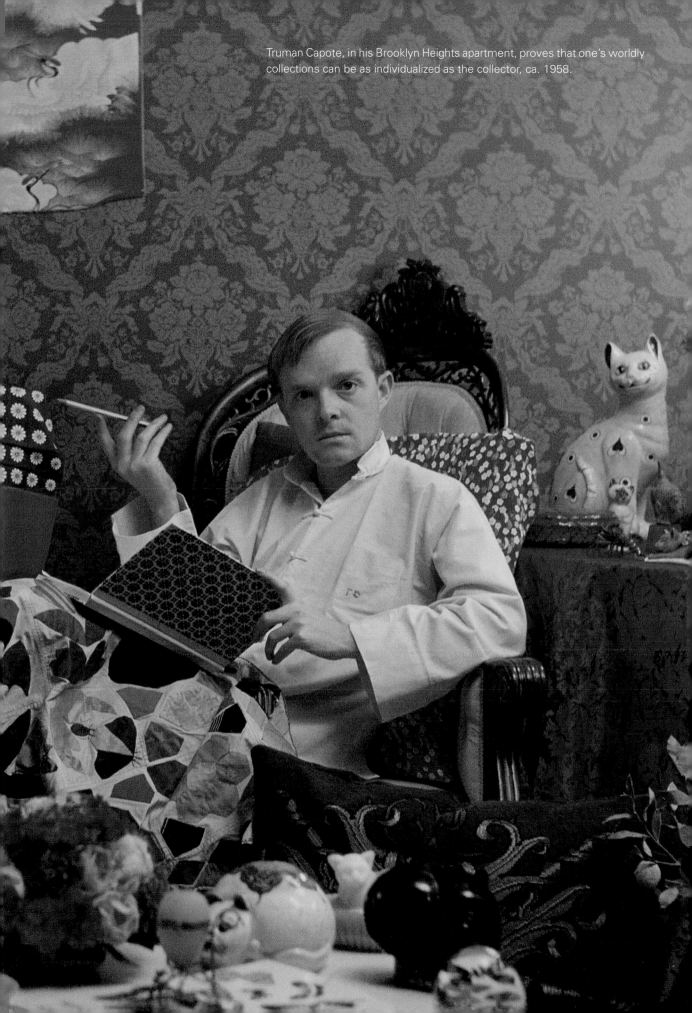

Truman Capote, in his Brooklyn Heights apartment, proves that one's worldly collections can be as individualized as the collector, ca. 1958.

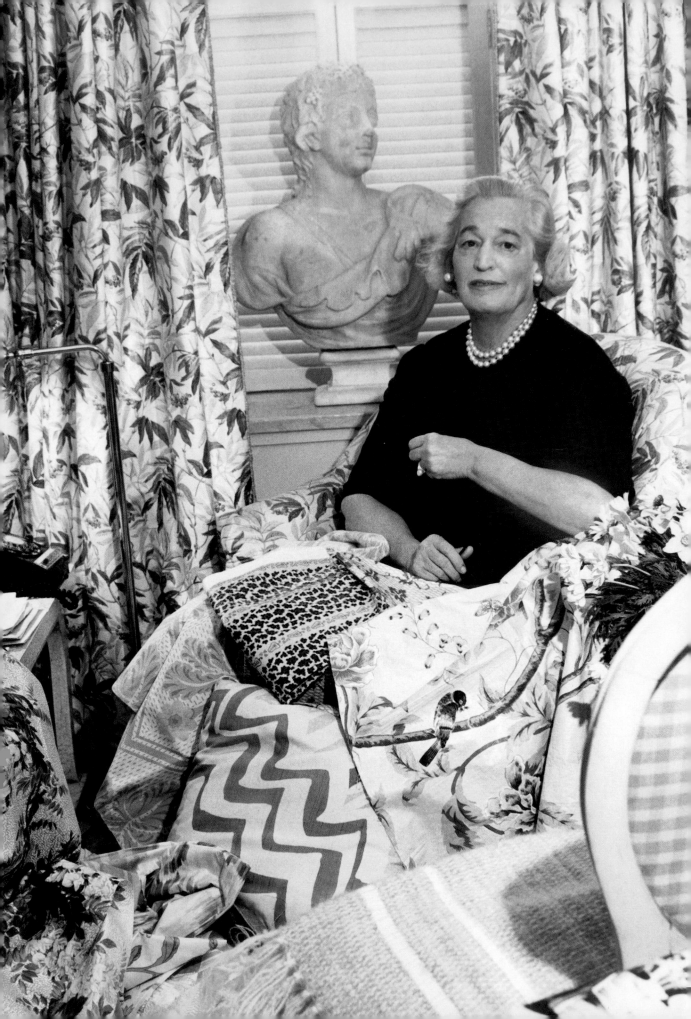

"EVEN THE SIMPLEST WICKER BASKET CAN BECOME PRICELESS WHEN IT IS LOVED AND CARED FOR THROUGH THE GENERATIONS OF A FAMILY."
—SISTER PARISH

The butter yellow of the walls, the simple floral fabrics, and stunning view are all hallmarks of a WASP room.

OPPOSITE: Sister Parish co-founded Parish-Hadley Associates, the interior design firm where she was renowned for her homey, cluttered traditionalism.

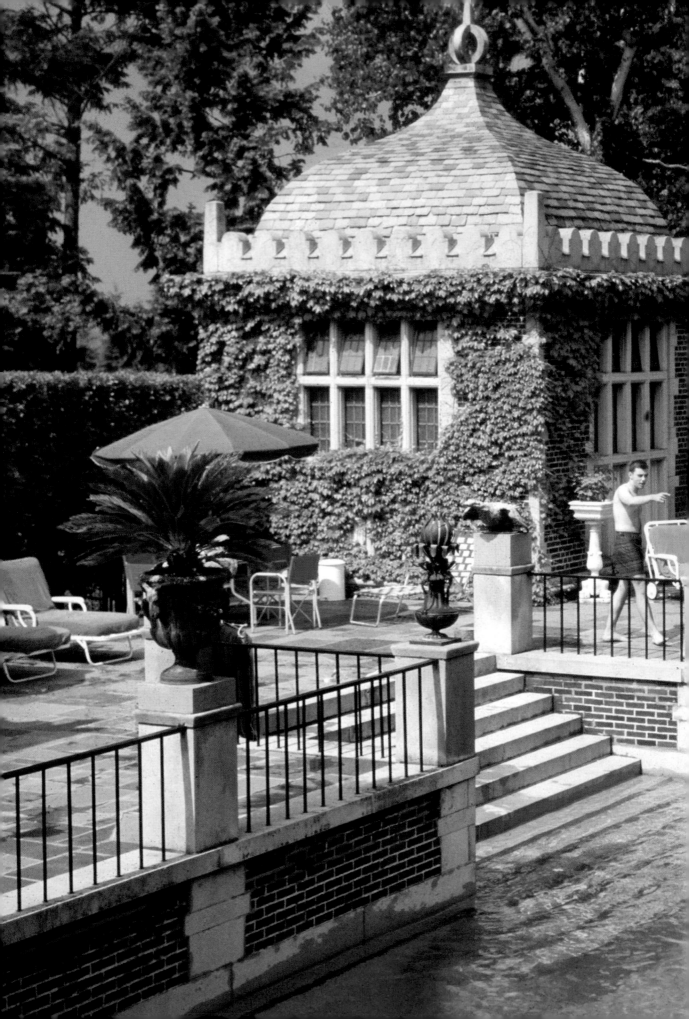

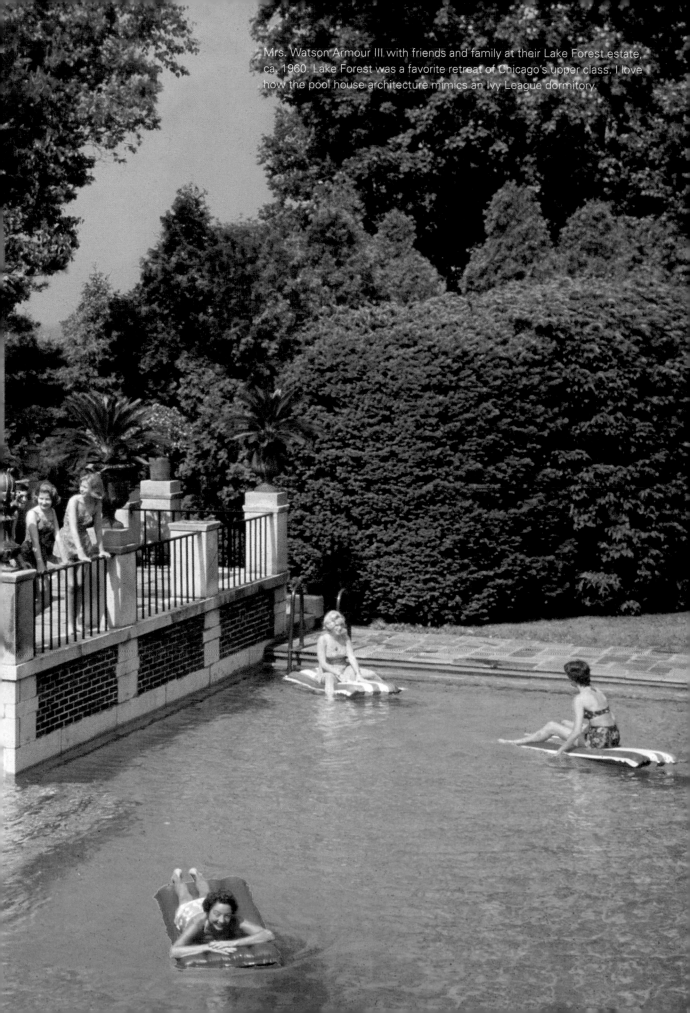

Mrs. Watson Armour III with friends and family at their Lake Forest estate, ca. 1960. Lake Forest was a favorite retreat of Chicago's upper class. I love how the pool house architecture mimics an Ivy League dormitory.

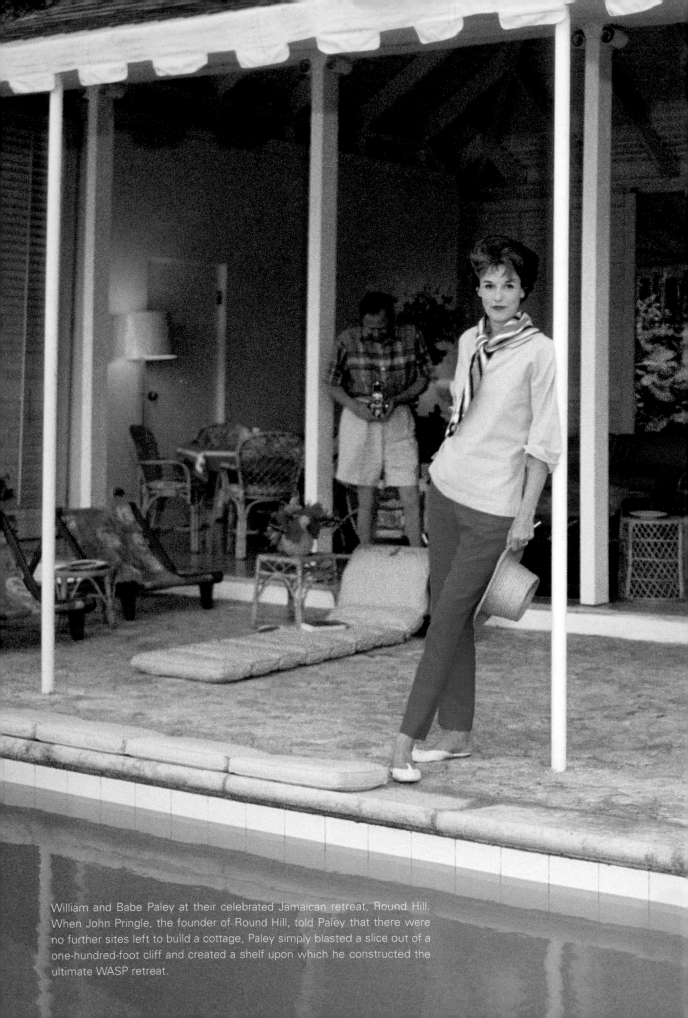

William and Babe Paley at their celebrated Jamaican retreat, Round Hill. When John Pringle, the founder of Round Hill, told Paley that there were no further sites left to build a cottage, Paley simply blasted a slice out of a one-hundred-foot cliff and created a shelf upon which he constructed the ultimate WASP retreat.

"... THE LOOK IS ENGLISH-AMERICAN, WITH A DASH OF SEASIDE RESORT
AND WOMEN'S HANDICRAFT. IT IS WHERE THE CHIPPENDALE SECRETARY
MEETS WITH NEEDLEPOINT-COVERED BRICK DOORSTOP, AND THE
LOBSTER-TRAP COFFEE TABLE MEETS THE PRIZED KERMAN RUG."
—LISA BIRNBACH, *THE OFFICIAL PREPPY HANDBOOK*

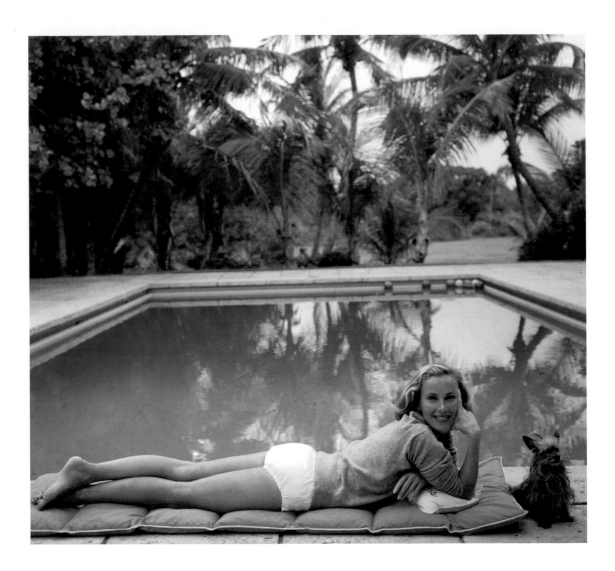

Socialite Alice Topping poolside in Palm Beach proves that some WASPs do
indulge in the art of the recline, ca. 1959.

OPPOSITE: The WASP home is more often than not decorated with a reflection
of a lifestyle than a design style.

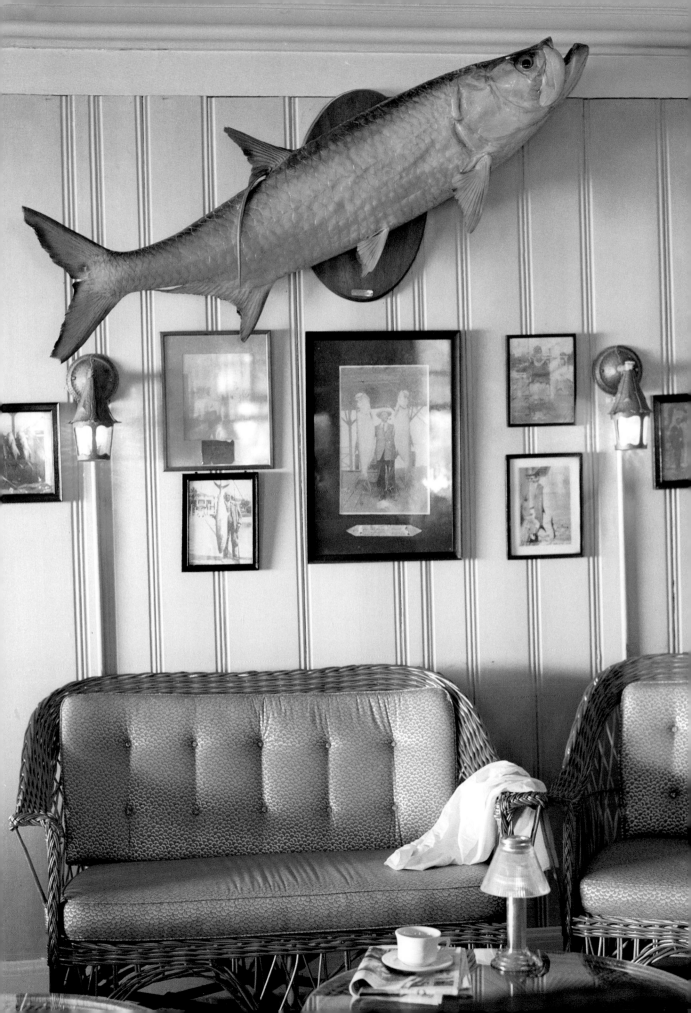

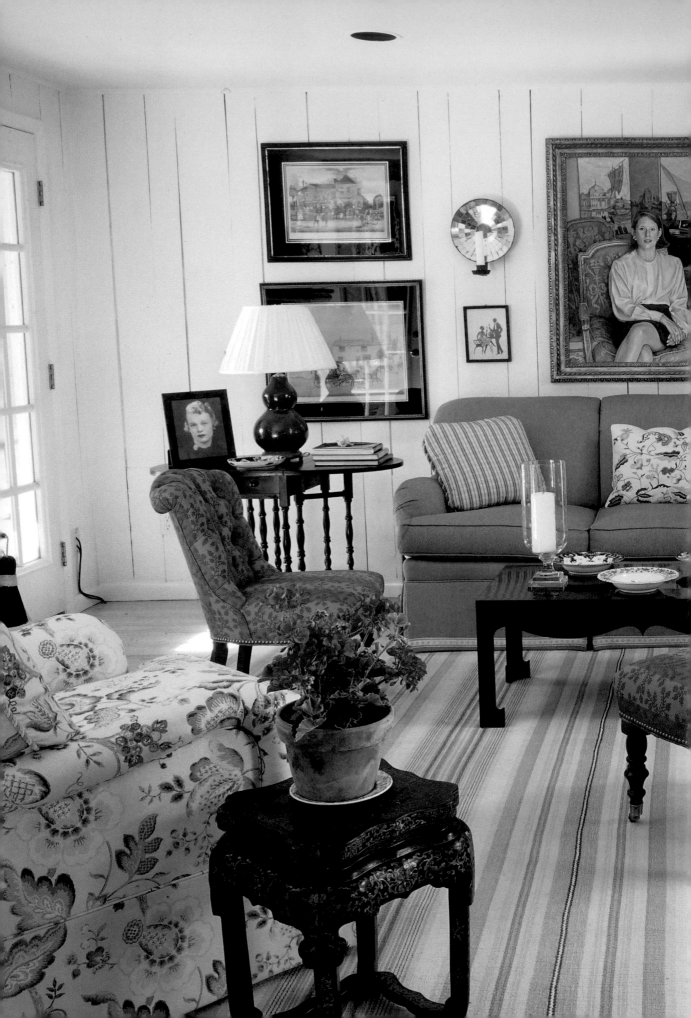

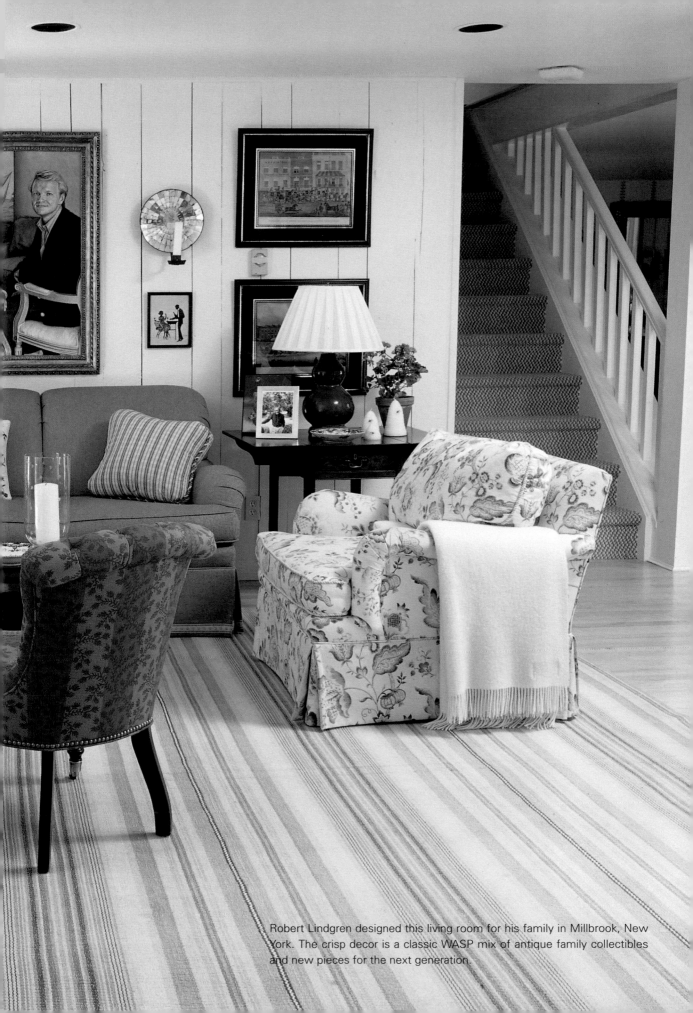

Robert Lindgren designed this living room for his family in Millbrook, New York. The crisp decor is a classic WASP mix of antique family collectibles and new pieces for the next generation.

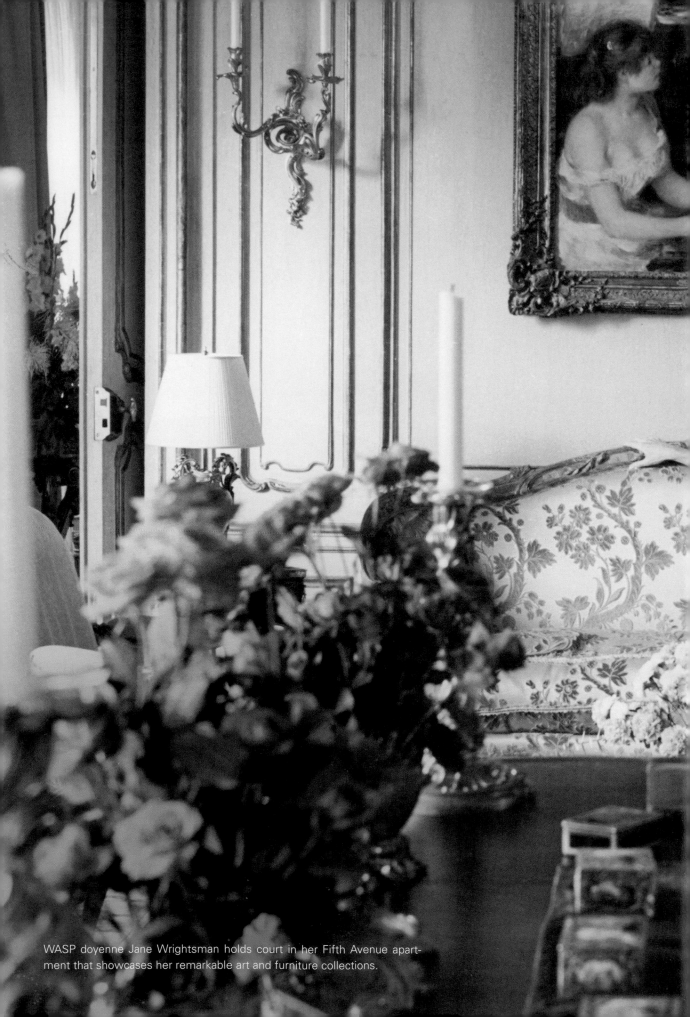

WASP doyenne Jane Wrightsman holds court in her Fifth Avenue apartment that showcases her remarkable art and furniture collections.

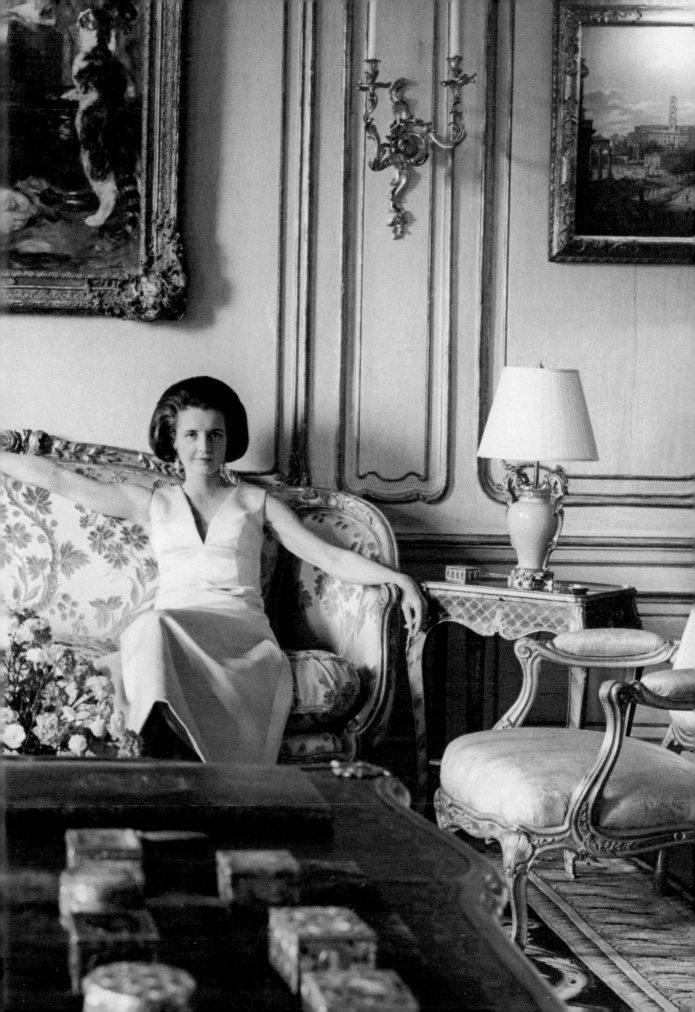

"WITHOUT EVEN GOING INSIDE, I SOMEHOW KNEW I WAS HOME."
—BUNNY WILLIAMS, *AN AFFAIR WITH A HOUSE*

A true WASP house lets its pedigree of time and place welcome its visitors first.

OPPOSITE: The importance of nature and family are hallmarks of WASP decor.

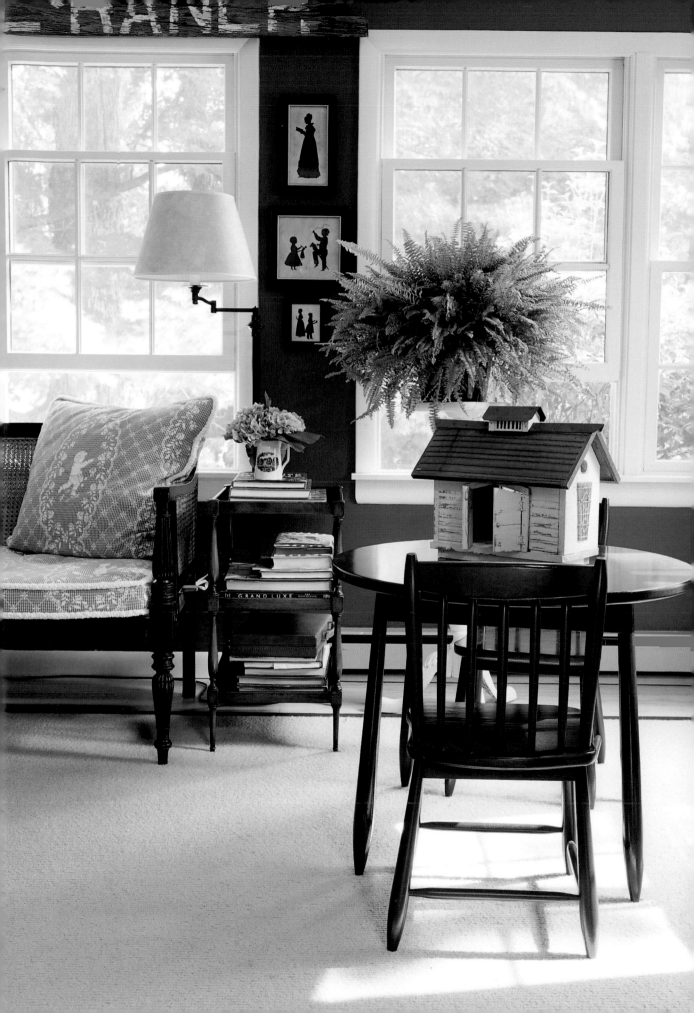

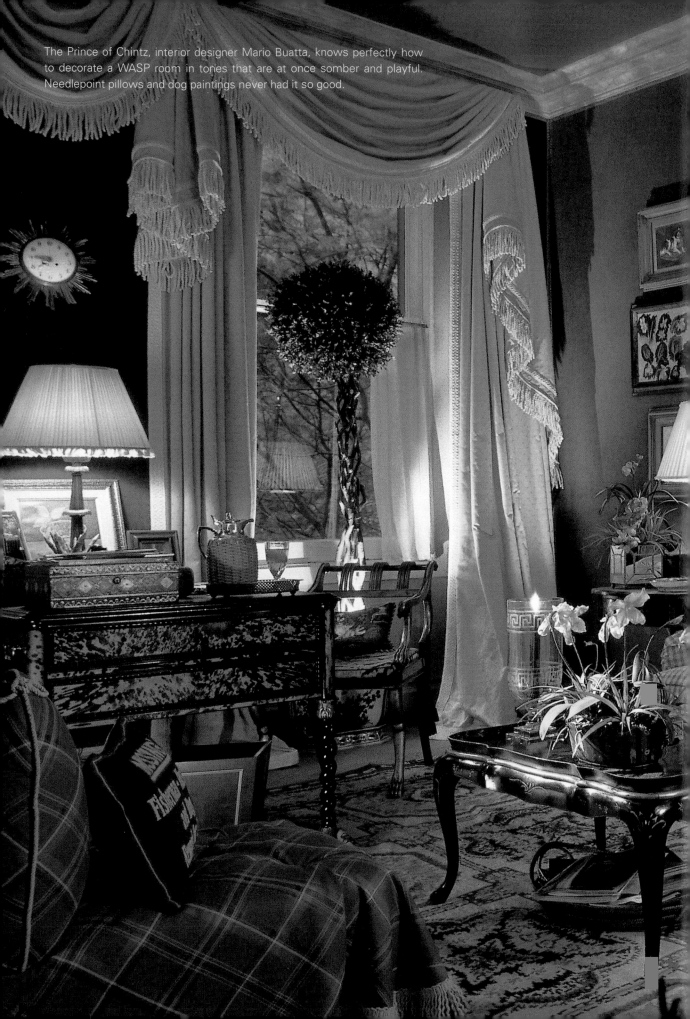

The Prince of Chintz, interior designer Mario Buatta, knows perfectly how to decorate a WASP room in tones that are at once somber and playful. Needlepoint pillows and dog paintings never had it so good.

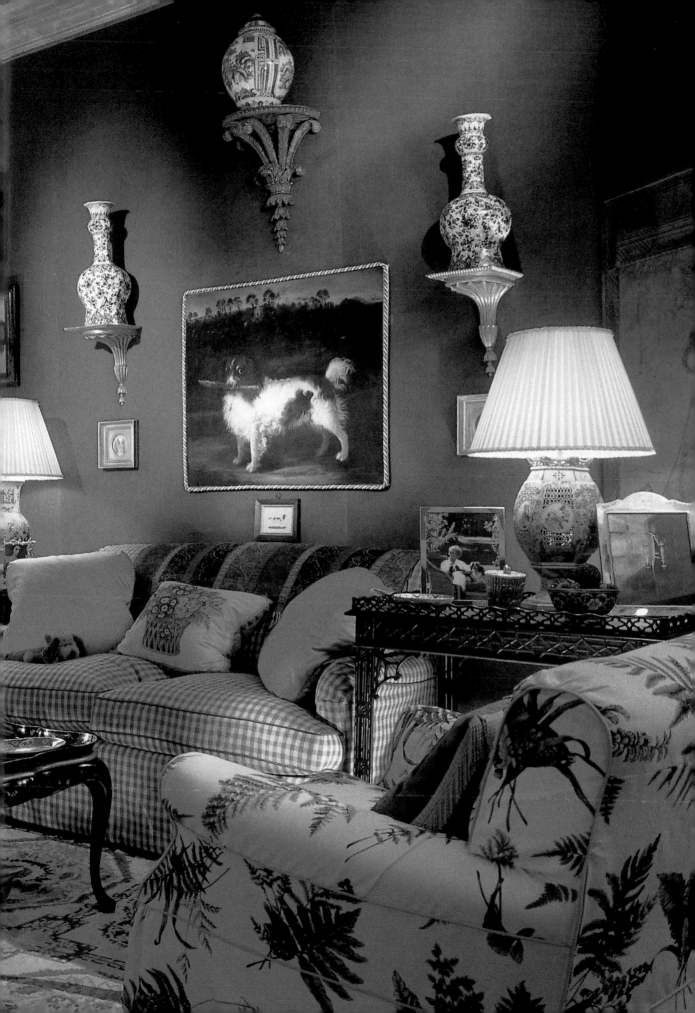

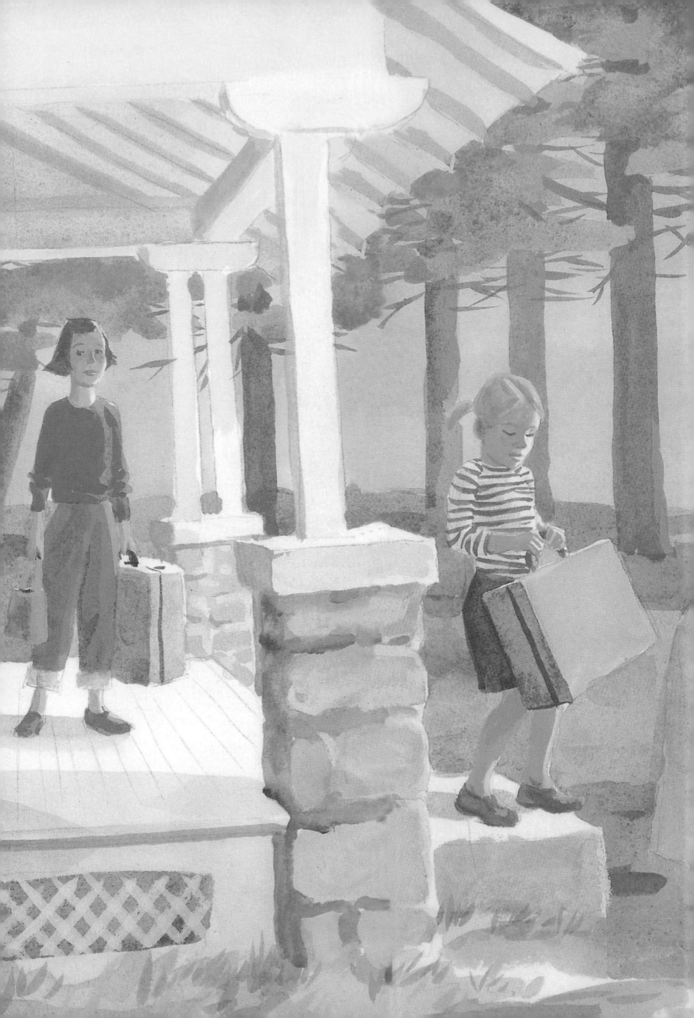

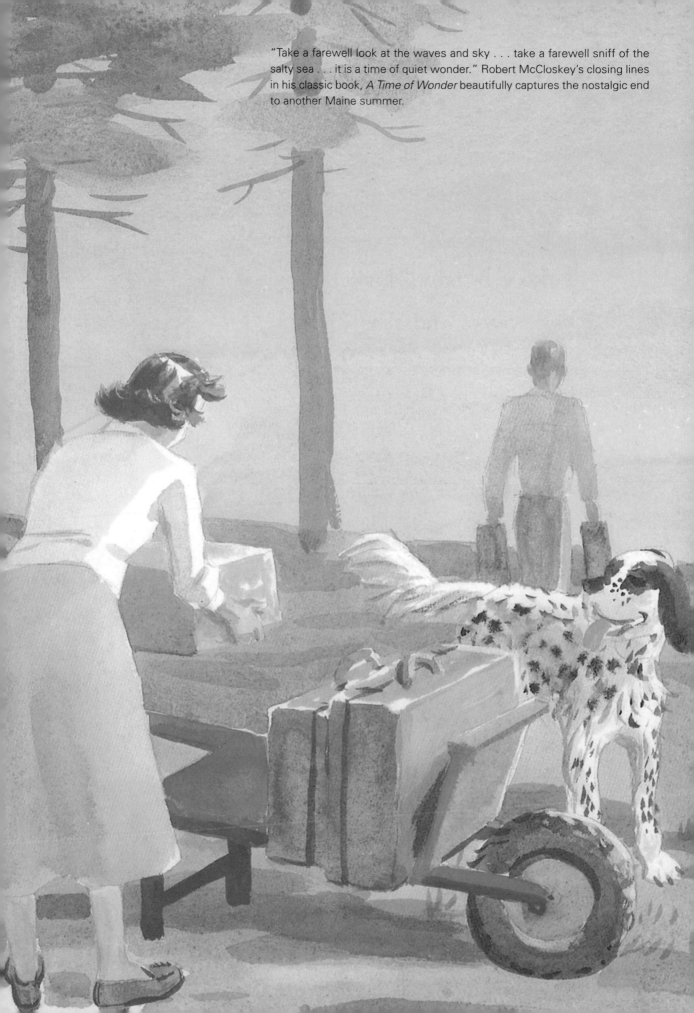

"Take a farewell look at the waves and sky . . . take a farewell sniff of the salty sea . . . it is a time of quiet wonder." Robert McCloskey's closing lines in his classic book, *A Time of Wonder* beautifully captures the nostalgic end to another Maine summer.

ACKNOWLEDGMENTS

Profuse thanks to Michael and Ian Baldwin, Jr., and all the Baldwins who graciously allowed me to reprint their photographs from Ian Baldwin's book, *Memoirs 1992—2001*. J. Crew has been an invaluable source of inspiration and support. Much appreciation also to Philip Reeser for helping me make the Assouline connection and for my editor there, the amazing Signe Bergstrom, and to dear Steven Stolman for being such a mensch.

CREDITS

Cover: Getty Images; p. 4–5: courtesy Baldwin; p. 6: © J. Crew; p. 8: courtesy Steven Stolman, pattern courtesy Thibault Design; p. 10; photo © Jean Pierre, used with permission from the Social Register Association; p. 12: author archive; p. 14: author archive; p. 16–17: courtesy Carey Rodd; p. 18–19: author archive; p. 20: © Bettmann/CORBIS; p. 22–23: © Bettmann/CORBIS; p. 24: courtesy Photofest; p. 25: © Condé Nast Archive/Corbis; p. 26–27: © Bettmann/CORBIS; p. 28: © Getty Images; p. 29: André Leon Talley/ *House & Garden* © 1988 Condé Nast Publications, Inc., quote © Lisa Birnbach; p. 30–31: courtesy Photofest; p. 32: © Condé Nast Archive/CORBIS; p. 33: © Norman Parkinson Limited/CORBIS; p. 34: © Hachette Photos; p. 35: © CORBIS Sygma; p. 36: © CORBIS; p. 37: © Art + Commerce; p. 38–39: © Getty Images. quote © George Howe Colt; p. 40-41 © Tim Graham/Getty Images; p. 42: © Rue des Archives/BCA; p. 43: top left: © Bettmann/CORBIS, top right: © Neville Elder/Corbis, middle: © Rick Friedman/Corbis, bottom left: © Jeffery Allan Salter/Corbis, bottom right: © Bettmann/CORBIS; p. 44–45: © Getty Images; p. 46: courtesy CR; p. 48–49: © Getty Images; p. 50: © Gilles Bensimon; p. 51: © Corbis; p. 52–53: courtesy Photofest; p. 54: © Keystone; p. 55: courtesy Susan Crater; p. 56–57: © Getty Images; p. 58: courtesy Photofest; p. 59: courtesy CR; p. 60–61: © Getty Images; p. 62–63: © Elliott Erwitt/Magnum Photos; p. 64–65: courtesy PLK/*Memoirs*; p. 66: © Getty Images; p. 68: © Royalty-Free/Corbis; p. 69: © Getty Images; p. 70–71: © 2006 Don Freeman; p. 72–73: From BLUEBERRIES FOR SAL by Robert McCloskey, copyright 1948, renewed © 1976 by Robert McCloskey. Used by permission of Viking Penguin, A Division of Penguin Young Readers Group, A Member of Penguin Group (USA) Inc., 345 Hudson Street, New York, NY 10014. All rights reserved.; p. 74: © Brooks Kraft/CORBIS; p. 76: © Ronald C. Saari; p. 78-79: courtesy Photofest; p. 80: © Ronald C. Saari; p. 81: top left: © Lake County Museum/CORBIS, top right: Time Life Pictures/Getty Images, middle: © Ronald C. Saari, bottom left: © Lake County Museum/CORBIS, bottom right: © Bettmann/CORBIS; p. 82–83: © Underwood & Underwood/CORBIS; p. 84: © Bettmann/CORBIS; p. 85: courtesy Photofest; p. 86–87: © 2006 Joel Meyerowitz; p. 88–89: © Bettman/CORBIS; p. 90: © Kevin Fleming/CORBIS, quote © George Howe Colt; p. 91: © Bettmann/CORBIS; p. 92–93: © Bettmann/CORBIS; p. 94: © Ronald C. Saari; p. 95: © Getty Images: p. 96–97: © Sophie Bassouls/CORBIS SYGMA; p. 98: © Lee Snider/Photo Images/CORBIS; p. 99: © The New Yorker Collection 1995 William Hamilton from cartoonbank.com.; p. 100–101: © 2006 Eileen Barroso; p. 102: courtesy Baldwin; p. 104–105: © Getty Images; p. 107: author archive; p. 108–109: © Mia Matheson; p. 110–111: courtesy Baldwin; p. 112: © Time Life Pictures, quote © Susan Minot; p. 113: © Bettman/CORBIS; p. 114–115: courtesy Photofest; p. 116–117: courtesy Photofest; p. 118: © Getty Images; p. 119: © Jennifer Livingston; p. 120–121: © Tony Roberts/CORBIS; p. 122–123: courtesy Photofest; p. 124: © 2006 Kate Kuhner; p. 125: top left: © Kate Kuhner, top right: author archive, middle: author archive, bottom: © Kate Kuhner; p. 126: © Condé Nast archives/CORBIS; p. 127: © Elizabeth Kuhner; p. 128–129: © Getty Images; p. 130-131: courtesy Baldwin; p. 132: © Miki Duisterhof; p. 133: © Getty Images; p. 134–135: courtesy Photofest; p. 136: author archive; p. 137: © Cardinale Stephane/Corbis Sygma; p. 138: courtesy Baldwin; p. 139: © Getty Images; p. 140-141: courtesy RWB; p. 142–143: courtesy J. Crew; p. 144: © Miki Duisterhof; p/ 146–147: © Getty Images; p. 149: © Geoffrey Shakerley; p. 150: © Condé Nast Archive; p. 151: © Jon Arnold Images / Alamy, quote © Susan Minot; p. 152–153: © Getty Images; p. 154–155: © CORBIS; p. 156–157: © Getty Images; p. 158: Condé Nast archive/CORBIS; p. 159: © Owen Franken/CORBIS; p. 160-161: © Getty Images; p. 162–163: © Getty Images; p. 164: © Getty Images; p. 165: © Miki Duisterhof; p. 166–167: © Don Freeman; p. 168–169: © Condé Nast Archive/CORBIS; p. 170–171: © Don Freeman; © Nick Johnson; p. 174–175: From A TIME OF WONDER by Robert McCloskey, copyright 1948, renewed © 1976 by Robert McCloskey. Used by permission of Viking Penguin, A Division of Penguin Young Readers Group, A Member of Penguin Group (USA) Inc., 345 Hudson Street, New York, NY 10014. All rights reserved.